Designing Information

JOEL KATZ

Designing Information
Human factors and common sense
in information design

As knowledge increases among mankind, and
transactions multiply, it becomes more and more
desirable to appreciate and facilitate the modes
of conveying information from one person to
another, and from one individual to the many.

William Playfair
The Commercial and Political Atlas, third edition,
1801

John Wiley & Sons, Inc.

Cover image: Joel Katz

Cover design: Joel Katz

This book is printed on acid-free paper.

Published by John Wiley & Sons, Inc., Hoboken, New Jersey

Published simultaneously in Canada

For general information about our other products and services, please contact our
Customer Care Department within the United States at (800) 762-2974, outside the
United States at (317) 572-3993 or fax (317) 572-4002.

Wiley publishes in a variety of print and electronic formats and by print-on-demand.
Some material included with standard print versions of this book may not be included
in e-books or in print-on-demand. If this book refers to media such as a CD or DVD
that is not included in the version you purchased, you may download this material at
http://booksupport.wiley.com. For more information about Wiley products, visit www.
wiley.com.

Library of Congress Cataloging-in-Publication Data:

Katz, Joel, 1943– author.

 Designing Information: Human factors and common sense in information design /
Joel Katz.

 p. cm

 Includes index.

 ISBN 978-1-118-34197-1 (hardback); ISBN 978-1-118-41686-0 (ebk); ISBN 978-1-118-
42009-6 (ebk); ISBN 978-1-118-44625-6 (ebk); ISBN 978-1-118-44629-4 (ebk)

 1. Brand name products. 2. Branding (Marketing) 3. Trademarks-Design. I. Title.

 HD69.B7W43 2011

 658.8'27--dc22

 2010049604

Printed in the United States of America

10 9 8 7 6 5 4 3 2 1

Information is not knowledge and knowledge is not wisdom.

James Gleick
The Information: A History, a Theory, a Flood

I certainly would be interested to work with a serious agency that can offer a flow of freelance projects. My specialty is Information Design, Branding, and Design Writing. You can preview my portfolio and my blog at....

Designer (not this one) responding to recruiting agency inquiry

Hmm...I've actually never heard of Information Design before (and I've been working in the creative industry for over 10 years now!). Maybe it would be best for us to talk over the phone. Call me when you have a moment.

Recruiting agency responding to designer

We want the book to look different enough so that teachers will want to buy it, but not so different that they feel they have to read it in order to teach it.

Textbook publisher (not this one) to designer (this one) on the design of a new middle school geography textbook

Contents

Full disclosure. *Philadelphia has been my home since 1972. I love it, and I would not dream of living anywhere else (in this country). I walk its streets, I read its newspaper, and I give my students assignments that engage them with local issues, problems, and people. The majority of my clients are regional. Philadelphia's designs are the designs I know. I hope that any criticism of Philadelphian design in this book will be taken constructively, in the spirit in which it is meant, and with the understanding that it is to some extent the result of geographic happenstance.*

I have never had any direct client-designer relationship with any of the originators of the designs that I may appear to criticize in the book, nor are any of those designs by designers with whom I competed for work.

Every effort has been made to accurately credit the designers, artists, and authors whose work I have reproduced and discussed. Some of those acknowledgments and links may be unintentionally inaccurate. To the extent that inaccuracies may have found their way into this book, I sincerely apologize.

Everything is designed.

Most people have little understanding of the design process, but we all live with its results: a sign on the highway, an explanation of a medical procedure in an emergency room, a diagram on how to build a piece of furniture, a chart that shows us our assets, a ballot, a data-driven decision.

Not everyone realizes this.

Many people assume that things just emerge in their finished visual form, like Athena springing, fully armed, from Zeus's forehead. This may explain why design isn't always as good as it needs to be.

Our job as designers is to

design with intent, so that the objects we design function as they are supposed to for those who need them and use them.

Our job as information designers is to clarify, to simplify,

and to make information accessible to the people who will need it and use it to make important decisions. Information needs to be in a form they can understand and use meaningfully, and to tell the truth of what things mean and how they work.

The purpose of this book

is to provide a description of issues that confront designers as we attempt to translate data into information so that our audience can understand it and apply it to answer their questions and meet their needs.

In its structure, this book endeavors to examine the many aspects of designing information. Its title is intentional: it is a book about ideas and process more than about showcasing designs and products that have already been designed to fill specific needs.

The velocity of the increase in accessible data is unprecedented, amazing, and increasing. Not very long ago in design history, cartographers (among the first modern information designers) were decorating their maps with sea monsters, locations of fictional characters, and imaginary islands, less for visual elegance than to fill the spaces where they had no information. "Terra incognita" had multiple meanings.

Our challenge today is almost the opposite from that of centuries, or even decades, past: to invent ways of sifting through the multitudes of data that bombard us daily, often numbing our senses and scrambling our brains.

In looking at and thinking about the issues of designing information rationally and functionally, I was informed and humbled by the work of preceding generations of information designers. As a teacher, I have learned as much from my students as I hope I have imparted. While I have occasionally found students a bit weak in cultural and design history, I attribute this in large measure to the ubiquity of technology, which permits some of the young to believe that everything happened this morning, or no earlier than yesterday. This makes technology part of the problem as well as potentially part of the solution.

The ideas in this book have been rattling around in my head for decades, in one form or another, and its goals and form have changed many times. I feel that many of the ideas and perceptions that occurred to me then have been confirmed.

Information design is a hot subject for books and websites and blogs these days. I've learned a great deal from the books I've read and the sites and blogs I've visited. To my great pleasure, as I communicated with peers and colleagues, I found that there is a thoughtful, generous community of designers who are willing to share and assist each other.

It is my sincere hope that this book may provide similar assistance and ideas to its readers.

1

Aspects of Information Design

The nature of information

To design it is to interpret it.
Chris Myers

Above. A reconstruction of my favorite Irish road sign, meaning "unprotected quay." It's simple, unambiguous, and powerful.

Below. The OPTE project. "The first goal of this project is to use a single computer and single Internet connection to map the location of every single class C network on the Internet."
— **Barnett Lyon**

Information
Complete for its purpose

Definitely true
Vitally important

Uninformation

Probably not untrue
Probably not important
Possibly interesting

Noninformation

Possibly true
Possibly not true
Probably not important
Possibly confusing

Misinformation

Definitely not true
Vitally important to avoid

Disinformation
Complete for its purpose

Deliberately not true
Used vengefully or

The nature of information

Like Caesar's Gaul, information is divided into three principal parts.

Information is what you absolutely must clearly communicate.

Uninformation is stuff that isn't necessarily important and that probably isn't untrue.

- Within uninformation is where the designer plays and dances.

- Within uninformation is **noninformation**, which is often uninformation appearing to be information.

Misinformation is stuff masquerading as information that is likely to distort, confuse, and mislead (and possibly injure, maim, kill).

- Misinformation is not necessarily deliberate but may be the result of unintentional incompetence, noncurrent data, or failure to correctly interpret source data.

- At the nadir of misinformation is **disinformation** (from the Russian *dezinformatsiya*), misinformation deliberately used to achieve a financial, political, or military objective.

Read Charles Seife. *Proofiness*. Seife identifies a host of ways in which numbers are used, or misused, to convince people and the media that things that are demonstrably not true are, in fact, verifiably true.

Go to http://charlesseife.com/books

See also Numerical integrity; Page 192 top left and bottom center.

Indicium est omne divisa in partes tres.

(All information is divided into three parts.)

Paraphrase of Julius Caesar, in *Commentarii de Bello Gallico*, ca. 40s BCE.

If the Hippocratic oath were written for designers, it would begin, "First, tell no lie."

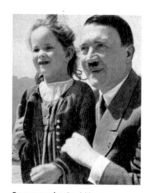

Propaganda. *Could be true; could be false; probably incomplete. Politicians just love small children, don't they? This photograph is from a 1940 pro-Hitler propaganda booklet.*

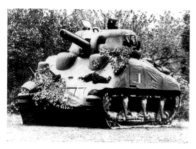

This inflatable tank is an example of disinformation used prior to the Normandy landings in 1944. Operation Fortitude, as it was called, involved the creation of fake field armies both north and south of the actual invasion landing site to divert Axis attention away from Normandy. It was one of the most successful military deceptions of the war.

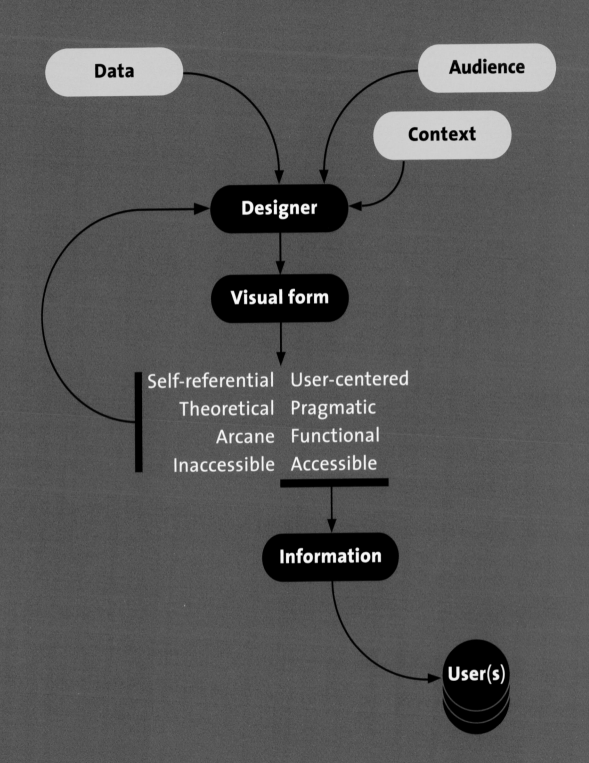

Self-referential vs. functional

Self-referential design is where (only) the **designer** understands.

Pragmatic design is where the **user** understands.

Whatever the medium and whatever the content, the purpose of information design is to convey information to the user. If the user can't understand it, the design and the designer have failed.

The difference is not unlike the difference between school and the world. In school, students function largely within a relatively homogeneous community of their peers and instructors, where they learn to research a problem, explore alternatives, and defend their solution in terms of their thinking and design process. In the world—in life—designers, especially information designers, deal with communicating information visually to a user group some-times very unlike themselves.

Often the designer, in life as well as in school, falls into the trap of designing for appearance, and using the data, or content, not as the core of a communications process but as the foundation for explorations of visual excess and irrel-evance. Many graphic and information design curricula are responding to society's needs and teaching that form grows organically out of the need to communicate content.

This conveys a powerful responsibility upon—and a great opportunity for—the designer.

"Intellectual"—non-user-centered—design, and personal explanations of self-referential design, lead back only to the designer, not forward to the user.

Read Jorge Frascara. *Communication Design: Principles, Methods, and Practice.*

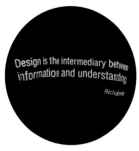

A seminal quote by Richard Grefe, Executive Director of the AIGA, on the back of a t-shirt worn by information designer Paul Kahn. I have said, "the designer is the medium between the information and the user." As with many quotes in this book, the identical idea can usually be attributed to many people.

Like good writing, good graphical displays of data communicate ideas with clarity, precision, and efficiency.
Michael Friendly

The data, the designer, and the audience are the fundamental continuum in information design.

If it doesn't work for the user, no amount of explanation can make it any better.

Accessible symbolism: the 168 chairs in the Oklahoma City bombing memorial. Inaccessible symbolism: the 1,776-foot height of the Freedom Tower.

Chaos out of order. *We are used to seeing ads like this in the automotive section of our newspaper (those of us who still read newspapers). Interestingly, this ad is comparatively well organized, but—not content to leave what might have been well enough alone—over-crowding and a riot of fonts and exhortations destroys what—in the hands of a capable designer—might have been much better than terrible.*

It's not enough to know the base data—in its most literal sense—of an information graphic. One has to understand what it means, which requires knowing how the particular set of information being visualized was selected and, from there, the designer's point of view.

Information, even after it has been distilled from data, and even when it is "true," has intention, interpretation, and often an agenda that has governed its selection: political, social, religious, and "pack-everything-in" are examples of possible motivations behind an information graphic.

Many data sets and information designs, past and present, have been constrained by a lack of data, geographic or statistical, the other side of the mirror of many current "info-graphics" that are overloaded with data just because it exists. It could be said that the task of information designers in the past—particularly cartographers—was to create "information" where no data existed, and that the task of information designers today is to refine and reduce an overabundance of data into meaningful and usable information.

Information design, when successful—whether in print, on the web, or in the environment—represents the functional balance of the meaning of the information, the skills and inclinations of the designer, and the perceptions, education, experience, and needs of the audience.

Often, these components are out of balance for any one or more of a number of reasons.

Data

- The data are incomplete, skewed, or missing; or too gross in grain, oversimplified, or lacking in meaningful detail;

- The data do not reveal their meaning because of lack of definition or misleading relationships within them;

- The data are too dense, arcane, or technical to be transformed into understandable information.

Designer

- The designer is unable to understand the meaning of—and therefore unable to distill and visualize—the data;
- The designer is not adequately sensitive to human factors issues and may not be able to model the needs, abilities, and limitations of the audience;
- The designer might be overly concerned with designing a visually compelling graphic, resulting in counter-intuitive or, worse, misleading or inaccurate design solutions.

Audience

- The audience may be unable to understand the information because of lack of visual literacy or education, unfamiliarity with visual conventions of the subject, lack of specialized intelligence, lack of interest in the subject, or other factors.

Go to http://blog.metmuseum.org/penandparchment/introduction/

See also Simple and complex; Connections among people; Connections in products; Information overload; Too much information; Page 192 top center.

Indifference toward people and the reality in which they live is actually the one and only cardinal sin in design.

Dieter Rams

Unsuccessful design happens when:

- no one understands;
- no one cares;
- it's not anyone's job;
- some or all of the above.

Determining the appropriate content for the communication of information requires a rigorous process of examination:

Is it true?

Is it relevant?

Is it necessary?

Does its inclusion add or detract?

Is it in a form that its audience can understand?

Intentional chaos. This "chart" of President Obama's proposed health care system was released by the Republican side of the Joint Economic Committee on 28 July 2010 (www.freerepublic .com/focus/f-news/2650278/ posts), purporting to show "Obamacare's bewildering complexity." It does not compare the plan's complexity either with the existing health care structure nor to any proposal put forward by the Republicans in Congress. A good example of misinformation. (The legend has been deleted.)

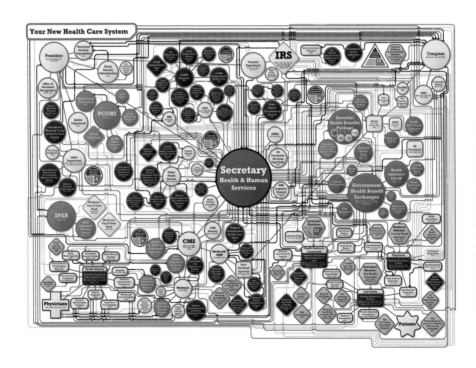

Rev. Father F. N. Blanchet made first use of this "Catholic Ladder" in July 1842 at the Cowlitz Mission to teach the Indians the main truths of the Catholic faith. Many copies of the ladder were made and presented to the Indian chiefs.

The 40 horizontal bars represent the 40 centuries BCE (when the world was declared by James Ussher to have been created in 4004 BCE). The 33 dots represent the years of Christ's life on earth. The 18 bars represent the 18 centuries CE and the 42 dots represent the 42 succeeding years.

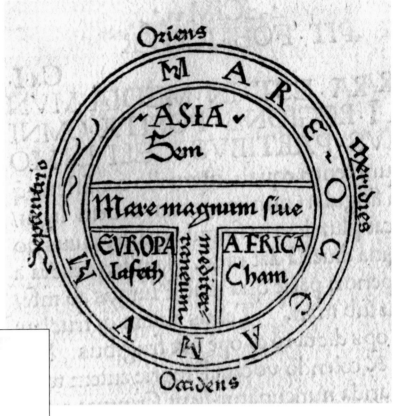

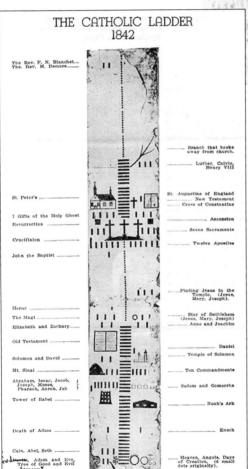

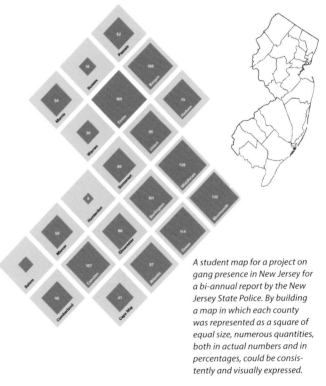

A student map for a project on gang presence in New Jersey for a bi-annual report by the New Jersey State Police. By building a map in which each county was represented as a square of equal size, numerous quantities, both in actual numbers and in percentages, could be consistently and visually expressed.

Non-wayfinding cartography

Left. The "T-in-O" map (so called for the letterforms created by the bodies of water and the surrounding ocean) is one of a large number of maps that emphasize theology over geography. Based not on geographic ignorance, as occasionally thought, its intent was to summarize a Christian world view in a simple and memorable form (not unlike Harry Beck's iconic London Underground map of 1931, which created a simple and memorable image of a complex movement network).

Although the map is shown as a flat disk for simplicity, it was well known that the earth is roughly spherical. Its construction is theologically governed: east is at the top, as it was believed that Paradise is to the east; Jerusalem is at the center; the three continents show the division of the world by the sons of Noah.

I categorize non-wayfinding maps and diagrams into four basic categories:

1 Geographic (not illustrated on this spread): the most familiar type of maps, they represent space with geographic accuracy and at a constant scale. They are the predominant map type in most atlases. Included in this category are simplified geographic maps designed to make wayfinding and movement networks more easily understandable.

2 Conceptual: these maps (and diagrams) may take extreme liberties with geography, or ignore it almost entirely, to describe or promote a concept or point of view. Many of these maps, especially in the past, when accurate geographic knowledge was incomplete at best, are often based on a theological or users' affinity view of the world.

3 Experiential (not illustrated on this spread), often diagrammatic: how place and space are experienced, felt, measured, and perceived, often very different from geography. Each of us experiences space and time uniquely. Children's perceptions of a place and the geographically distorted units of space and time experienced in transit travel with no visible geographic references are in this category.

4 Numerical/statistical: maps that adjust geography to reflect place-specific statistics. They are used to show change, relationships between and/or among places or political entities, and other numerical or statistical (non-geographic) comparisons.

Many maps and diagrams embody a combination of these categories.

Read Alessandro Scafi. *Mapping Paradise: A History of Heaven on Earth.*

Go to Cartographia: http://carto graphia.wordpress.com/about

http://blog.metmuseum.org/pen andparchment/exhibition-images/ cat300r2_49e

http://www.strangehorizons .com/2002/20020610/medieval_ maps.shtml

See also Anatomy and function; Escaping geography; A movement network genealogy; Map or diagram?

Another student project, like the map on the opposite page, illustrates two phases of a U.S. government housing program awarded to cities—the Neighborhood Stabilization Program. Phase 1 grants (right) were awarded on a system based on need. Phase 2 grants (far right) were awarded competitively. The area of each square is proportional to the size of the grant; the colors of the squares relate to 20 additional graphs in the project; and the distribution of the squares locates the cities geographically in the United States.

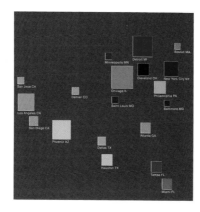

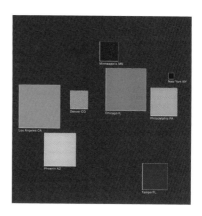

Described by Edward R. Tufte as "the best statistical graphic ever drawn," Minard's map has long been the subject of discussion, analysis, and attempts to improve it. Some of these are shown in Section 6 of this book.

Places

Space

Figurative Map of the successive losses in men of the French Army in the Russian campaign 1812
Drawn up by M. Minard, Inspector General of Bridges and Roads in retirement. Paris, Novem...

The numbers of men present are represented by the widths of the colored zones at a rate of one millimeter for every ten thousand men; they are further...
the zones. The red designates the men who enter into Russia, the black those who leave it. ___ The information which has served to draw up the map is...
from the works of M.M. Thiers, of Segur, of Fezensac, of Chambray and the unpublished diary of Jacob, pharmacist of the Army since...
In order to better judge with the eye the diminution of the army, I have assumed that the troops of Prince Jerome and of Marshal Davoust who had been det...
and Moghilev and have rejoined around Orcha and Vitebsk, had always marched with the army.

GRAPHIC TABLE of the temperature in degrees of the Réaumur thermometer below zero.

The Cossacks pass the frozen Niemen at a gallop.

— 26° December 7 — 30° Decemb... — 24° December 1 ° November 28 — 11° — 21° November 14

The table below was retrofitted from the data in the Minard map and other sources.

Although it is possible to order the table by date (as it is), by troop numbers, by geography, or by temperature (for the return), the table remains columns of numbers—code.

Time and number: date and temperature

Events: battle and river crossings

Napoleon's Russian Campaign
Kovno–Moscow–Kovno, October–December 1812
Data mapped by Charles Joseph Minard 1869

Day	Date	Number of troops	Location	Temperature °C	°F	°R	Notes
0	23 June	422,000	Kowno				River Nieman
		400,000					Macdonald separates
		340,000	Vilna				Oudinot separates
		175,000	Witebsk				
		145,000	Smolensk				
		145,000	Dorogobouge				
		127,000	Chjat				
		100,000	Mojaisk				Maskown River
	18 October	100,000	Moscou	0	32	0	
		100,000	Tarantino				
	24 October	100,000	Malo-jarosewli	0	32	0	Rain
		96,000	Mojaisk				
		87,000	Wizma				
	09 November	55,000	Dorogobouge	-13	9	-9	
	14 November	37,000	Smolensk	-26	-13	-21	
		24,000	Orscha	-23	-9	-18	River Dneiper
	21 November	20,000	Botr	-14	7	-11	
		50,000					Joined by Oudinot
	28 November	50,000	Studienska	-25	-13	-20	River Berezina
	01 December	28,000	Minsk	-30	-22	-24	
	6 December	12,000	Moloderno	-38	-34	-30	
		14,000	Smorgoni				
	7 December	8,000	Vilna	-33	-27	-26	
		4,000					
		10,000					Joined by Macdonald
174	14 December	10,000	Kovno				River Nieman

Survived 2%

Died 98%

A re-creation of the "executive summary" of Minard's diagram.

This [the Minard map above] is one of the worst graphs ever made. [Tufte's] very happy because it shows five different pieces of information on three axes and if you study it for fifteen minutes it really is worth a thousand words. I don't think that's what graphs are for. I think they try to make a point in two seconds for people who are too lazy to read the forty words underneath. And to make me spend fifteen minutes studying it doesn't make sense....

Seth Godin

Quoted by Jorge Camoes on 21 January 2008
http://www.excelcharts.com/blog/minard-tufte-kosslyn-godin-Napoleon/

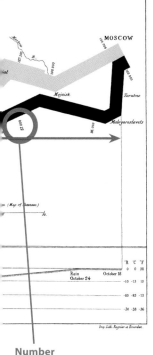

Number of living soldiers remaining

In *The Visual Display of Quantitative Information* (1983), Edward R. Tufte introduced the design community (and beyond) to Charles Joseph Minard's 1869 graphic of Napoleon's disastrous march to Moscow and back in the winter of 1812–1813.

Minard's map integrates four types of information design (and six categories):

1 Space (often used interchangeably with geography, to which it occasionally bears a resemblance). While simplified, Napoleon's route maintains a consistent and accurate scale, with adequate geographic references.

2 Time (return only). Minard uses dates keyed to temperature to show both the speed at which distance was covered and temperature's relationship to the staggering loss of troops.

3 Numbers—of troops and their relationship to place and temperature. (The Réaumur temperature scale sets the freezing point of water at 0° and the boiling point at 80°.)

4 Events. Troop strength and reinforcements; river crossings during the brutal winter, on the return, particularly at the River Bérézina. (Since that time, *Bérézina* has been used by the French as a synonym for disaster.)

Minard's graphic has beome something of a self-perpetuating industry and continues to fascinate designers, information architects, information scientists, statisticians, teachers, and students; it is truly the 800-pound gorilla in the information design room.

To ask for a map is to say, "Tell me a story."
Peter Turchi

The brilliance of Minard's map is the ability to integrate and permit comparison of qualitative, quantitative, and geographic information in the same graphic.

Read Edward R. Tufte. *The Visual Display of Quantitative Information.*

Go to http://www.datavis.ca/

http://www.datavis.ca/gallery/re-minard.php

http://bigthink.com/strange-maps/229-vital-statistics-of-a-deadly-campaign-the-minard-map

See also Anatomy and function; It's about time; Escaping geography; Page 192 right.

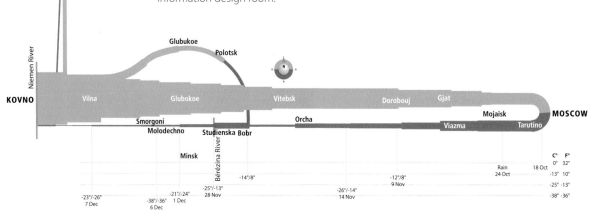

Everyone needs to do a "Minard," it seems. This was done by the author, who makes no claim to its superiority.

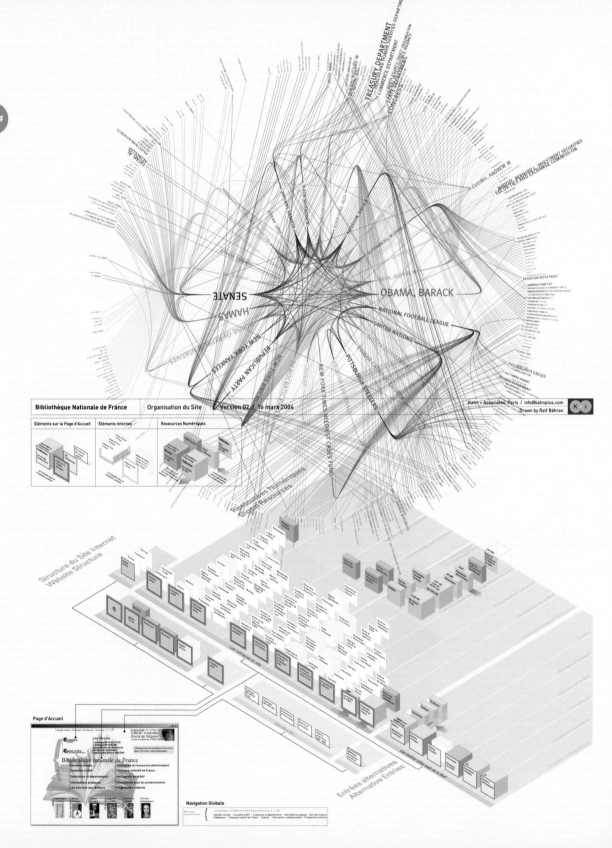

Bibliothèque Nationale de France | Organisation du Site | Version 02 / 16 mars 2004 | Kahn + Associates, Paris / info@kahnplus.com

Drawn by Ralf Bähren

Eléments sur la Page d'Accueil | Eléments Internes | Ressources Numériques

Ressources Numériques
Digital Resources

Structure du Site Internet
Website Structure

Page d'Accueil

Bibliothèque nationale de France

Navigation Globale

Entrées alternatives
Alternative Entries

Simple and complex

This visualization of the orga-
nizations and personalities
most mentioned in The New
York Times in 2009 was made
by information artist Jer Thorp.
Connections between these
people and organizations are
indicated by lines. Data is from
the NYTimes Article Search API:
developer.nytimes.com

We have long been visualizing things that we cannot see,
either because they are too small, too far away, or have
working components that are enclosed. With the advent of
the internet and the attendant proliferation, collection, and
organization of data, we are now mapping and visualizing
connections and relationships at an unprecedented rate.

Many of these visualizations are extremely practical, and
aid in understanding relationships within a complex site
or organization. Others deal with unimaginably complex
relationships among data, and their creation is aided—and
impossible without—sophisticated computer applications.

Unfortunately, being able to visualize ungraspable relation-
ships does not necessarily make them more graspable. There
comes a point where the data—whether it is visualized or
listed—simply run into the limits of the human mind.

While computers expand their capacity at an exponen-
tial rate (Moore's law—the number of transistors that can
be placed inexpensively on an integrated circuit doubles
approximately every two years), human beings do not evolve
at the same rate. So we find ways of understanding the larger
picture and its meaning.

Many designers working with computers have pushed this
genre of information design out of the realm of communi-
cation and into that of art. The algorithms they write have
become the notational tools of visual information art, much
as musical scores are the notational tools of aural art, permit-
ting their forms to be archived, revisited, and re-applied to
new instruments, data, and ideas.

> Some information
> is very simple;
> some is very
> complex. The trick
> is to make complex
> information
> understandable.

Bruno Martin

Read Philip Morrison, Phyllis
Morrison, Office of Charles and
Ray Eames. *Powers of Ten: A Book
About the Relative Size of Things
in the Universe and the Effect of
Adding Another Zero.*

Manuel Lima. *Visual Complexity:
Mapping Patterns of Information.*

Paul Kahn, Krzysztof Lenk. *Map-
ping Websites: Digital Media
Design.*

George L. Legendre. *Pasta by
Design.*

Go to http://powersof10.com/

http://www.flickr.com/photos/
blprnt/sets/72157614008027965/
with/3291244820/

See also Too many numbers.

In the fall of 2003, Kahn +
Associates, Paris, was engaged
by the Département de la
bibliothèque numérique at
the Bibliothèque nationale de
France (BnF) to analyze the
public websites of three major
English-language national
libraries and compare them
with the website of the French
national library. The Library of
Congress, the British Library,
and the National Library of
Australia were the other three
websites analyzed.

Simple to look at and delicious
to eat, this pasta shape (stroz-
zapreti: priest stranglers) are
mathematically extremely com-
plex. One of 189 illustrations in
Pasta by Design.

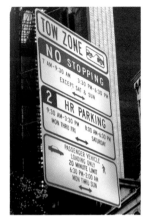

An example of a parking sign type in use prior to the introduction of new regulations. It wins no design prizes, with silly pictograms, a lot of unneccessary rules, and an ambiguous use of figure-ground changes—but at least no vertical splits.

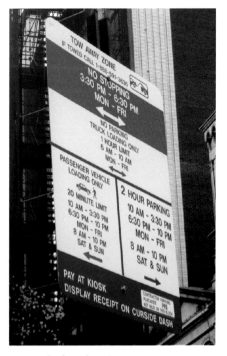

An example of a parking sign after the introduction of new regulations. The new regulations required a vertical split because there was so much "information." Some elements were unnecessary, such as the graphic of the contractors' placard: the contractors know what their placard looks like.

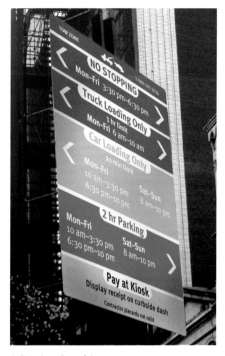

A digital mockup of the students' sign format applied to the same location. No vertical split and coded color for loading zones and payment information. Category headline treatments are typographically uniform, and there is a clear hierarchy of importance.

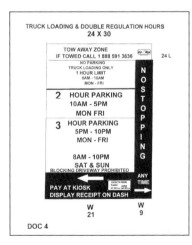

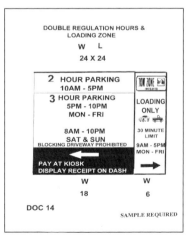

Two pages from the RFP (Request for Proposal) that led to the signs shown top center.

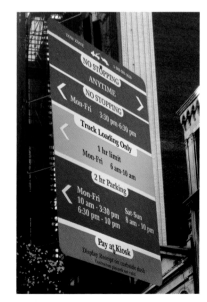

In 2008 the Philadelphia Parking Authority (PPA) changed and complicated the parking game by introducing a more complex set of regulations than had previously existed, all in the city's best parking interests:

- *Encourage full-day workers to use parking garages by raising the cost of street parking, thereby reducing traffic congestion aggravated by parkers circling the block and polluting the air.*

- *Increase the number of loading spaces and the specificity of contractors' permit regulations.*

- *Replace meters with kiosks, to accept credit and debit cards as well as cash and Authority pre-paid cards.*

- *[Presumably] communicate these regulations effectively.*

The implementation of these objectives led to a multifold increase in the complexity of regulations needing to be communicated by signs, which now also had to identify the payment kiosks and explain their use.

Every silver lining has a cloud.
Left. The PPA enthusiastically received the students' solution. Their vendor kept asking them (and me) for fonts, which we kept sending. They never explained what their problem was or what they needed. So they just ignored the design. Like a plague, the bastardization of the students' design continues to proliferate throughout the city.

This is a story of a well-intentioned endeavor undone by its own inherent conflicts: on-street parking in downtown ("Center City") Philadelphia.

When parking was relatively inexpensive (i.e., less expensive than garages), on-street parking was monopolized by commuters who ran out every few hours to feed the meter. Those who needed only short-term parking circled the block (polluting the air) or used garages (with extremely high charges for the first hour) and got angry, resentful, and started shopping and visiting services outside Center City.

New regulations were developed to mitigate this trend and to balance, to the extent possible, the parking needs of residents, workers, and visitors, as described in the caption at left.

The signs communicating parking regulations—even when those regulations were comparatively simple—were never examples of typographic excellence and clarity. When the new regulations, signs, and kiosks were implemented, the conflicts between communicating extremely complex information, the context in which it operates, and the audience it is addressing became almost impossible—a perfect example of no good deed going unpunished.

The students' solution, notwithstanding the unfortunate implementation that followed it, suggests that there are some conditions that are so difficult to communicate that a wholly satisfying design solution is likely to elude even the best designers. This was a revelation to them, as design students are often taught (and designers like to believe) that there is no design problem that cannot be solved well.

The answer is to collaboratively address the multiple aspects of the problem holistically, so that operations are brought more closely in line with the designer's ability to communicate them in a particular context and the user's ability to understand them.

See also Staging information.

In addition to parking sign modules, the students also made an effort to improve the kiosk graphics, without being able to alter its physical components.

There's never enough time to do it right, but always enough time to do it over.

Printer's saying

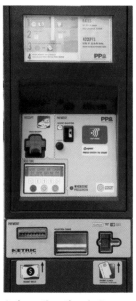

And sometimes there isn't.
Designed in a rush, the placement of components and instructions appears to have been determined by engineering expediency rather than by consideration of users' needs.

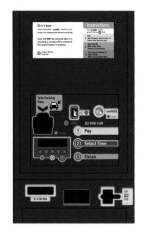

This diagram is both simple and clear, particularly with regard to the volume of the drink and the proportions of each ingredient. It follows the principle of information expansion, using two-dimensional space generously to avoid confusion and visual complexity. Unlike the layered graphic of the same information below, it does make seeing the overlap of ingredients abd their combination time consuming.

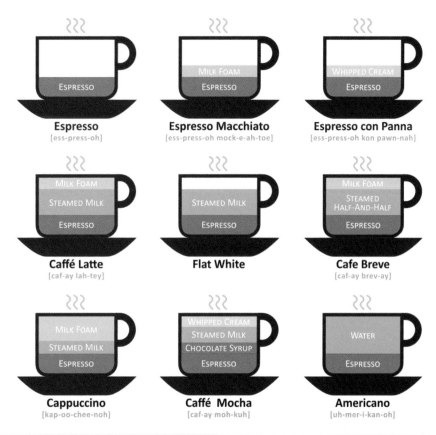

Espresso [ess-press-oh]	**Espresso Macchiato** [ess-press-oh mock-e-ah-toe]	**Espresso con Panna** [ess-press-oh kon pawn-nah]
Caffé Latte [caf-ay lah-tey]	**Flat White**	**Cafe Breve** [caf-ay brev-ay]
Cappuccino [kap-oo-chee-noh]	**Caffé Mocha** [caf-ay moh-kuh]	**Americano** [uh-mer-i-kan-oh]

Rancher, analogous to the diagram at right.

Triplex, analogous to the Venn diagram at right.

This elegant and intriguing Venn diagram uses space efficiently by layering, but relative quantities are difficult to ascertain, and understanding the components requires memorizing or looking back and forth at the legend.

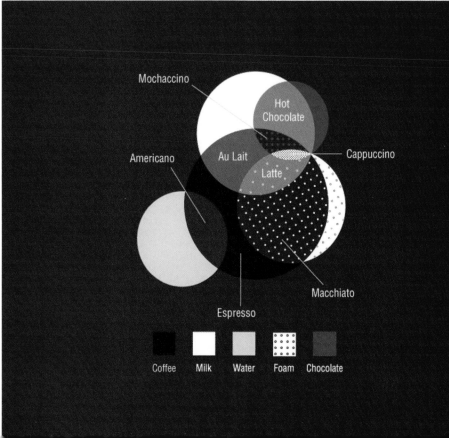

Dispersed vs. layered

It's all about how much you fill the cup. *Massimo Vignelli with his original coffee cup that he designed for Heller. People complained about the semicircular notch in the lip (they were burning their palms when hot coffee spilled into the concave handle) and Heller asked him to plug it up.*

Vignelli's apocryphal response was that Americans might try emulating the more elegant Italian demitasse serving and not fill their cups to the brim.

Heller plugged it up anyway. Michael Bierut recalls that Vignelli described filling in the notch was like pulling the wings off a butterfly: "So simple to do, but all you have left is a bug."

There is always a range of responses to visualizing given quantities and categories of information. Although both the page and the screen are two-dimensional planes, information can be visually layered by adding the illusion of three-dimensional space: in other words, substituting the illusion of volume for the "reality" of area—think of a sprawling ranch house compared to a triplex apartment with the same square footage. Another device is the illusion of transparency, which permits multiple notation types to be layered on top of each other in acknowledged two-dimensional space—the fundamental premise of the Venn diagram, named for John (Donald A.) Venn (1834–1923).

Imagine a data set with three or four variables combined in most of their possible variations. The designer can visualize those combinations in two basic ways. One is to visualize each combination separately; the other is to create a multivariate Venn—provided the data subsets permit—in which transparency and pattern are used to layer different components in a way that creates a compact but dense graphic.

The trade-offs are straightforward. In the case of many separate data subsets, each subset (combination of variables) is immediately understandable, but comparison among them can only be done one pair at a time. In the case of a layered diagram—a multidimensional Venn, so to speak—it is easy to see in which combinations each variable is used, but a sense of the whole and components of each data subset are more difficult to ascertain and compare. The diagram with separated components uses two-dimensional space, repetition, and redundancy liberally; the Venn diagram with layering and transparency uses two-dimensional space efficiently but requires concentrated study.

Read Massimo Vignelli. *The Vignelli Canon.*

Go to http://topics.nytimes.com/top/opinion/editorialsandoped/oped/columnists/charles_m_blow/index.html?s=oldest&

See also Dimensional comparison.

How is the data best viewed? Each technique— horizontal expansion or vertical expansion—offers its own advantages and disadvantages.

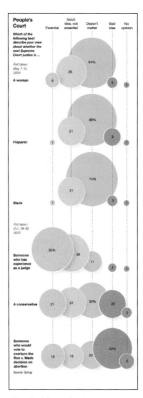

Blow by blow. *Charles M. Blow is the current visual Op-Ed columnist for* The New York Times, *for which he regularly designs charts and graphs that in general are characterized by a limited number of variables and straightforward graphics. His work is socially progressive and often deals with and communicates important social issues.*

1 : ASPECTS OF INFORMATION DESIGN

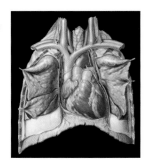

The Anatomy Fallacy.
Frank H. Netter (1906–1991) has been called "Medicine's Michelangelo" by The New York Times. *In a career spanning more than half a century he created thousands of anatomical and medical illustrations that can be found in every medical school library.*

Without in any way diminishing his accomplishment or disparaging the importance of Netter's work, his illustrations are an example of the illusion that if you know what something looks like you know how it works (and, presumably, how to use it and how to fix it).

Anatomy is important to physicians in the same way that geography is important to infantry in a foreign country. But anatomical exactness is not necessarily helpful in explaining how the heart works, how it interacts with the lungs, and how it feeds other major parts of the body.

In the sequence of these diagrams, the diagram at the top came first: it really is the way the heart works— a completely circular system. This clearer diagram of the heart's function, however, was felt by the designer to be too unfamiliar for a lay audience.

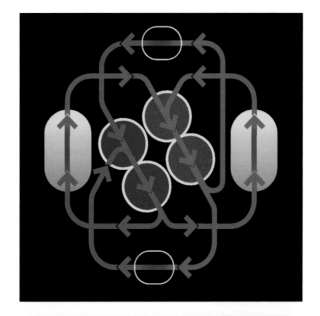

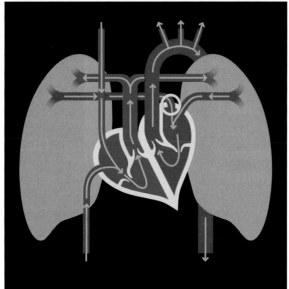

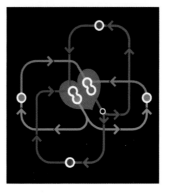

This is the first concept for a functional diagram for a book on the heart. It was eventually replaced by the diagram below, which offered a vocabulary that could easily be adapted for multiple diagrams of heart function by turning layers on and off.

This diagram, and the version on the cover, are anatomically inaccurate, as de-oxygenated blood goes out to the lungs and oxygenated blood out to the body from the top of the heart, not the bottom; it is is, however, functionally accurate.

The final diagram used in the book. The yellow circle highlights the right pulmonary vein as it enters the left atrium. In virtually all dimensionalized illustrations, this route and its connection is hidden by anatomical information physically in front of it.

The cover illustration is further anatomically abstracted in homage to Harry Beck's London Underground map.

Anatomy and function

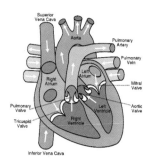

This diagram, typical of dimensionalized diagrammatic illustrations of the heart, obscures many of the connections between the pulmonary veins and arteries and the heart. The final diagram we developed for **The Heart** is able to show all those connections and details by creating the diagram two dimensionally so that nothing is obscured by anatomy.

Below. Artist Christine Zelinsky used black to indicate the walls of the heart (1980s). Below center, George Giusti reverses the convention, using the intuitive colors of red and blue to differentiate between arterial and venous blood (1962).

Anatomical illustrations and geographic maps both show the physical appearance of things: anatomy of the body and the geography of the physical world. But anatomical illustrations do not show how the body works, and geographic maps do not explain how a place is experienced or a movement network used. How bodies and environments work are an entirely different matter.

In anatomical illustrations you see veins, arteries, bones, muscles, ligaments; in geographic maps, rivers, streams, streets and highways, athletic fields, cemeteries. There is a great deal of information to be gained from this detail—especially if you are about to perform open-heart surgery or plan a highway or residential development or just a long walk. Sometimes, anatomical or geographic fidelity can actually mask important elements of the subject.

But how do impulses from the brain carried by the nerves keep your heart beating? How will the capacity of an urban infrastructure need to be increased to accommodate new development? What's going on inside the box in a diagram of a rocket ship labeled "engine"? For this information—about function rather than appearance—you need a way of looking at things that reveals how they work.

Our circulatory system is like one big train network, like the ones many of us played with as children: our heart is the roundhouse and pumping stations, from which the trains—blood molecules—are dispatched; our lungs are the fueling stations; our upper and lower body are the destinations.

The best way to show how something works is not necessarily to show what it looks like.

Read David Macauley. *The Way We Work.*

Frank H. Netter. *Atlas of Human Anatomy.*

Fred Smith, Joel Karz, Richard Saul Wurman. *The Heart.*

Go to www.davidmacaulay.com

See also Metaphor and simile; Perils of geography; Page 193 bottom.

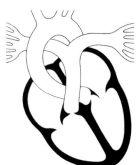

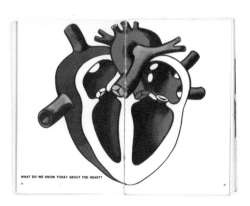

WHAT DO WE KNOW TODAY ABOUT THE HEART?

David Macaulay is a master of illustrative informational diagrams of everything from castles to human anatomy, combining an accessible style and humor with a high degree of functional accuracy.

This metaphoric illustration of kidney function was done by a student utilizing familiar kitchen objects.

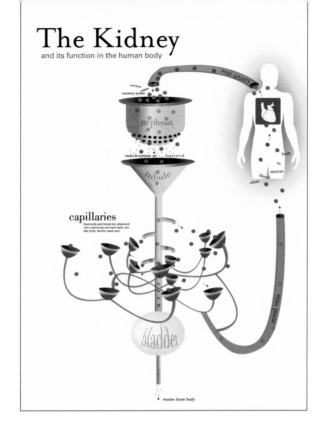

The Kidney
and its function in the human body

Below top. A monoclonal antibody tagged with a radio-active isotope that binds only to recently dead heart tissue is capable of transmitting a scin-tillated image that would show doctors the extent of a current heart attack.

Below bottom. A visualization of an "immuno-combination antibody," which features two different binding arms, in this case one that binds to antigens on the surface of cancer cells, the other that carries a killer cell. In this way, the antibody would target only those cells infected with cancer and would leave healthy cells alone.

Metaphor and simile

Richard Saul Wurman's deceptively obvious statement reveals an understanding of human factors that is as accurate as it is simple. I grew up with diagrams in encyclopedias (labeled, for example, "engine," "cockpit") that taught as much about the function of the object diagrammed and its parts as a photograph of the outside of a car explains the workings of the internal combustion engine. The workings of the human body are a combination of rail transit maps (when it's working) and Star Wars, the movies as well as the Strategic Defense Initiative (when it's not). Most of us are actually more familiar with battles in space than we are with the functions and processes of our own body. But we can use much of the familiarity we have to transfer information to things with which we are much less familiar.

Metaphor provides the opportunity to perceive the function of many disparate things as parallel and related.

Using metaphor and simile to show how different parts of our body work without resorting to anatomical drawing is a problem I have been assigning my students in design for many years, as it encourages them to think about how things work and to visualize functions rather than appearances.

See also Anatomy and function.

People only understand something relative to something they already understand.

Richard Saul Wurman

Don't confuse knowing what something looks like with understanding how it works.

An antibody to destroy the fatal endotoxins released when septic shock bacteria are exposed to antibiotics (actually, the monoclonal antibodies bind to the endotoxins and neutralize them, and are flushed out of the body through the liver).

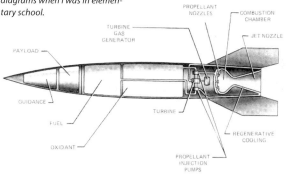

Less than meets the eye. This diagram of a rocket ship does show where important components are located relative to each other, but they are labeled as "black box" objects and there is no information about how anything works and virtually no information about what they look like. I remember being frustrated by these so-called diagrams when I was in elementary school.

PAYLOAD
GUIDANCE
FUEL
OXIDANT
TURBINE GAS GENERATOR
PROPELLANT NOZZLES
COMBUSTION CHAMBER
JET NOZZLE
TURBINE
REGENERATIVE COOLING
PROPELLANT INJECTION PUMPS

1 : ASPECTS OF INFORMATION DESIGN

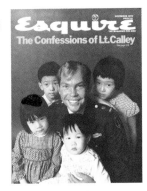

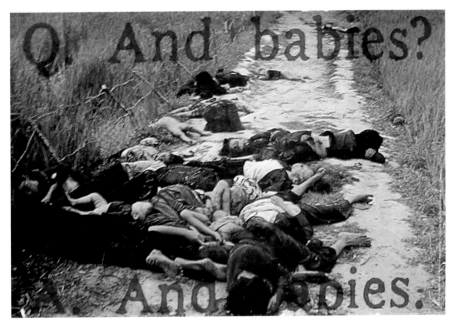

The Esquire *cover above (November 1970) was one of the many brilliant and corrosive collaborations of art director George Lois and photographer Carl Fischer.*

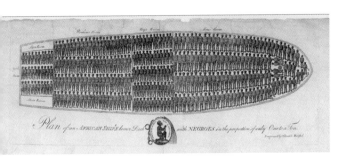

By November 1969, Americans began to hear of the My Lai massacre. Life *magazine published Ronald Haeberle's gruesome color photos and the chilling images sent shockwaves around the world. In 1970 the Art Workers Coalition (AWC—a group of progressive New York artists) produced this poster. It was designed by artists Frazer Dougherty, Irving Petlin, and Jon Hendricks, using text from an interview with a participant in the massacre combined with Haeberle's photo.*

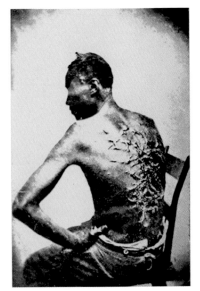

Above. A drawing of the slave ship Brooks, first published in an abolitionist broadside by William Elford and the Plymouth chapter of the Society for Effecting the Abolition of the Slave Trade in November 1788. The broadside incorporated another iconic abolitionist image, of a slave in chains, asking, "Am I not a Man and a Brother?"

Left. "The Scourged Back," ca. 1860. This specific whipping was made to appear more brutal by the subject's rare Keloid Cyst skin condition, causing excessive growth of scar tissue. To what extent is exaggeration of the full reality by an image justified by the "justness" of the cause it is serving?

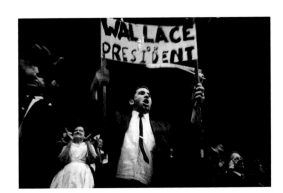

A recent manifestation of prejudice. Enthusiasts at a rally and speech by Alabama Governor George Wallace at the Mississippi Colosseum, 1964.

Emotional power

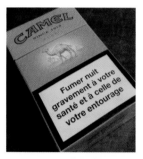

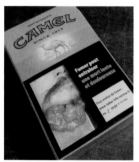

French cigarette packages graphically and typographically warn smokers about the dangers of smoking. The front reads: "Smoking is gravely harmful to your health and the health of those around you." The back reads: "Smoking can lead to a slow and miserable death." And in case that's not clear, there's a picture….

Whether the U.S. government has the right to require photographs like these on packages of cigarettes sold in this country is, as of June 2012, making its way through the courts.

The relationships among words, images, and numbers are complex and protean, as there are ways for each to support and enhance, or discredit and contradict, the other.

Clear and powerful images often need little or no accompanying text to make their point. In such cases, a picture is worth not just 1,000 words but in fact can soar emotionally well beyond them. Symbols, associated with good or evil, learned through narrative and history, can communicate through experience and memory.

The best and most communicative images and symbols are simple and direct—whether pictorial, symbolic, or numerical—without extraneous elements that reduce their power or make them difficult to remember.

On the left and the right, Nazism is grist for the rhetorical mill. Politicians and commentators, to score points in the news cycle, continue to commit unspeakable acts of historical disproportion.

Dick Polman
in the Philadelphia Inquirer
23 February 2012

Don't devalue the currency.

As exaggerations and superlatives and words with a powerful but specific meaning are used more often and out of context, the meaning and power of the words and their original connotations become compromised and diluted. Whether verbal, pictorial, or graphic, exaggeration and inexact allusions raise the volume without increasing understanding.

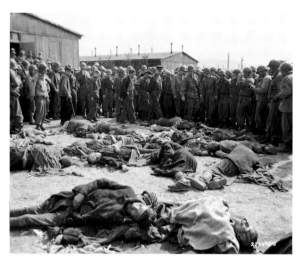

The many photographs, documents, and symbols from the Holocaust so overwhelm rational processing that their casual use is deadening. I include it as an example of the possibilities of word-free communication and the power of icons associated with images of the world's most powerful and most unsettling events.

Ohrdruf-Nord. *German civilians were brought from the town of Ohrdruf to exhume the bodies from a mass grave at Ohrdruf-Nord concentration camp and rebury them in individual graves. General Patton wrote that he suggested that the rest of the inhabitants of Ohrdruf be brought to the camp to view the bodies, and that the army had "used the same system in having the inhabitants of Weimar go through the even larger slave camp [Buchenwald] north of that town." In this photo, General Eisenhower can be seen in the center background, wearing a cap rather than a helmet.*

36

This ad—one of a seemingly infinite series targeting different categories of advertisers and subscribers—is a classic example of, at the very least, noninformation. It is so uninformative and ambiguous that it's impossible to tell whether it qualifies as misinformation.

This envelope was sent to me by the Atlantic. I expected better from them; I've been called naive.

This envelope and false "information" is like what we have come to expect from lenders who prey on the gullible (in this case, seniors).

Is it *really* urgent?

RESPONSE REQUI

We must hear back from you w
next 10 days. An urgent, post:
envelope is enclosed for your co

How often has each of us received communications by mail and, now, by e-mail, with one or more of the hyperbolic phrases at the right? (And that doesn't include the opportunity to help a person liberate millions of dollars in an overseas bank account, usually originating in Nigeria.)

Advertising and promotions are as American as apple pie; but misleading sales promotions, false catch lines, and unintentional ambiguity masquerading as real information are something different. The appropriate use of language is one of the bastions of civil discourse, and it is always disheartening to see it abused, especially in politics.

Equally troubling is the deliberately imprecise use of language in order to imply that the subject, service, or item under discussion is particularly successful or worthwhile. Often, as in the example shown on the facing page, the assertion is not necessarily untrue (although I wonder about how the data were gathered and interpreted) but meaningless nonetheless.

See also The branding fallacy; Numerical integrity.

For named recipient only

Do not deliver to wrong addressee

Do not forward

Open immediately

Response required

Important information enclosed

Do not bend, fold, spindle or mutilate

Final offer

Official business

Last chance

Pre-qualified

You may have already won

And in trying to unsubscribe online:

Thank you for your interest
(I never had any interest)

We're sorry to see you go *(I was never there)*

GOVERNMENT LENDING DIVISION
Housing & Recovery Act of 2008 Eligibility Notice

Eligible Lender: All Financial Services
20 Pleasant Ridge Drive - Suite F
Owings Mills, MD 21117
Notice Expiration: January 9, 2012

Date: December 9, 2011
Telephone: 1-888-444-1850

Joel Katz N18042 4012 T10 P1
123 N Lambert St
Philadelphia PA 19103-1106

Eligibility ID 1209HC5155

The U.S. Government has approved a new mortgage-stimulus package for senior homeowners 62 years of age or older as a result of the Housing & Recovery Act of 2008. This program has already helped thousands of seniors save their home. To take advantage of this program, seniors must inquire before the deadline.

As a HUD approved lender, we are authorized to assist seniors in gaining all the information on the new program and to help seniors safely apply prior to the

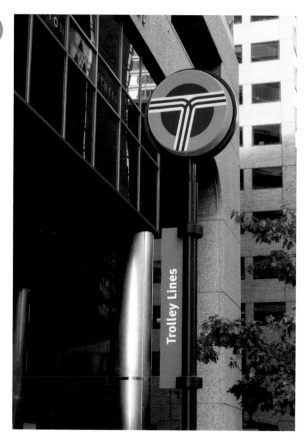

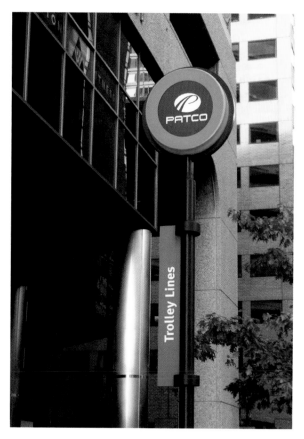

Every silver lining has a cloud.
Above left. An overarching transit mark designed to connote transit in Center City Philadelphia by subordinating the brands of the two entities that operate rapid rail transit. The intent was to make transit identification transparent to visitors who cannot be expected to know how to differentiate between them, especially when the PATCO mark does not connote "metro," "transit," "underground," or motion. Initially approved by all stakeholders, SEPTA reversed course at the 11th hour (after prototypes and before the first 33 stations were implemented) and demanded that all these signs carry the logotypes of the entity operating transit at the station being signed.

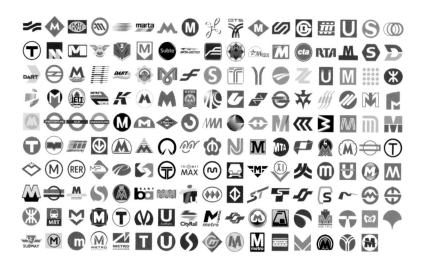

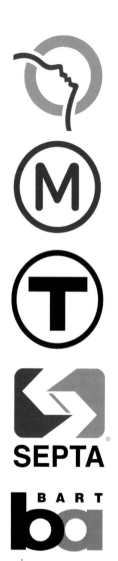

Branding, brand building, brand awareness, and brand loyalty have become increasingly important in selling products, services, and corporate cultures. Successful branding and the communication of information are not necessarily mutually reinforcing, however. And I'm not sure why the "brand awareness" of a transit operator is important: the user needs to recognize that there is transit, not necessarily the brand of its operating entity. There usually isn't a lot of choice.

While a reasonably coherent vocabulary of symbols has evolved for bathrooms the world over, public transit networks are still using a wide range of marks to brand themselves and/or to communicate the presence of transit service.

- Some operating entities—as in Paris and Boston—separate their corporate name from a more universal letterform symbol that connotes transit (RATP and "M" for "Métro" in Paris, and MBTA and "T" for "Transit" in Boston).

- Some—as in Philadelphia and San Francisco—use a letterform mark for their brand ("S" for "SEPTA" and "ba" for "BART," respectively, that have no intrinsic connotation of transit).

- Some—as in Atlanta—use a logomark that may suggest transit, or at least movement—integrated with the operating entity's logotype, or—in the case of San Francisco's Muni network—a logotype only.

As discussed on pages 130–131, marks, logomarks, logotypes, and pictograms that inherently allude to the service being referenced—in this case, transit—will be inherently more immediately understandable to a visitor who has no reason to know the name or logo of the operating entity.

A brand that is not self-explanatory has to be learned. This represents an impediment to users unfamiliar with non-self-revealing logotypes or logomarks.

Read Alina Wheeler. *Designing Brand Identity.*

Alina Wheeler and Joel Katz. *Brand Atlas.*

Go to www.metrobits.org

See also Synecdoche; Is a picture worth 1,000 words? Page 193 top and center.

Top to bottom. Transit marks from Paris (operating entity), Paris (Métro), Boston, Philadelphia, San Francisco (BART), San Francisco (MUNI), and Atlanta.

A prototype of a "civic typeface"—Chatype—designed for the city of Chattanooga TN by designers Robbie de Villiers and Jeremy Dooley. A nice idea, but one might wish for something better drawn and more legible.

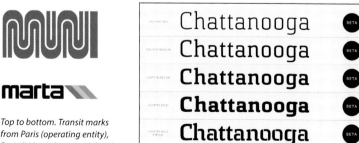

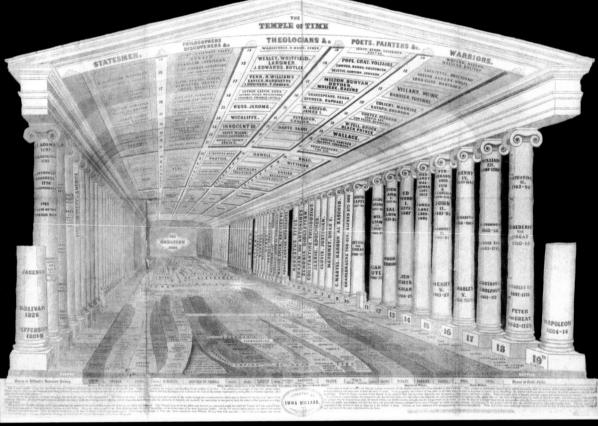

"The Temple of Time" by Emma Willard (1787–1870), the pioneering American girls' educator. The "Temple of Time" is a three-dimensional projection of historical chronography. The vertical columns represent centuries, with those on the right showing names of important figures from the Old World while those on the left show figures from the New World. The floor is a historical stream chart.

The ceiling functions as a chart of biography. Both of these timelines attempt to weave parallel variables of geography, philosophy, important persons, and other ideas and events within the timeline fabric.

Qualitative Issues

Perceptions, conventions, proximity

By understanding how things work, you can start to think about improving them.

Maurice Kanbar

By understanding why things don't work, you can figure out how to design them so that they do.

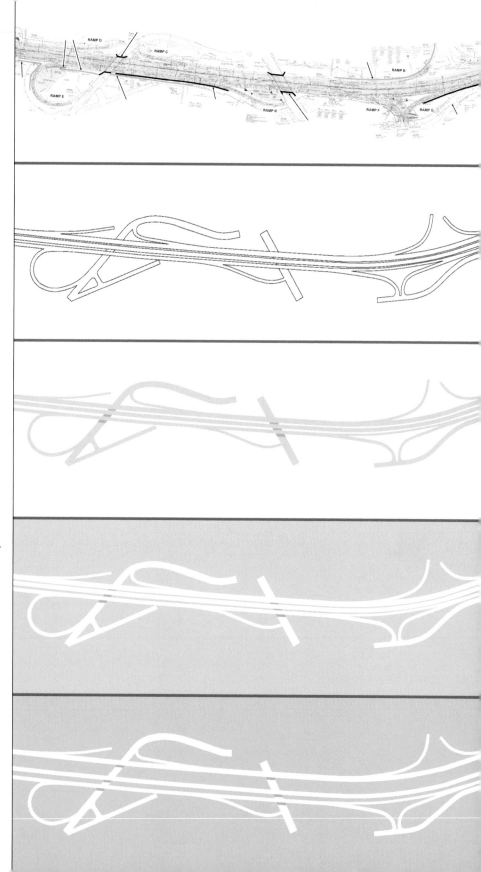

The original engineering drawing on which the illustrations below are based.

This highway map fragment triples the number of lines necessary to indicate the actual roads, and makes it difficult to discern what is road and what is void.

Replacing outlines with paths whose thickness approximates the relative road widths vastly simplifies reading and, with the use of shadows, clarifies roadway level.

Clarity is enhanced by making the roads white on a neutral field, as we tend to equate lighter values with openness and pathways.

The roads' direction is clarified by separating the roads that run in one direction from the roads that run in the opposite direction, notwithstanding the roads' physical—or geographic—adjacency.

Lines

A map in Rome and a reconstruction of it without its unneccessary holding lines.

The line has three functions:

- as the definition of an edge or boundary of an area or object (a container of space);

- as a connection or pointer from one object to another (or from an object to its label);

- as a linear element, such as a road or trackage, in maps and diagrams, connoting something that we know has width but whose function is one dimensional.

In this last context, lines used as the boundary of a linear element are to some extent a vestige of the past, when shapes, bands, and solids were all defined by bounding lines because of the difficulty of reproducing tone. This convention is no longer necessary and has never been particularly effective or elegant.

Almost all engineering drawings of roads, and altogether too many maps for the general public, render a road—which is a path—with three lines: the two bounding lines and the band between them. The result is the creation of three lines to represent one. As shown in the example below, this makes our eyes and brain do extra work to determine which is the figure and which is the ground, and to discern one road or path from another.

Three lines: two boundaries and a path

One line

Lines are not always the enemy. There are occasions where lines serve to differentiate between areas (including linear map elements) that are confusingly close in hue, value, chroma, or some combination of the three. In these instances, boundary lines can be helpful, even necessary, provided that they do not assume a life of their own.

See also The middle value principle; Color and monochrome.

Make every mark count.
Dennis Kuronen

Notational complexity almost always results in informational inefficiency.

Examples of campus maps that use more lines than necessary and subscribe to fallacies of "dimensionality."

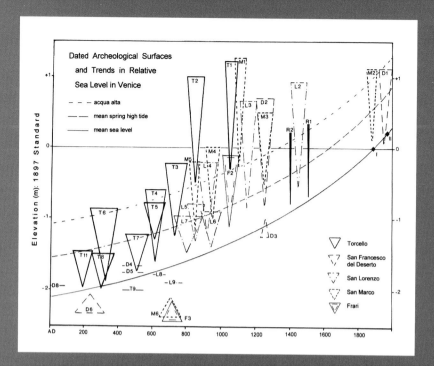

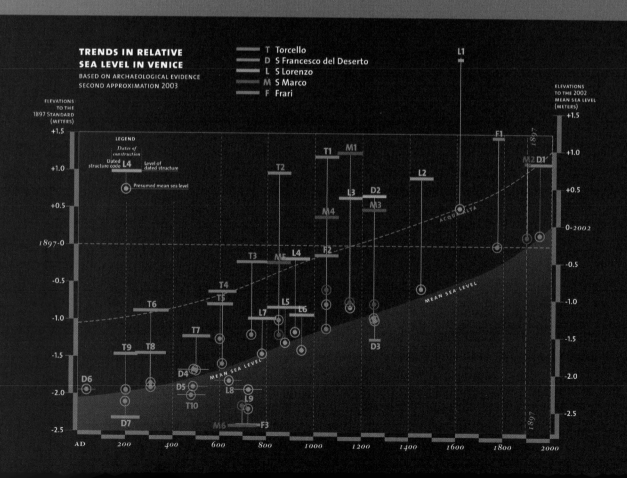

Unintended consequences of shape

Left. In this graphic, the archeologist's graduate student fell into the trap of connecting the three pertinent points of a stroke and a point to make a triangle. In reality, the two points that define the horizontal stroke represent a period of time during which the artifact was built or made. The height of the triangle represents the distance above the contemporaneous lagoon level that the artifact would have been. The connection of the horizontal timeline and the "drop" to presumed lagoon level creates a triangle, a visually powerful shape that has no relationship to the data and confuses the reading of the graphic.

Left. This redesign of the original, in addition to its helpful use of color, avoids the problem of misleading shapes. The use of a vertical line connects the bar—which clearly shows height above lagoon level and timeframe—to the target at which the artifact was found. Those targets, unlike the triangle apexes in the original, define a conventional scatter point array that shows the rise of the lagoon for 2,000 years.

The illustration on the facing page represents a classic example of what can happen when a perfectly intelligent person sets out to visualize data without being able to perceive the consequences of his work.

In this example, the vertical measurement of each triangle represents distance or depth and the horizontal base represents a period of time. When you connect the three points they make a triangle. That's different.

A triangle defines an area, and a comparison of triangles suggests that there is meaning in their proportions and areas: a wide, short triangle should intuitively connote something different than a narrow, tall triangle. But in this case that is untrue: the proportion and size of the triangles mean nothing, a clear case of unintentional misrepresentation. The meaning of the dimensions in this graphic—the width of the base and the height of the "drop"—are confused and rendered meaningless by the differences in size and proportion of the triangles.

Academics don't always have access to designers. They have graduate students and Excel. In any particular area of study they tend to use similar and familiar (to each other) notation (often the result of using the same, very basic, graphic software). As a result they understand each other's visualizations. Apart from their colleagues, however, these visualizations are often confusing and difficult for everyone else to understand. Shapes generate their own interpretive meaning regardless of the intentions behind them.

Intellectually logical coding—as in the example on the facing page—is often *perceptually* counterintuitive. What may seem rational to the academician may be perceived incorrectly or with difficulty by the user.

See also Connotations of color; Color and monochrome.

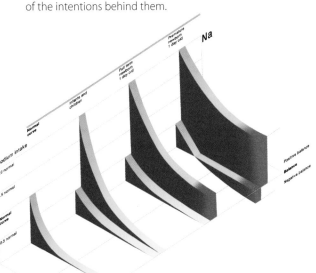

One of three graphs describing the way infant kidneys process insufficencies and oversufficiencies of salt, water, and acid. The graphs were on a poster that was used as a discussion theme for the Fifth International Pediatric Nephrology Symposium.

The graphs were intended to help physicians explain to parents the difficulties that the kidneys of their newborns—especially premature newborns—were experiencing. Among themselves, the nephrologists used a different notation that would be difficult for parents to understand.

A nutritional food wheel by students. Their solution addresses everything that has never worked with food pyramids and the recent "food plate":

The use of a pie chart visually shows recommended quantities and does not imply that one category of food is superior to another;

Subcategories of the five major groups are described simply and clearly;

A check-off ring of circles, which could be used when shopping and/or posted on the refrigerator, is included to help users plan a well-balanced weekly diet;

Recognizing that portion size varies greatly between individuals of different sizes, habits, and metabolism, portion size is not emphasized.

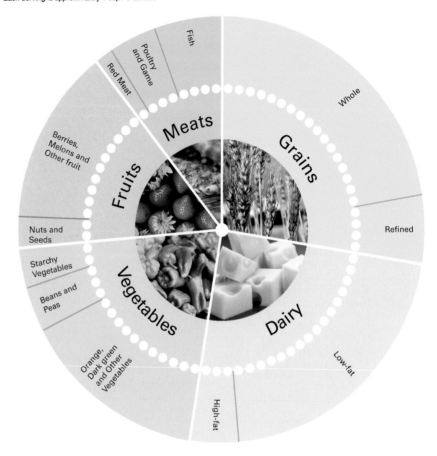

THE FOOD WHEEL

Based on an 81-serving per week diet.

Each serving is approximately 1 cup / 5 ounces

Fish
Poultry and Game
Red Meat
Meats
Berries, Melons and Other fruit
Fruits
Nuts and Seeds
Starchy Vegetables
Beans and Peas
Vegetables
Orange, Dark green and Other Vegetables
High-fat
Dairy
Low-fat
Refined
Whole
Grains

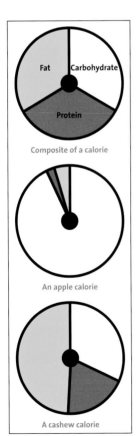

Fat — Carbohydrate
Protein
Composite of a calorie

An apple calorie

A cashew calorie

Grains	Dairy	Vegetables	Fruits	Meats
Whole	**Low-fat**	**Orange, D. Green, and Other Vegetables**	**Berries, Melons, and Other Fruit**	**Fish**
Brown rice	Cottage cheese	Asparagus	Avocado	Crab
Buckwheat	Fat-free milk	Broccoli	Kiwi	Shrimp
Oatmeal	Nonfat cream cheese	Carrots	Lemons	Flounder
Popcorn	Skim yogurt	Mushrooms	Mango	
Quinoa	Frozen yogurt	Spinach	Oranges	**Poultry and Game**
Rolled oats	Low-fat cheese		Peaches	Chicken
Rye		**Beans and Peas**	Pears	Turkey
Wheat bread	**High-fat**	Tofu	Pineapple	
Wheat pasta	Butter	Lima beans		**Red Meats**
Wild rice	Cheese	Green beans	**Nuts and Seeds**	Beef
	Chocolate		Peanuts	Pork
Refined	Cream cheese	**Starchy Vegetables**	Sunflower seeds	Ham
Bagel	Frozen custard	Corn		
Muffin	Ice cream	Potatoes		
Cake	Ricotta			
Cookies	Sour cream			
Grits				
Saltine crackers				
White rice				

Peter Bradford, in a project for American Health magazine, set out to define a calorie in understandable terms, rather than as an approximation of the energy needed to increase the temperature of 1 kilogram of water by 1 °C. Learning that a calorie is composed of carbohydrate, protein, and fat, but in different proportions depending on the food, Bradford used this simple and clear pie chart to communicate calories in a useful way.

[Mis]connotations of form

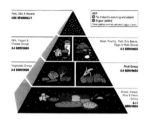

The original 1992 pyramid.

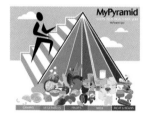

The 1995 pyramid, linked to a USDA website, with no information at this level.

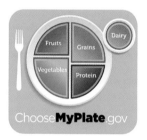

The $2,000,000 food plate, hardly an improvement. The description of the five food groups in the new plate is also not coherent. "Proteins" represents a source of calories, such as carbs or sugars. Fruits, vegetables, grains, and dairy are food categories (and not all dairy is drinkable, as the representation of a glass implies). So, what are the sources of proteins? Meat, fish, fowl: food categories.

The top of a pyramid has always represented—historically and connotationally—both small quantity and great importance: one king and lots of slaves; one lord and lots of serfs; a unique and expensive diamond on a pile of costume jewelry.

In every food pyramid, or triangle—first developed by the U.S. Department of Agriculture in 1992—one of those two linked connotations is reversed. The top of the pyramid represents the category of foods that you should eat least of (only one pharaoh) but also the least healthy rather than the most. The 2005 UDSA "My Pyramid" eliminates that conflict by making the pyramidal shape completely meaningless.

In June 2011 the USDA unveiled with some fanfare a food "plate," almost as vacuous as its pyramids. It cost $2,000,000 to develop and provides very little information. As discussed elsewhere, circles are not the best shapes for quantitative comparisons. Comparing four pie non-wedges without a common center, and then comparing those to a full circle, is not only imprecise but silly. Allowing for the fact that the distribution of these food groups is deliberately generalized—each individual has unique needs and caloric requirements—the plate seems not to offer much guidance or room for individualized application. Dairy is outside the plate (representing a glass of blue milk seen in plan). Try comparing the area of a circle to that of an irregularly proportioned quarter-circle.

Differences in shape are differences in kind. Differences in color and size are differences in degree.

Bruno Martin

Use the form that most clearly connotes the differentiations within the data to be visualized; avoid forms that intuitively contradict the data.

Go to http://well.blogs .nytimes.com/2011/07/28/ designing-a-better-food-label/?scp=1&sq=nutrition%20 label%20gets%20design%20 overhaul&st=cse

http://berkeley.news21.com/ foodlabel/

See also The pyramid paradox.

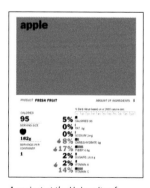

A project at the University of California, Berkeley, School of Journalism, undertook to design a better food label. These are two examples of the winning entry by San Francisco designer Renee Walker. The label visually shows the propor- *tion of each ingredient in the food product. One hopes that the labels will be considered by the U.S. Food and Drug Administration, which is expected to revise the existing nutrition label.*

Nutrition Facts

Serving Size 1/2 cup (about 82g)
Servings Per Container 8

Amount Per Serving

Calories 200 Calories from Fat 130

	% Daily Value*
Total Fat 14g	**22%**
Saturated Fat 9g	**45%**
Trans Fat 0g	
Cholesterol 55mg	**18%**
Sodium 40mg	**2%**
Total Carbohydrate 17g	**6%**
Dietary Fiber 1g	**4%**
Sugars 14g	
Protein 3g	
Vitamin A 10% · Vitamin C 0%	
Calcium 10% · Iron 6%	

The nutritional food label in the United States lists the percentage supplied that is recommended in one day based on a 2,000-calorie daily diet.

2 : QUALITATIVE ISSUES

47

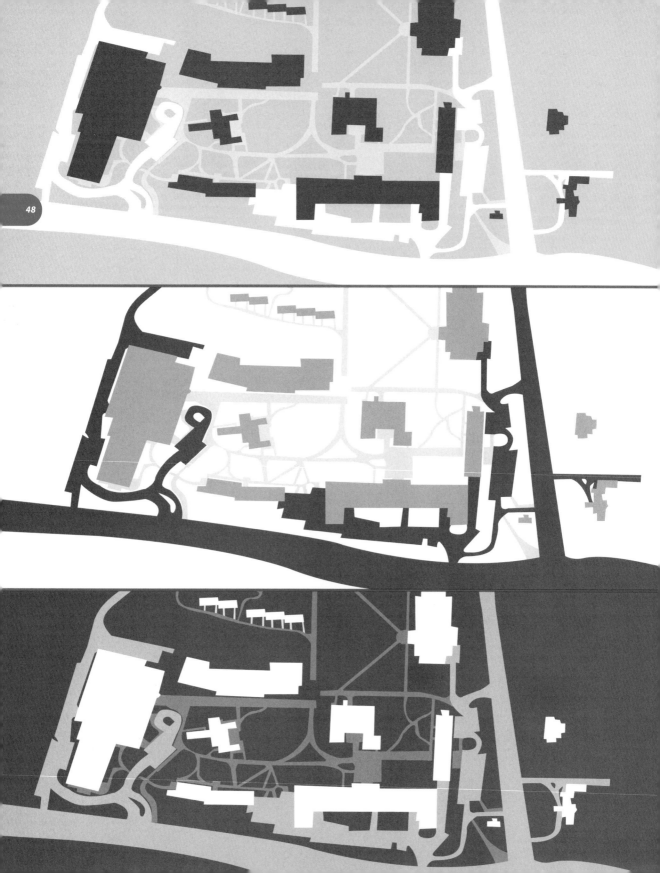

The middle value principle

Value, like color and typeface, has connotation: we respond, intuitively, to the lightness and darkness of things, specifically in maps.

Differentiation in value of things that are like or unlike aids in our intuitive perception of what they represent.

In any map, there are things we pass through or move along: streets and roads; paths; rivers and canals. Within these categories, we move along some (highways, streets) faster than along others (hiking trails).

There are things we cannot pass through (except through doors and gates): buildings and walls.

And there are things that are neutral: we can move around in them, perhaps, but we may not want to, or they may not necessarily be designed for that: background; unassigned open space; lawns; woods; bodies of water.

If that neutral background is a middle value in a map, then the open movement corridors and the dark impenetrable objects are as unlike each other as possible in value, both a rational and pragmatic consideration.

See also Lines; Color and monochrome.

Color can modify— and possibly even contradict—our intuitive response to value, because of its own powerful connotations.

The best one can do is to understand how we perceive line, value, and color; to know what they connote; and to balance complementary and/or contradictory connotations in support of user needs.

This campus map correctly indicates buildings as the darkest value but misses the boat with its use of line and lack of differentiation between roads and background.

Vignelli corrected the 1972 counterintuitive color assignment in a revision he made in 2008: water is blue and open space has been eliminated. This revision also addressed other issues for the better, discussed in Section 5.

The counterintuitive palette in the two hearts at near right and center right, discussed on pages 30–31, demonstrates the pitfalls of using color arbitrarily when longstanding and universally understood and accepted color conventions exist. Without labels or a legend, there is no way for a general audience to understand which color represents arterial blood and which venous. The diagram on the right, notwithstanding the obvious liberties taken with anatomy, will be understood, even without labels, by many.

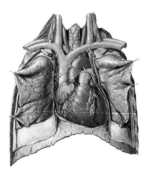

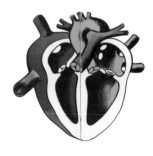

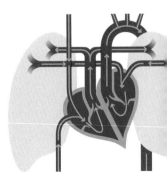

Connotations of color

We all know that grass is green and water is blue. Most of us know that arterial, oxygenated blood is described as "red," and that venous blood, lacking oxygen, is described as "blue." Good cowboys wore white hats and outlaws wore black hats.

How do we know?

In the case of the first example—grass and water—simply from observation. Grass is not always green, of course: in times of drought, and in winter, it verges on brown.

In the case of the second example—blood—we learned these conventions in middle school biology and have seen them in medical illustrations. While we have never actually observed "blue," deoxygenated blood, we recognize it from the bluish cast of veins close to the surface of our skin.

The natural world around us and our own bodies are examples of color conventions making sense, and where distortions of those conventions can be confusing and unsettling.

Functional conventions—conventions that have a functional reason for existing—make our lives easier, and bridge, through a shared visual vocabulary, communication barriers of concept and language.

See also A movement network genealogy; Pages 210–213.

Violating established and functional color conventions makes it more difficult for the audience to understand an information graphic or a map. Respecting them gives the user that much less on which to expend unnecessary energy.

Schweiz auf Schwarz

In the black. This illustration in the Frankfurter Allgemeine *accompanies an article on the banking crisis and issues between Switzerland and the rest of the European Union. The title translates roughly as "Switzerland in the Black."*

Bidirectional color consistency: in the Paris Métro, each line is represented by a(n almost) unique color and that color is never used anywhere else (except twice). While it contradicts many of the considerations described in the text, it deals creatively with the problem of needing too many colors for easy identification and recollection.

I once was told to take the "dark green line," (the 12) but it was by a typically obsessive information designer.

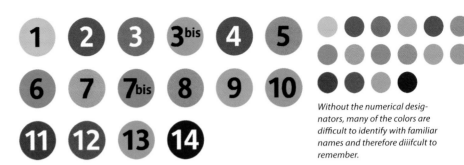

Without the numerical designators, many of the colors are difficult to identify with familiar names and therefore diiifcult to remember.

A contextually ideal solution, the set of billiards balls: two groups are distinguished by a combination of unidirectional and bidirectional color/shape coding, which also respects humans' color recognition and retention limitations. Only one possible improvement: making the "8" white on the black field with a white outline to distinguish it from both sets.

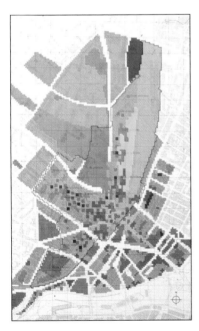

Unidirectional color consistency. In this planning study for downtown Geneva, Switzerland—Étude d'Aménagement—any repeating category in the book's 48 maps is always represented by the same color, even though that color may also be used for different categories in other maps.

Right. Look at the two columns of color. Close your eyes and try to name them all. Chances are you will be better able to remember both the names of the colors and the colors themselves in the left column. At a very early age we learned the names of everyday colors and to visualize them within a close tolerance; subtle colors, with sophisticated names, came to our attention later and are less precisely embedded in our memory. Remember Mr. Paint Pig?

Red	Brick
Orange	Persimmon
Yellow	Ochre
Green	Olive
Blue	Turquoise
Violet	Prussian
Purple	Pink
Black	Heliotrope

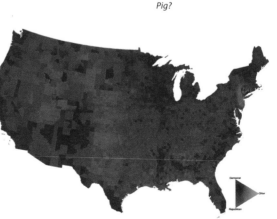

Right. The use of a continuously graded palette clearly shows the extremes but is only suggestive of accuracy in the wide middle range.

Color constraints

A grid purporting to represent the 16,000,000+ colors rendered by a 24-bit color monitor. It's all well and good to say—even to prove—that all 16,000,000+ colors are there, but why does it matter if one can't tell them all apart?

The Ishihara Color Test is a color perception test for red-green color deficiencies named after its designer, Dr. Shinobu Ishihara, a professor at the University of Tokyo, who first published his tests in 1917.

The test consists of a number of colored plates, each of which contains a circle of dots appearing randomized in color and size. Within the pattern are dots which form a number visible to those with normal color vision and invisible, or difficult to see, for those with a red-green color vision defect.

How many colors can dance on the head of a pin? How many colors can the human eye distinguish and the mind remember? 16,000,000? I don't think so. (16,777,216 actually: 256 shades each of red, green, and blue, yielding that many colors on an 24-bit color display.)

In the technological world that means your monitor can render and transmit every color imaginable.

In the real world that means between little and nothing. Most research suggests that we are capable of clearly distinguishing among (and remembering) five to seven colors, depending on the many contextual variables such as movement, brightness and color temperature, and stress. Therefore, in the human world—as opposed to the technological universe—we must think with reasonable care about the color choices we make.

An important issue in information graphics is coded color. Ideally, a color will mean the same thing whenever it is used (bidirectional consistency). If the data set requires more coded colors than can be easily differentiated, every color should be used consistently, although used for different, non-redundant things in different color subsets (unidirectional consistency).

A few considerations to make coded color choices as effective as possible:

- Use colors that are clearly distinguishable from each other;

- Use colors with simple, familiar, universally used, and easily remembered names and associations;

- If you use colors of similar value, type color/value can be the same on all backgrounds (unlike in the Paris métro);

- Be aware of the "danger," "caution," and prohibitory connotation of certain colors;

- Disregard any of the above if using them will compromise the effectiveness of the solution for the greatest number of people in the greatest number of contexts;

- Consider the color blind (about 8% of males, 0.5% of females) to the extent possible;

- Context is extremely important: choosing, recognizing, and remembering colors do not happen in a vacuum.

A palette of colors is perceived differently than a palette of grays (non-color), as is white type on a dark field than black type on a light field.

Read Josef Albers. *Interaction of Color: New Complete Edition* (hardcover; expensive).
Joseph Albers. *Interaction of Color: Revised and Expanded Edition* (paperback; inexpensive).

Go to http://www.pantone.com/pages/pantone/index.aspx

See also Color and monochrome; From color to grayscale.

53

2 : QUALITATIVE ISSUES

COLOR

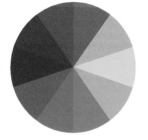

HUE

VALUE

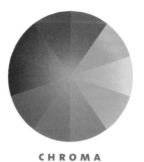

CHROMA

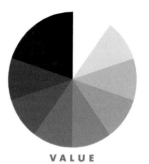

VALUE

PATTERN

PATTERN

Pattern permits layering.
While opaque colors cover up the colors that are beneath them and transparent colors mix with the colors beneath them, pattern permits multiple, overlapping designations to be perceived simultaneously, as in this delightful map of Scandinavia, designed for Champion Papers Imagination XV Scandinavia Paper Showcase in 1971 by James Miho.

Color and monochrome

55

Options for differentiation in color, grayscale, and black-and-white.

The resources available with black-and-white—grayscale—are vastly more constrained than with color.

Turning a color image into grayscale tends to work well only with photography and not always then: the way we perceive the limited palette of grays makes it impossible to preserve the differentiation made possible by differences in hue and chroma offered by color. A grayscale palette offers us only value with which to work.

For examples of pattern and issues of value differentiation in practice, see the next page. Pattern, often misused or excessively used, can, used effectively, compensate for many of the differentiations afforded by hue and chroma.

Never think that you can successfully turn a color diagram into monochrome with a simple keystroke.

Read Craig Holdrege. *The Giraffe's Long Neck: From Evolutionary Fable to Whole Organism.*

Go to http://natureinstitute.org/ pub/ic/ic8/moth.htm

http://creationism.org.pl/ groups/ptkrmember/inne/ folder.2005-08-23.2635798529/ document.2005-02-26.1486728076

See also Color constraints; From color to grayscale.

Color can determine life and death, illustrated by the archetypal so-called proof of Darwin's concept of natural selection in the case of the peppered moth by Bernard Kettlewell in the 1950s.

"A dark variety of the otherwise light-colored peppered moth appeared in England in the mid-nineteenth century and its numbers continued to grow in the industrial areas of England. Kettlewell set out to show experimentally that the dark variety of moth prospered because it was better camouflaged against the soot-darkened, lichen-free tree trunks in industrial areas. He released light and dark peppered moths onto tree trunks in the polluted forests. He not only recaptured…proportionately more dark moths than light moths, but also observed birds feeding predominantly on the light moths. He obtained exactly the opposite results in an unpolluted forest with much lighter tree trunks. He concluded that natural selection via bird predation in polluted forests was causing peppered moth populations to evolve from the light to the dark variety."

Craig Holdrege, director of The Nature Institute (Ghent, NY), realized in the 1980s that peppered moths don't rest on trees. It turns out that Kettlewell actually placed moths on trees in a vastly higher proportion than would normally occur, encouraging birds to feed on them in the way but not for the reason that his results described.

2 : QUALITATIVE ISSUES

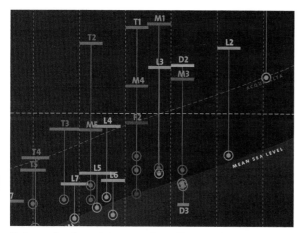

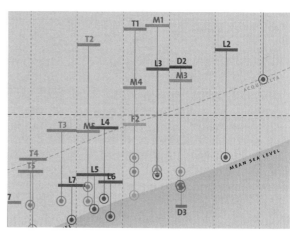

Various options for retaining
the legibility of a reasonably
complex diagram in grayscale.

Above. The original TIFF as
grayscale. Categorical distinc-
tions that were clear in color are
lost in grayscale conversion.

The conversion at left inverted.
Many of the same problems in
the original conversion remain.

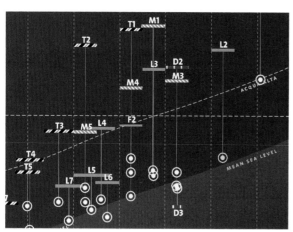

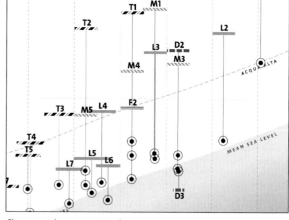

The original vector document
has been modified to simulate
the value palette of the original
while increasing legibility with
the use of pattern.

Changes to the vector original,
using a white background and
patterned lines to code the sites.

The use of shapes and value to
clarify both the time indicators
and the drop to show con-
temporary lagoon level. This
variation is probably the most
successful of the five.

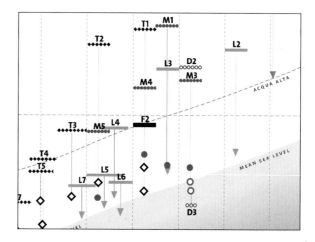

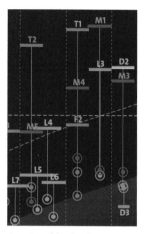

A section of the details used on the opposite page to demonstrate color to grayscale alternatives. The original diagram is discussed on pages 44–45.

Facing page. The use of color enhances distinctions that require alternative strategies when confined to black-and-white or grayscale, as shown by converting the color diagram to grayscale, whether with dark or light background.

Pattern—usually a second- or third-tier option in graphics where full color is available—becomes a valuable asset when working within the constraints of grayscale.

There is a significant difference between originating an information graphic in color and then having to adapt it to monchrome, and thinking of it in monochrome from the very beginning. It is a natural human tendency to translate from color to monochrome by doing the equivalent of the "desaturate" command in Photoshop; but it often—perhaps usually—doesn't work. There are too many nuances of differentiation that are likely to be expressed by variations in hue and chroma to translate successfully into a monochrome palette without a certain amount of reflection and experimentation (because patterns have connotations, too).

In a great number of cases, grayscale conversion will destroy much of the differentiation that you used color for in the first place.

See also Color constraints; Color and monochrome.

57

Catholic Schools in South Philadelphia
The archdiocese divides the region into "Pastoral Planning Areas," or PPAs.
South Philadelphia is divided into two, both of which have South Street as the northern border:

Changes, 2006-2010

PPA 640
East of Broad
Registered Catholics -22%
Elem. school enrollment -29%

PPA 630
West of Broad
Registered Catholics +5%
Elem. school enrollment -25%

○ St. Gabriel
TASKER ST. St. Thomas Aquinas
MIFFLIN ST.
SNYDER AVE.
PASSYUNK AVE.
St. Monica Senior School ○
SHUNK ST. St. Monica Junior School
Annunciation ○ B.V.M.
Sacred Heart of Jesus
St. Nicholas of Tolentine
95
MILE
Epiphany of Our Lord ○
RITNER ST. WOLF ST.
OREGON AVE.
Our Lady of Mount Carmel
St. Richard BIGLER ST.
76 ○ PACKER AVE.
HARTRANFT ST.
PATTISON AVE. Holy Spirit
New School at former Stella Maris School
○ Closing
○ Open, merging with closed schools
○ Unaffected

Catholic Schools in South Philadelphia
The archdiocese divides the region into "Pastoral Planning Areas," or PPAs.
South Philadelphia is divided into two, both of which have South Street as the northern border:

Changes, 2006-2010

PPA 640
East of Broad
Registered Catholics -22%
Elem. school enrollment -29%

PPA 630
West of Broad
Registered Catholics +5%
Elem. school enrollment -25%

○ St. Gabriel
TASKER ST. St. Thomas Aquinas
MIFFLIN ST.
SNYDER AVE.
PASSYUNK AVE.
St. Monica Senior School ○
SHUNK ST. St. Monica Junior School
Annunciation ○ B.V.M.
Sacred Heart of Jesus
St. Nicholas of Tolentine
95
MILE
Epiphany of Our Lord ○
RITNER ST. WOLF ST.
OREGON AVE.
Our Lady of Mount Carmel
St. Richard BIGLER ST.
76 ○ PACKER AVE.
HARTRANFT ST.
PATTISON AVE. Holy Spirit
New School at former Stella Maris School
○ Closing
○ Open, merging with closed schools
○ Unaffected

This pair of maps clearly demonstrates the danger of not adjusting an information graphic designed in color when converting to grayscale. The diagram at the top appeared on the newspaper's website, where differentiation among colors made the categories clear. In the printed newspaper, the same graphic appeared in grayscale, otherwise unaltered, which largely destroyed the differentiation between two of the three categories of information.

Below. A detail of another map on the same subject, which used shape and the clearly visible differences between black and white to show two categories of data distinctly.

First-generation identification: the label is on or next to the object being identified.

Second-generation identification: the label is connected to the object being identified.

Third-generation identification: the object is labeled with a code, which then must be decoded from a list (hopefully) nearby. This inevitably requires head and eye movement back and forth and a certain amount of memory activity.

See opposite page for legend

Generations of labeling

Konstantin Grcic is a product designer who curated an exhibit at the Istituto Svizzero di Roma in 2010, BLACK[2]: "A black/ square shape or form cannot be found in nature. This is what interested me: 'creation' as a deliberate and conscious act of human intelligence."

The program catalog (the design of which is unattributed) is an example of elegant high design and a failure from an informational point of view. A complex isometric visualization of the exhibition is further complicated by third-generation labeling and its legibility reduced by centered typography.

A detail is below.

The identification of a visual element is easier to understand the closer it is to the object being identified. As obvious as this "law of proximity" sounds, it is not always practiced for one of any number of reasons: indifference, carelessness, or the designer's idea of visual and typographic elegance. The only semi-valid reason for the practice of labeling distant from the object it is identifying is the absence of adequate real estate. In this case the designer would do well to look at the number of elements she is trying to fit into the available space. Numbers, letters, and words must all be decoded to be understood: the closer the name, designator, or related information is to the object being identified the better.

Not unlike genealogical relationships, labeling can be thought of in generations:

- First-generation labeling labels the object on or at the object.

- Second-generation labeling connects the object to its label, which may be some distance away, with, for example, a callout rule. The clearer the relationship of the label to the object—and the fewer callout rule crossings—the clearer the identification will be.

- Third-generation labeling uses code—alphanumeric or symbolic—that requires the user to repeatedly look, remember, and search to match codes and make the connection between label and object. Often, in practice, the legend is far away from the subject, sometimes even on another page.

Another example of broken connections occurs in books where an image is disconnected from the text is it referenced by, either because of sloppy design or, more often, the economic publishing necessity of grouping high-quality, full-color images in their own signature, dozens or even hundreds of pages away from their textual reference. This, of course, is disruptive both to the flow of text and to the contextual connection of text and image. One of the great potential of books adapted for the screen is the ability to transcend the constraints of printing on paper and put high-quality illustrations with their references in the text. The ideal condition, on screen as well as in print, is for all related elements to be in close proximity to each other.

> If you have no room for first-generation labeling, you may be trying to fit too much information in too small a space.

See also The middle value principle.

59

Legend for map at far left

1 Athletics
2 President's House
3 Student Housing
4 Student Union
5 Benjamin Hall
6 Adams Law Building
7 Wheeler Building
8 Thompson Library
9 Jones Writers' House
10 Admissions
11 Roxborough House
12 Classrooms

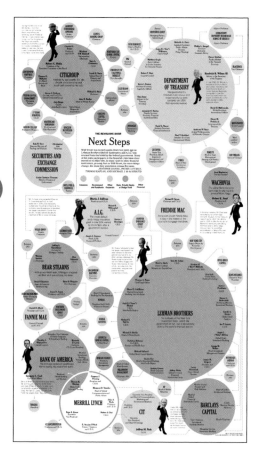

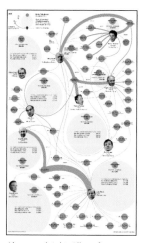

Above and right. All are from The New York Times.

The details below right are shown at twice the scale of the complete graphics above.

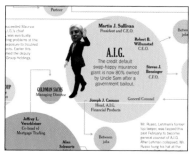

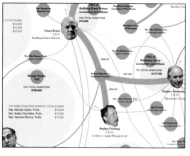

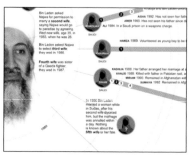

Genograms, developed by Monica McGoldrick in the '80s, can create a pictorial display of a person's family relationships and medical history. They go beyond a traditional family tree by allowing the user to visualize hereditary patterns and psycho-logical factors. Genograms can be used to identify repetitive patterns of behavior and to recognize hereditary tendencies.

Connections among people

A family tree from the Museo della Civiltà Romana in EUR, south of Rome. The tree begins at the lower left with Julius Caesar (died 44 BCE) and ends with Nero (died 68 CE).

Human beings are social animals. We are connected to each other through affection, family, emotion, money, and power. Through history, many of those connections have been devious, illegal, clandestine, and deadly. Detailing those relationships—not unlike decoding the human genome on a vastly smaller scale—has been (especially clandestine relationships) an exhausting labor of love and law by many designers and artists over many centuries. In doing so, they have developed notations specific to the complexities and nature of the relationships under exploration.

Read Monica McGoldrick, Randy Gerson, Sueli Petry. *Genograms.*
Mark Lombardi. *Global Networks.*

See also Connections in products; Meaning in visualizing numbers.

Mark Lombardi (1951–2000) was a pioneer in graphing connections between people and events. In the early 1990s he began researching and documenting contemporary financial and political scandals and found, overwhelmed by his notes on index cards, that by drawing connections which he called Narrative Structures, he could more successfully focus on the information.

Movie posters habitually neglect to link the actors' name with their image, presumably because of Byzantine contractual requirements. It's a good thing I know that Queen Latifah is female. The names have been recolored for clarity at this small scale.

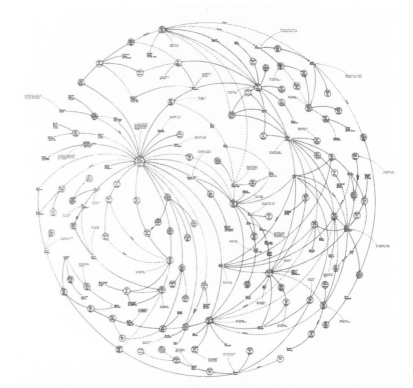

Which button to push? The braille indicators in many elevators, due to their size, shape, location, and type, look just like buttons. In some elevators, they are even lit.

Buttons are for pressing. These are not.

I cannot count the times that I have pressed these indicators. They tell me my floor. They're round. Who knows what those white things next to them are?

This panel goes a long way to addressing the problem by providing only one "button."

B	1	3	5	7	9			15	17	19	21	23	▼
▲	S	2	4	6	8	10	14	16	18	20	22	24	

Let's not forget superstition. In addition to having no 13th floor (unlucky), this building has no 12th floor either, to keep the odd and even floor numbers in line.

This panel and the wall sign at left show the rationality often regarded as particularly European. There is no ambiguity caused by letters that mean different things in different languages, about which floor is the ground, or access/egress floor, and which floor is below grade. In a hospital in The Netherlands, the floor below grade was labeled -99.

"T"? (A visitor told me it stands for "Terrace.")

Connections in products

I guess I'm not the only one who pushes the wrong button.

Which button to push?

Since braille markers for elevator buttons became mandatory in 1990 with the passge of the Americans with Disabilities Act (ADA), elevator panels had to be retrofitted or rede-signed to comply with this requirement. In most cases in my experience, braille markers have been added adjacent to the buttons that actually work. In some cases, these small plaques replaced existing floor numbers; in others, they appear to have been added adjacent to the actual buttons.

Making connections between objects and their labels, or between explanatory text and the objects or parts of objects they reference, is serious business, with the consequence for doing it badly being a high level of annoyance or worse.

Generally, making appropriate connections in products and other objects, such as instrumentation, is taken quite seri-ously: heavy equipment control panels and airplane cockpits are examples. Often, however, where the user is the general public, or where the consequences factor is perceived as small, common sense seems not to be applied or even considered.

Read Donald A. Norman. *The Design of Everyday Things.*

Henry Petroski. *The Evolution of Useful Things: How Everyday Artifacts—From Forks and Pins to Paper Clips and Zippers—Came to Be as They Are.*

See also Connections among people.

It is impossible to know what the designer of unintentionally misleading or confusing graphics was thinking. It may be the result of a desire for visual elegance, uniformity, or misplaced notions of simplicity and visual harmony, which unfortunately mitigate self-revealing ease of use. It is crucial to think about how the user will understand the design.

Which knob to turn? A diagram of my Thermador cooktop from the 1980s. Extraordinarily sexy and photogenic, I kept turning on the wrong burner because of the counterintuitive knob assignment. Donald Norman suggested I run colored tape from knob to burner (I didn't do it).

The way the knobs should have been assigned. Even better would have been to move the two center knobs just slightly towards the burners they control.

Which button to push? I'd push the colored one. I'd be wrong.

The data for the table provided to the designer.

		1900	1910	1920	1940	1950	1960	1970	1980	1990	2000
Non-hispanic white	Male	5.8	5	6.2	8.8	10	8.7	11.7	12.5	13	15.4
	Female	81.9	77.4	77.4	71.5	67.3	60	51.9	40.2	29.9	28
Nonhispanic Black	Male	4.9	3.4	5.3	10	13.4	16.1	19	23.7	24.9	32.7
	Female	58.2	39.4	54.9	56.9	56.8	50.6	45.1	37.8	31.2	30.8

The Excel visualization, also provided.

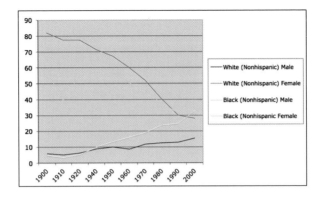

The finished graph by the designer.

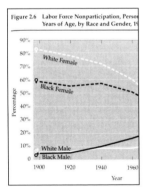

Every silver lining has a cloud. *The publisher decided that its in-house typographic standards should apply to graphs as well as text and arbitrarily changed the typeface of all the graphs, not— in my opinion—to their benefit, as well as adding unncessary axis labels.*

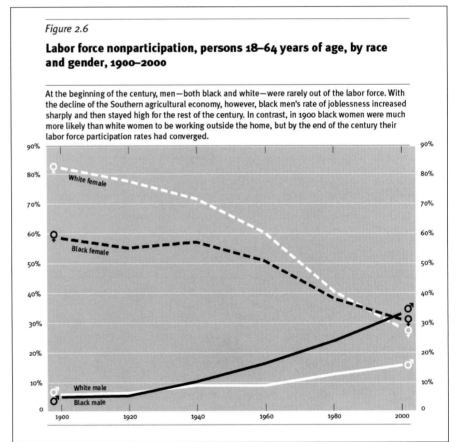

Figure 2.6

Labor force nonparticipation, persons 18–64 years of age, by race and gender, 1900–2000

At the beginning of the century, men—both black and white—were rarely out of the labor force. With the decline of the Southern agricultural economy, however, black men's rate of joblessness increased sharply and then stayed high for the rest of the century. In contrast, in 1900 black women were much more likely than white women to be working outside the home, but by the end of the century their labor force participation rates had converged.

Consistent and mnemonic notation

These are the symbols used by Consumer Reports for its product ratings. The open red circle on the left is their lowest rating; the closed black circle on the right is their highest rating; the open circle in the center is neutral.

This symbol set is counterintuitive in several ways:

- *While red-green is usually clear for stop-go and, presumably, bad-good (except for the color blind), red-black for bad-good (without green) may not be universally clear.*

- *There is no clear intuitive progression from bad to good; the empty circle just looks empty, and is likely to have a negative rather than a "product neutral" connotation.*

- *The "very bad" symbol has an open center and the "very good" is solid—is that for the color-blind? If so, why red-black at all?*

Below are two proposals for a notationally consistent, mnemonically positive, color-blind neutral solution, similar to the symbol set used but certainly not first or uniquely—in 20 American Cities in 1967. A clear and easy-to-remember progressive value system clearly differentiates empty (bad) from full (good) and the steps in between. Because it is line art and does not require gray values or a halftone screen, it is color and technology independent.

The value of consistent notation is well known for the design of groups of statistical graphs, many of which have similar data categories. Like unidirectional color consistency described on page 52, it helps a user to have data categories similarly coded in multiple data sets.

In many publications—where the author cannot afford a designer or recognize the need for one—many graphs are (non-)designed by Excel or another spreadsheet application. These applications arbitrarily assign color, line weight, pattern, and other characteristics without regard to meaning, context, or offering the user the ability to change them. As the number and names of data categories change from graph to graph, it is almost guaranteed that the color used for a particular data category will also change from graph to graph within what is supposed to be a unified set.

As we have discussed, many colors have connotations. In graphing an investment portfolio, gold, silver, and green come readily to mind. More important is the repetition of one color connoting the same thing over and over again. Such consistency and appropriateness will make sets of color-coded information easier to understand and connect.

In this set of grayscale graphs for an analysis of 100 years of census data, we were given data as both tables and as Excel graph output. The set of graphs had certain recurring data categories, particularly race and gender.

Consequently, it made both intellectual and intuitive sense for white persons to be shown by white lines and black persons to be shown by black lines, and for males and females to be shown consistently (our choice of a solid line for males and a dashed line for females was arbitrary). In order to avoid the need for a legend, in keeping with our ideas about generations of identification (pages 58–59), we labeled the lines on the lines themselves, adding a white or black male/female symbol for easier identification, especially where lines crossed or were close together.

Using the middle value principle (pages 48–49) permitted white and black lines to represent white and black persons, respectively, and in other graphs deep gray lines represented Latinos and other "brown" ethnic groups.

Read Michael Katz, Mark Stern: *One Nation Divisible: What America Was and What It Is Becoming.*

See also Generations of labeling.

65

Harvey Balls are used to communicate qualitative information symbolically. Harvey Poppel is generally credited with inventing Harvey Balls in the 1970s while working at Booz Allen Hamilton as a consultant. (Harvey Balls are also sometimes referred to as Booz Balls.) The font is available free online.

2 : QUALITATIVE ISSUES

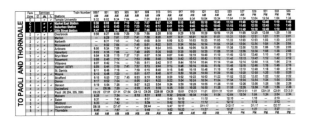

A conventional analog train schedule, 2011.

In the 1880s, Etienne-Jules Marey, a French engineer and photographer, developed this schedule for trains from Paris to Lyon. Edward Tufte writes, in The Visual Display of Quantitative Information: *"Arrivals and departures from a station are located along the horizontal [x-axis]; length of stop at a station is indicated by the length of the horizontal line. The stations are separated in proportion to their actual distance apart. The slope of the line reflects the speed of the train…. The intersection of two lines locates the time and place that trains going in opposite directions pass each other."*

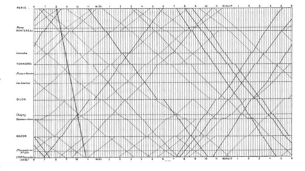

Tufte has superimposed on Mary's schedule a line, shown in red, describing the time path of the TGV (train à grande vitesse) that began service in 1981.

Often, vernacular design expresses genuine sophistication, as in this shop window in Paris.

Analog to digital. *Imagine the effort required to adjust to a digital time display after 500 years of analog clocks and 300 of analog watches.*

Josef Pallweber, a Swiss timepiece maker born in Salzburg, Austria, created and produced a mechanic-digital clock model in 1956. In 1970, the first digital wristwatch with an LED display was mass-produced—the Pulsar, by the Hamilton Watch Company (hinted at two years earlier when Hamilton created a prototype digital watch for Kubrick's 2001: A Space Odyssey).

Time and timelines have interested—one could say "obsessed"—historians and designers for centuries, and the history of timelines is a rich and interesting one.
Right. A timeline by Joseph Priestly (1733–1804), the scientist, theologian, and philosopher. He believed such charts would allow students to "trace out distinctly the dependence of events to distribute them into such periods and divisions as shall lay the whole claim of past transactions in a just and orderly manner."

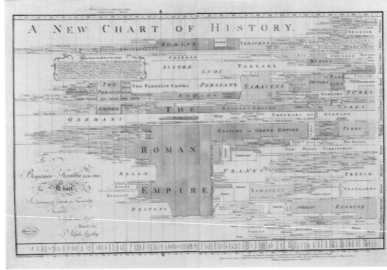

It's about time

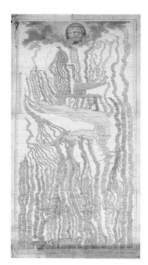

An 1828 timeline by Friedrich Straß.

It is no accident that "family" and "familiar" come from similar Latin roots.

History is full of designs that met resistance, if not outright rejection, when they were introduced because they were innovative—*unfamiliar*—in some fundamental way. Many of these innovative ways of describing space and time, and communicating process or statistical information, are now part of the history and conventional vocabulary of information design. Some are not.

All new designs, regardless of their "superiority" in terms of efficiency, accuracy, or multivariacy (Marey's schedule visually describes the speed of each train as a bonus, something impossible in a traditional train schedule), are often resisted and evaluated poorly until their positive aspects are understood and widely adopted.

Read Daniel Rosenberg, Anthony Grafton. *Cartographies of Time: A History of the Timeline.*

Dava Sobel. *Longitude: The True Story of a Lone Genius Who Solved the Greatest Scientific Problem of His Time.*
———. *Galileo's Daughter. A Historical Memoir of Science, Faith, and Love.*
———. *A More Perfect Heaven: How Copernicus Revolutionized the Cosmos.*

See also Learning from Minard; Page 196.

> If I had asked my customers what they wanted, they would have said a faster horse.
> **Henry Ford**

67

A student graphic visualizing a new hypothesis of the spread of seafaring and agriculture by Albert Ammerman of Colgate. The upper map shows the equality of distance between Cyprus and the heel of Italy, and between there and the coast of Spain. The lower map, by treating geography as elastic, shows that the spread of seafaring and agriculture between the heel of Italy and Spain was accomplished in 40% of the time as from Cyprus to Italy.

> One way to think about a figure of this kind runs along these lines: the scholar making a timeline likes to keep subdividing until one reaches the threshold of incomprehension.
> **Albert Ammerman**
> *Archeologist*

2 : QUALITATIVE ISSUES

Andrew was six years old when he drew this multiple-view composite of his preschool, located on the third floor of a neighborhood church. The church's steeple is drawn in elevation; the stairs (two long flights) are shown in section; and the layout of the three classrooms and play area are shown in plan.

Jean Metzinger (1883–1956): Tea Time (Woman with a Teaspoon), 1911, dubbed "The Mona Lisa of Cubism" by art critic André Salmon. The artist shows the teacup in both plan and elevation.

Point of view

Read John Berger. *Ways of Seeing.*
——. *About Looking.*

Errol Morris. *Believing Is Seeing (Observations on the Mysteries of Photography).*

Richard Saul Wurman. *Various Dwellings Described in a Comparative Manner: Being a Collection of Comparative Descriptive Drawings in Perspective of Thirty-five Dwellings of Significance from Around the World.*

Point of view is attitudinal as well as physical. The former represents a way of looking at things, a way of *thinking* about looking at things, and then finding a way to implement and express those thoughts about looking.

Looking at three-dimensional physical things, particularly buildings, has evolved into a rational three-dimensional system, using plan, elevation, and section to reveal a great deal of how it is built or works. The more plans, the more elevations, and (especially) the more sections, the more complete the two-dimensional reconstruction of a three-dimensional building or object will be.

See also Pages 197; 200 top left and center left.

69

Near right. Elevation, section, and plan of the central keep of the Chateau de Chambord in France's Loire Valley, one of 35 buildings drawn by students of Richard Saul Wurman at North Carolina State University in the early 1960s.

Center right. Peppers visualizing elevation, section, and plan, a concept articulated by the Architecture in Education program sponsored by the Cincinnati chapter of the American Institute of Architects, far right.

architecture in education

Plan, Section & Elevation

You can explain these terms by using two bell peppers. The outer walls are like the outer walls of a house. The inner walls like those inside of a house separating rooms.

Plan of a Bell Pepper Cut one pepper in half horizontally, so you can see the plan of the pepper. Dip the cut pepper into paint and make a print demonstrating a plan of the pepper.

Elevation of a Bell Pepper Cut the other pepper in half vertically and you can remove the face or elevation of the pepper...

Section of a Bell Pepper ...to look inside at a section of this pepper.

2 : QUALITATIVE ISSUES

This graphic on the evolution of scroll to screen appeared in The New York Times.

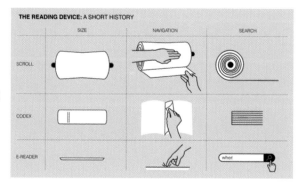

Technology is rapidly changing the way we communicate and acquire information on the screen via the web; books are staying pretty much the way they've been for hundreds of years. This ongoing revolution in technology has ramifications.

Books are a comparatively mature medium of communication, and almost everyone knows how to find their way around in them; the screen, a fairly recent medium of communication, is undergoing rapid and continual change, in some cases at a rate that the human mind finds difficult to keep up with.

As websites explore new ways of organizing access to and distributing information, they often stumble in their navigational structure. This might be best described as "I've fallen in and I can't get out," an analogy for not knowing where you are and how to move around as you go deeper into a site.

Oddly enough, some of the characteristics of the web (as a source) and the screen (as a medium) are the very qualities that can make navigation difficult. On a website, the user views one screen at a time (allowing for scrolling). She can go backwards; or forwards; or skip around, but, even with a site map, she cannot easily and efficiently flip through the site, the way a reader can flip forwards and backwards through a book she is reading.

This is certainly not to suggest that the book is a better or more efficient medium of communication than the web, nor is it to suggest that these comparisons will not change, and soon. It is, however, to suggest that the book format is well developed considering its physical limitations, and that the web needs to confront the characteristics that constrain users from getting the information they want and moving around the information in a time-efficient and rational way.

Read David L. Ulin. *The Lost Art of Reading: Why Books Matter in a Distracted Time.*

Go to http://www.nytimes .com/2011/09/04/books/review/ the-mechanic-muse-from- scroll-to-screen.html?scp=1&sq =from%20scroll%20to%20 screen&st=cseww

See also Information release sequence.

Below. This capture is from a video posted on www.macru mors.com on 22 January 2012 demonstrating a patented eBook prototype by the KAIST Institute of Information Technology Convergence.

The video shows a number of novel ways to navigate eBooks besides the simple "page flip" motion found on Apple's iBooks app.

The new gestures shown include:

Page flipping, by spreading pages and then flipping through;

Page flipping with finger bookmarking;

Multiple page turning using multiple fingers;

Faster swipes turning multiple pages;

Longer presses, then swiping, turning multiple pages;

Writing the page number.

Title of book

Chose a topic from the table of contents.

Go to page.

Topic 37

I have ever had pleasure in obtaining any little anecdotes of my ancestors. You may remember the inquiries I made among the remains of my relations when you were with me in England, and the journey I undertook for that purpose. Imagining it may be equally agreeable to(1) you to know the circumstances of my life, many of which you are yet unacquainted with, and expecting the enjoyment of a week's uninterrupted leisure in my present country retirement, I sit down to write them for you. To which I have besides some other inducements. Having emerged from the poverty and obscurity in which I was born and bred, to a state of affluence and some degree of reputation in the

Go to the topic and begin reading.

 Title of site

| Section 1 | Section 2 | Section 3 | Section 4 |

Choose a section or chapter and click.

 Title of site

| Section 1 | Section 2 | Section 3 | Section 4 |

 Topic
 Topic
 Topic
 Topic
 Topic
 Topic
 Topic

Choose a topic from the water-fall menu.

 Title of site

| Section 1 | Section 2 | Section 3 | Section 4 |

Topic

I have ever had pleasure in obtaining any little anecdotes of my ancestors. You may remember the inquiries I made among the remains of my relations when you were with me in England, and the journey I undertook for that purpose. Imagining it may be equally agreeable to(1) you to know the circumstances of my life, many of which you are yet unacquainted with, and expecting the enjoyment of a week's uninterrupted leisure in my present country retirement, I sit down to write them for you. To which I have besides some other inducements. Having emerged from the poverty and obscurity in which I was born and bred, to a state of affluence and some degree of reputation in the world, and having gone so far through life with a considerable share of felicity, the conducing means I made use of, which with the blessing of God so well succeeded, my posterity may like to know, as they may find some of them suitable to their own situations, and therefore fit to be imitated.

Begin reading.

To choose another topic, return to the main section/chapter menu.

Go back to the table of contents and choose another topic.

Choose another topic.

Topic 14

I have ever had pleasure in obtaining any little anecdotes of my ancestors. You may remember the inquiries I made among the remains of my relations when you were with me in England, and the journey I undertook for that purpose. Imagining it may be equally agreeable to(1) you to know the circumstances of my life, many of which you are yet unacquainted with, and expecting the enjoyment of a week's uninterrupted leisure in my present country retirement, I sit down to write them for you. To which I have besides some other inducements. Having emerged from the poverty and obscurity in which I was born and bred, to a state of affluence and some degree of reputation in the

Go to the topic and begin reading.

Topic

I have ever had pleasure in obtaining any little anecdotes of my ancestors. You may remember the inquiries I made among the remains of my relations when you were with me in England, and the journey I undertook for that purpose. Imagining it may be equally agreeable to(1) you to know the circumstances of my life, many of which you are yet unacquainted with, and expecting the enjoyment of a week's uninterrupted leisure in my present country retirement, I sit down to write them for you. To which I have besides some other inducements. Having emerged from the poverty and obscurity in which I was born and bred, to a state of affluence and some degree of reputation in the world, and having gone so far through life with a considerable share of felicity, the conducing means I made use of, which with the blessing of God so well succeeded, my posterity may like to know, as they may find some of them suitable to their own situations, and therefore fit to be imitated.

Begin reading.

Topic

14

I have ever had pleasure in obtaining any little anecdotes of my ancestors. You may remember the inquiries I made among the remains of my relations when you were with me in England, and the journey I undertook for that purpose. Imagining it may be equally agreeable to(1) you to know the circumstances of my life, many of which you are yet unacquainted with, and expecting the enjoyment of a week's uninterrupted leisure in my present country retirement, I sit down to write them for you. To which I have besides some other inducements. Having emerged from the poverty and obscurity in which I was born and bred, to a state of affluence and some degree of reputation in the

Mark the place of your first topic with a finger.

Title of site

| Section 1 | Section 2 | Section 3 | Section 4 |

I have ever had pleasure in obtaining any little anecdotes of my ancestors. You may remember the inquiries I made among the remains of my relations when you were with me in England, and the journey I undertook for that purpose. Imagining it may be equally agreeable to(1) you to know the circumstances of my life, many of which you are yet unacquainted with, and expecting the enjoyment of a week's uninterrupted leisure in my present country retirement, I sit down to write them for you. To which I have besides some other inducements. Having emerged from the poverty and obscurity in which I was born and bred, to a state of affluence and some degree of reputation in the world, and having gone so far through life with a considerable share of felicity, the conducing means I made use of, which with the blessing of God so well succeeded, my posterity may like to know, as they may find some of them suitable to their own situations, and therefore fit to be imitated.

To return to your first topic, return to the section menu.

Title of site

| Section 1 | Section 2 | Section 3 | Section 4 |

Topic
Topic
Topic
Topic
Topic
Topic
Topic

Select your orignal topic.

Topic

37

I have ever had pleasure in obtaining any little anecdotes of my ancestors. You may remember the inquiries I made among the remains of my relations when you were with me in England, and the journey I undertook for that purpose. Imagining it may be equally agreeable to(1) you to know the circumstances of my life, many of which you are yet unacquainted with, and expecting the enjoyment of a week's uninterrupted leisure in my present country retirement, I sit down to write them for you. To which I have besides some other inducements. Having emerged from the poverty and obscurity in which I was born and bred, to a state of affluence and some degree of reputation in the

Flip back and begin reading.

Title of site

| Section 1 | Section 2 | Section 3 | Section 4 |

Topic

I have ever had pleasure in obtaining any little anecdotes of my ancestors. You may remember the inquiries I made among the remains of my relations when you were with me in England, and the journey I undertook for that purpose. Imagining it may be equally agreeable to(1) you to know the circumstances of my life, many of which you are yet unacquainted with, and expecting the enjoyment of a week's uninterrupted leisure in my present country retirement, I sit down to write them for you. To which I have besides some other inducements. Having emerged from the poverty and obscurity in which I was born and bred, to a state of affluence and some degree of reputation in the world, and having gone so far through life with a considerable share of felicity, the conducing means I made use of, which with the blessing of God so well succeeded, my posterity may like to know, as they may find some of them suitable to their own situations, and therefore fit to he imitated.

Begin reading.

Left. An environmental interpretive project for Independence National Historical Park in Philadelphia, using the information in the detail of the reconstructed document at right, an inventory of names and occupations of the 500 block of Market Street north side in 1787, based on Philadelphia's tax assessment for the North Ward. Granite pavers show the property lines of each dwelling with its owner and owner's occupation.

Every silver lining has a cloud.
Notice in the inventory (right) that Negroes, slaves, and servants are treated as property for taxation purposes. It was my intention to include this powerful and important historical information in the project, believing that it was of interest and benefit to all visitors. The National Park Service disagreed.

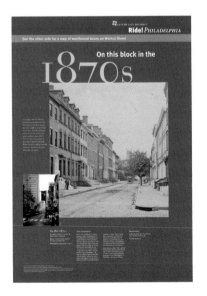

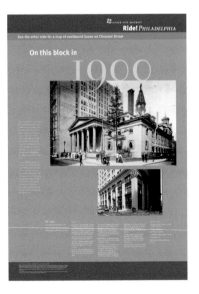

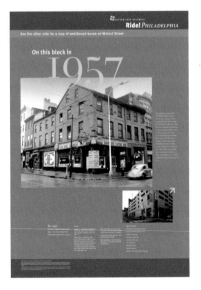

Interpretation

```
Joseph Redman, Gentleman
    150 oz plate          56
    3 Negroes            100
    2 horses              40
    1 cow                  5
    1 phaeton             30
    1 chariot             40
    Occupation           200
  & for Chas Syng's Est.
    Dwelling           1,100

William Sheaff Estate
    Empty dwelling       750

Michael Kunkle, Merchant
    Dwelling           1,000
    24 oz pl               9
    1 bound Negro         12
    1 horse               15
    Occupation           150

William Bell, Merchant
    Dwelling           1,100
    100 oz. pl.           37
    1 servant             12
    Occupation           300
```

Interpretation is information design applied to aid and enhance our understanding of non-statistical aspects of the past, present, or future. Interpretation, either with type, images, or usually both, tells stories about human experience that help us understand relationships among people and interaction among events.

While much information design is directed at factual under-standing, describing and mirroring experience, and ease of use, interpretive information design creates a narrative that enlarges our understanding of the complexity of life and history.

The line between information design and interpretive design is a soft one, and—like all history—"is written by the victors," in the words of Winston Churchill (1874–1965). That means we need to be as demanding with interpretive work as with all information design, that the connections we make and the facts we are interpreting are verifiably true.

See also Numerical integrity.

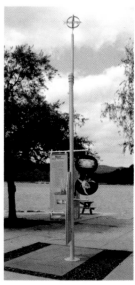

Left and facing page. Four of 72 bus shelter interpretive posters on the back of bus maps mounted on glass: every sign has two sides. Intended to engage passengers waiting for buses, the images show what existed at each specific corner in the past and what is there cur-rently. Data include the cost of a quart of milk at the time, the U.S. president, and local lore.

Above. Views of 11 untra-ditional interpretive and interactive stations at boat landings along the Hudson River, from Troy to Manhattan, to promote river stewardship, communicate local history, and engage children with interac-tive displays and challenges.

3

Quantitative Issues
Dimensionality, comparison, numbers, scale

There are lies, damn lies, and statistics.

Benjamin Disraeli

Two statisticians were hunting deer with bows and arrows.

The first statistician shot and the arrow landed five feet in front of the deer.

The second statistician shot and his arrow landed five feet behind the deer.

They looked at each other: "Got 'im."

Page from a student's data notebook for a project dealing with reconciling statistics from four different sources on housing during the recession, for the National League of Cities, at The University of the Arts, 2011.

SAN DIEGO

BP:
| | (07-08) | | (08-09) |
07: 3,422 > 31.005% decrease ⎫
08: 2,361 > 24.693% decrease ⎬ -55.698
09: 1,778
10: ___

F(% conversion):
07- 1.92%
08- 4.35%
09- 4.35%
10- 3.57%

UNEMP. (07-08) (08-09)
07: 4.5 > 33.333% increase ⎫ 95
08- 6.0 > 61.667% increase ⎬
09- 9.7 > 4.124% increase ⎭ (09-10)
10- 10.1 99.124

Foreclosures: (07-08)
07- 1/52 > 126.087% increase
08- 1/23 ⎤ no change
09- 1/23 ⎦ 17.857% decrease ⎫ (09-10)
10- 1/28 > ⎬ 108.23

avg. home price (07-08) (08-09)
07- 580.4 > 33.563% decrease ⎫ -40.332
08- 385.6 > 6.769% decrease ⎬ (09-10)
09- 359.5 > 7.149% increase ⎭ ~ -33.183
10 385.2

Cleveland
 (07-08) → 36.794%
BP: 3,574 > ~~decrease~~ decrease
07- 2,259 > ⎫ (08-09)
08- 1,809 > ~~%~~ decrease ⎬ -56.714
09- ⎤ 19.92
10- ⎦

 F(% conversion):
 07- 3.33%
unemp: (07-08) (08-09) 08- 3.33%
07- 6.0 > 13.333% increase ⎫ 47.157 09- 2.38%
08- 6.8 > 33.824% increase ⎬ 10- 2.5%
09- 9.1 > 6.593% decrease ⎭ (09-10)
10- 8.5 40.564

foreclosures: (07-08)
07- 1/30 > no change
08- 1/30
09- 1/42 > 28.571% decrease (08-09)
10- 1/40 > 5.0% increase ~ 33.571 (09-10)

avg home price: (07-08) (08-09)
07- 128.9 > 15.826% decrease ⎫ -17.393
08- 108.5 > 1.567% decrease ⎬ (09-10)
09- 106.8 > 6.648% increase ⎭ ~ -10.745
10- 113.9

What do Romans want? Presumably to understand their public transit network, just like all of us. In Rome, that generally means buses and trams and their relationship to its two subway lines (like Philadelphia, Rome has a lot of buses; Paris, like New York, has an extensive subway network). Their current map is an example of the "pack everything in" school of (non)information design.

Horror vacui is not confined to present-day maps of urban areas. Maps have long been cluttered with decorative cartouches and imaginary beings and places; phrases such as "terra incognita," "here there be dragons," or the location of the kingdom of Prester John have been around since the beginning of mapmaking.

I began the work in progress of the same area of Rome at the right out of frustration with existing Rome bus maps. Like any map, diagram, or statistical graphic with less than the full amount of information available, it is literally "incomplete"; but it will be usable, I believe, by large numbers of people when finished.

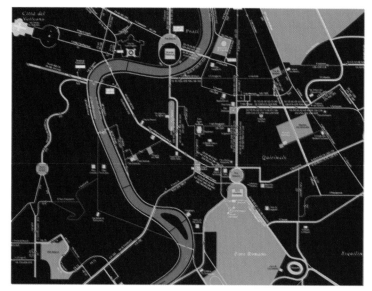

If the information sets are too dense, the designer must establish a hierarchy of needs to constrain the breadth of information to ensure that the graphic communicates what can be clearly understood.

Movement is multi-modal: pedestrian to car or transit to pedestrian. This map is intended for an audience of visitors probably oriented to larger streets and higher-profile destinations (musuems, palazzi, churches, and monuments) than to the finer grain of information that can be found on a more detailed street map. In large, complex cities, the visitor just may need two maps.

Information overload

How many angels can dance on the head of a pin? How much information can you put on a map? How many numbers can you put in a table? A lot, but that doesn't mean they can be usefully understood.

The term "information overload" has been in the design lexicon for decades, but it is not always respected in practice.

Whether a complex table with too many figures and variables but no connections, or a bus map of a city that shows everything possible, the result of information overload is that very little of too much will be understood. Possibly the user will be overwhelmed and completely paralyzed with fear of the anticipated effort and complexity.

This is an issue of usability, not of accuracy: completeness is a contextual and situational concept. Not all the information that you can physically put on a map, in a diagram, or in a table will enhance understanding. It will often compromise it.

Read Mark Ovenden. *Transit Maps of the World.*
————. *Paris Underground: The Maps, Stations, and Design of the Metro.*

Go to http://www.atac.roma.it/?lingua=ENG

http://www.atac.roma.it/

See also Simple and complex; Too much information; Too many numbers; Map or diagram?; The road is really straight; Transitions and familiarity; (Ir)rational innovation.

Never eat more than you can lift.
Miss Piggy

Data-rich is often information-poor.
Bruno Martin

Would you rather have your audience read all of less or none of more?

79

Facing page below. No one city is the only offender. This detail of an 11 x 17" handout of Philadelphia militates against understanding by showing everything—everything. In solving a complex information design problem, the needs of a very small number of potential users with very specialized interests need to be sacrificed to the product's usability by the many.

In the 11 years between these two maps, legibility and issues of comprehension have deteriorated. While the earlier map, on the left, suffered from an overload of information, it adhered to some sound principles of information design, many of which are discussed in Section 2: moderate chroma and light value colors that allow the type to be read; consistently light movement corridors; and transit stations along the route of the transit lines.

The current map, on the other hand, does the original one better (worse, actually): adding hotels in bright red; reducing the size of the type that was none to large to begin with; increasing both the value and the chroma of the background colors; and inexplicably shifting from white streets on coded color fields to gray streets on a white field outside Center City and showing interstate highways in blue. In both maps the district background colors are coded to a downtown pedestrian signing system.

L'Antisèche du Métro can be loosely translated as "Cheat Sheet for the Métro," "Idiot's Guide to the Métro," or "The Slacker's Guide to the Métro"; an antisèche is a rolled piece of paper that has the answers to a test. The booklet attempts to perform an extremely valuable function, in a pocketable size, with an impressive quantity of data, but in a notation virtually impossible to understand.

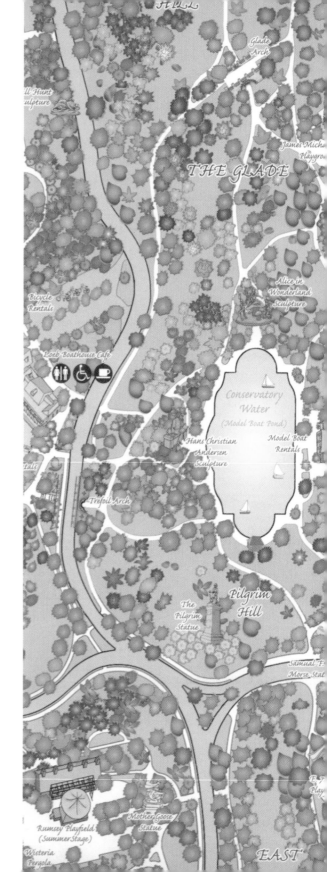

Too little information. You can understand it but it doesn't mean very much. I know, I know, on the first day of the season it's nice to be reminded which team is in which division in which conference (as if we haven't been reading about it all preseason). But do we really need to see all those zeros?

NFL

National Conference

EAST	W	L	T	Pct.	Pts.	Op.
Dallas	0	0	0	.000	0	0
N.Y. Giants	0	0	0	.000	0	0
EAGLES	0	0	0	.000	0	0
Washington	0	0	0	.000	0	0
SOUTH						
Atlanta	0	0	0	.000	0	0
Carolina	0	0	0	.000	0	0
New Orleans	0	0	0	.000	0	0
Tampa Bay	0	0	0	.000	0	0
NORTH						
Chicago	0	0	0	.000	0	0
Detroit	0	0	0	.000	0	0
Green Bay	0	0	0	.000	0	0
Minnesota	0	0	0	.000	0	0
WEST						
Arizona	0	0	0	.000	0	0
San Fran	0	0	0	.000	0	0
Seattle	0	0	0	.000	0	0
St. Louis	0	0	0	.000	0	0

American Conference

EAST	W	L	T	Pct.	Pts.	Op.
Buffalo	0	0	0	.000	0	0
Miami	0	0	0	.000	0	0
New England	0	0	0	.000	0	0
N.Y. Jets	0	0	0	.000	0	0
SOUTH						
Houston	0	0	0	.000	0	0
Indianapolis	0	0	0	.000	0	0
Jacksonville	0	0	0	.000	0	0
Tennessee	0	0	0	.000	0	0
NORTH						
Baltimore	0	0	0	.000	0	0
Cincinnati	0	0	0	.000	0	0
Cleveland	0	0	0	.000	0	0
Pittsburgh	0	0	0	.000	0	0
WEST						
Denver	0	0	0	.000	0	0
Kansas City	0	0	0	.000	0	0
Oakland	0	0	0	.000	0	0
San Diego	0	0	0	.000	0	0

No information at all. OK, it's a bracket, for those among us who may not know. A good half-page of newsprint wasted.

Too much information

Clearly there are different types of information overload. Discussed on the previous spread are maps that contain so much data that they may be between difficult and impossible to use for *any* purpose, because, presumably, they were intended to address *every* purpose.

Communicating large amounts of information successfully requires a certain amount of selection, an analysis of the need weighed against the increased difficulty of finding and understanding more. Functionality is the objective and the principal issue.

81

Left. "Central Park Entire," by Edward Sibley Barnard and Ken Chaya, identifies every major tree species in the Park and locates more than 19,000 trees and a great deal of additional information as well. It took two years.

It seems to me that the icon palette is inadequate to differentiate clearly among the 170+ tree species.

The alternatives are many, and certainly a less literal use of color and form are among them, but only on the assumption that the user will be unable to identify individual trees by their leaf shape and subtle color differentiation.

Above. The legend of the "Central Park Entire" tree map, which includes icons of over 170 species of trees.

The maps on the left of the comparisons above are the work of David Imus, a one-man cartography office near Eugene, OR, and the winner of best of show in 2012's annual Cartography and Geographic Information Society competition. The Imus map of the United States is adoringly described on Slate and compared, in these two selections, with the corresponding map by National Geographic.

Not wishing to seem negative, I nevertheless find the differences between the two rather minimal. Yes, the Imus map is handsome and legible, a bit more so than National Geographic's: none of the type is tilted or curved, an amazing feat indeed; as a consequence, type hierarchies might be more easily perceived. I certainly prefer that the interstate highway shields do not have a yellow background—no one is going to use a 4 x 3' map to drive across

the country—but of course that makes them harder to follow. The rendering of relief is well done, but it reduces the contrast between the information and the background.

All in all, a fine geographic map of the United States, and a well-written article, but I question whether the inclusion of so much data, no matter how well done, has real value except as an exercise.

10 different numbers. *Sports lovers often love statistics (sometimes as much as the game) and the networks are only too happy to oblige. Unfortunately, their presentation often sets up a huge interference problem, in which the very quantity of numbers that mean very different things and their proximity to each other make it very difficult to sort through them in the minimal time allotted. In this case:*

3 numbers deal with time;
2 numbers deal with the play;
2 numbers deal with the score;
1 number identifies a player;
2 numbers deal with that player's performance.

6 time outs left (the yellow shapes above each team's identification panel); not numbers exactly but a numerical notation nonetheless.

Hey, on what yard line is the ball?

This case is also an example of the occasional difficulties of using team colors in the score panel. Baltimore's color is violet; New England's colors are blue with red. The violet and blue are really too close in hue and value to be differentiated quickly. If New England's identification panel were red instead of blue, it might help the viewer distinguish between the two teams more easily.

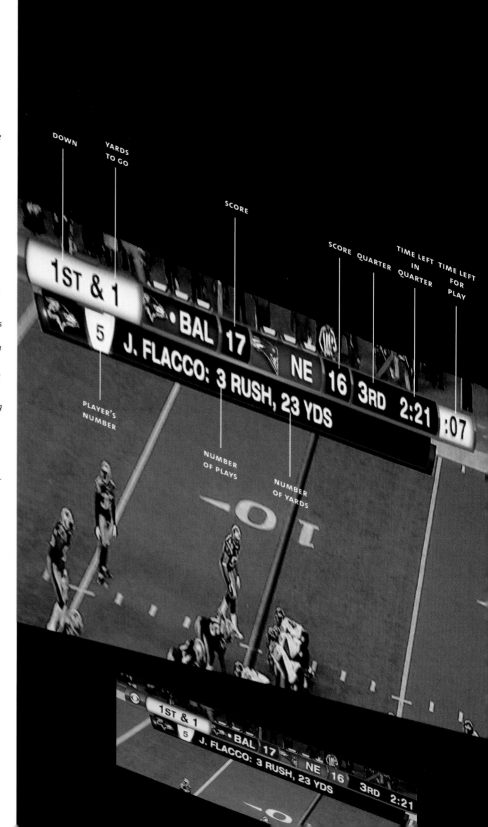

DOWN

YARDS TO GO

SCORE

SCORE QUARTER

TIME LEFT IN QUARTER

TIME LEFT FOR PLAY

PLAYER'S NUMBER

NUMBER OF PLAYS

NUMBER OF YARDS

Too many numbers

An information graphic can have too many numbers in more than one way:

- There are too many numbers in the data, a familiar information-overload problem, the solution to which is to make an effort either the reduce the quantity of data or to structure it in a workable hierarchy so that it can be perceived as staged.

- The numbers are organized in a way that they interfere with each other, not unlike a type-heavy slide on the screen during a verbal presentation. Mutual interference (discussed on pages 134–135) can be quantitative as well as qualitative.

Technology gives us the ability to acquire data at a rate unimaginable not too long ago. With that ability comes the need to figure out how to analyze them.

Read Stephen S. Holt. *Mapping the New Millennium.*

See also Simple and complex; Information overload; Too much information; An intelligible ballot.

83

Perhaps not too unlike the Palm Beach County's need for a presidential ballot that would work with their not-state-of-the-art machines in the 2000 presidential election, various branches of our government seem committed to providing us with a huge amount of (admittedly rather important) numbers with little regard to how they are organized, structured, and understood.

There seem to be two issues in these examples:

1) there are a lot of numbers of many different sizes whose location, meaning, and relationship to each other may not be entirely clear;

2) all the numbers seem to be of a uniformly bold weight, contributing to reduced differentiation,which suggests that they are all equally important and might mean the same thing.

Hole in the ozone layer.
Stephen Hall tells a terrifying story about how the hole in the ozone layer went undetected for so long. It is a cautionary tale about the dangers of throwing out data that don't agree with preconceptions and the difficulties of gathering a quantity of numbers so vast it defies study. See page 198.

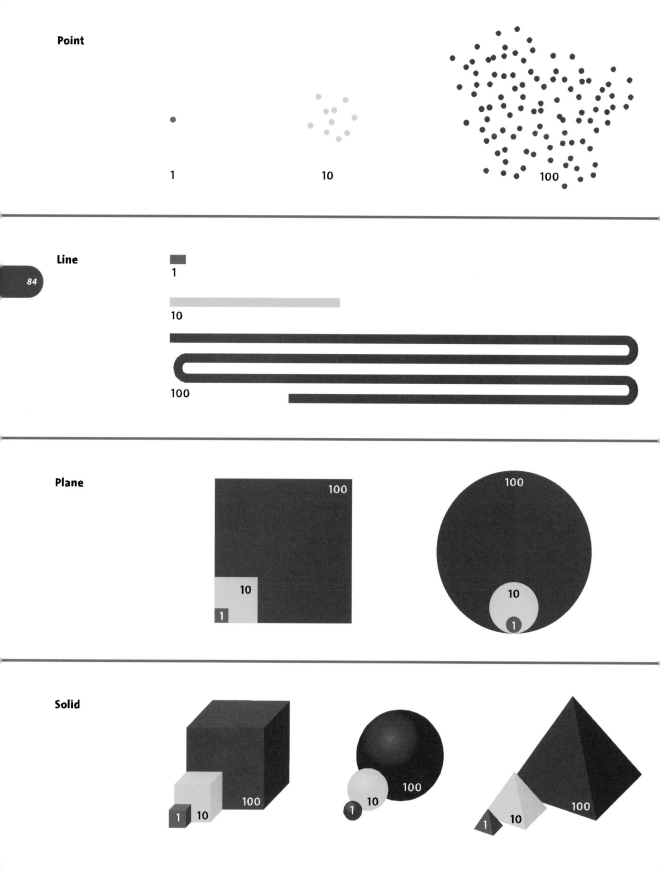

Point

1

10

100

Line

1

10

100

Plane

100

10

1

100

10

1

Solid

1

10

100

1

10

100

1

10

100

Point. Chaos; like a queue in Italy.

Line. When possible, excellent. Being for all intents one dimensional, lines use a lot of real estate.

Plane. Efficient. Being able to use two dimensions greatly reduces the need for excessive length in one dimension. Better than using squares or circles, however, would be, in a square or rectangle, adjacent bands that permit comparison in one dimension only, below, provided that the smallest quantity is identifiable.

Solid. Super efficient but extremely difficult to understand. The pyramid, particularly, defies intuitive estimates of volume (see the following spread).

Like generations of identification, visual quantitative comparisons depend on a number of factors, among which are:

- the disparity in the quantities being compared;
- the number of dimensions in the graphic being used for the comparison.

The more dimensions involved in a comparison, the harder the brain has to work to sort them out. Like conscious and unconscious decoding, graphic comparison solutions represent a balance between ease of comprehension and the need for the efficient use of space.

Read Werner Oechslin, Petra Lamers-Schutze. *The First Six Books of The Elements of Euclid*. The palette used in these illustrations is an homage to that book.

Edwin A. Abbott: *Flatland: A Romance of Many Dimensions*.

See also The pyramid paradox; Numerical integrity.

The more dimensions used in quantitative comparisons, the larger are the disparities that can be accommodated. As irony would have it, however, the ease of comparison generally diminishes in direct proportion to the number of dimensions involved.

85

A hybrid of line and plane, this variation of the planes at left shows comparisons in only one dimension. The single unit, however, is difficult to discern.

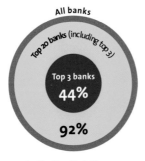

In *The New York Times*

Sixth-grade math department. *The left circle is a reconstruction of a diagram in* The New York Times, *showing market share among U.S. banks. Unfortunately, the graphic is incorrect, with the percentage relationships determined by diameter rather than by area (πr^2).*

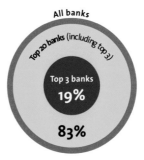

**Actual percentages of
The New York Times diagrams**

The true percentages represented by The New York Times's *circles are shown in the center graphic; a graphic accurately representing the percentages is at the right.*

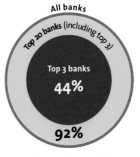

**Correct diagram of
The New York Times data**

3 : QUANTITATIVE ISSUES

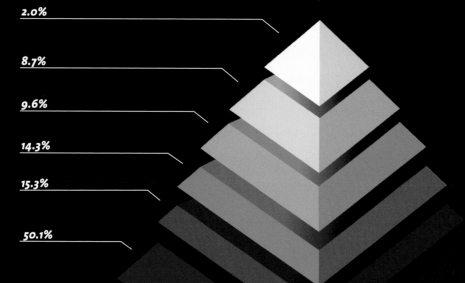

"2.0%": **actually 0.2%**

"8.7%": **actually 1.2%**

"9.6%": **actually 5.7%**

"14.3%": **actually 12.9%**

"15.3%": **actually 16.7%**

"50.1%": **actually 63.5%**

This pyramid (reconstructed) appeared in an annual report in 1984 and has been widely reproduced in design annuals and compendia of annual report and statistical design because of its handsome and dramatic rendering. Unfortunately, not a single percentage is correct, with distortions ranging from 9% to 1,000%. The way our brains perceive volume is often distorted by what we can't see, something that would never happen if these percentages were displayed as segments of a line or rectangle.

2.0%

8.7%

9.6%

14.3%

15.3%

50.1%

This pyramid accurately represents the percentages stated in the original diagram. Our brains simply do not want to accept the volume percentages because of what we cannot actually see.

The pyramid paradox

"The Hierarchy of Digital Distractions" by David McCandless respects the two aspects of the pyrimidal form, with the smallest quantity and the most important quality at its apex.

What's wrong with the picture at the top of the facing page?

It's wrong. Demonstrating once again that our eyes (our brains, actually) are inclined to fool us when dealing with three-dimensional shapes, especially when rendered on a plane surface.

In life, we can walk around a cube, a sphere, or a pyramid and sense that its volume is very different than a plane rendering or an elevation. In the case of a pyramid, the volume of each trapezoidal segment increases dramatically as you move toward the base, and the volume of the little pyramid at the top is much, much smaller than its height alone might suggest.

With a pyramid, or a cone or cube or sphere, all that we can't see leads us to misjudge its volume. The pyramid on the top is a re-creation of a widely reproduced annual report graph. All slices of the pyramid represent significantly different percentages than stated, the greatest distortion being 1,000%, 10 times. The pyramid below it accurately renders the percentages that the first pyramid purports to.

This example raises a fundamental question: do we want our representation to *be* accurate or do we want it to *appear* or *feel* accurate? In using three-dimensional objects, and sometimes even two-dimensional objects, it is difficult to achieve both.

Go to http://well.blogs.nytimes.com/2012/06/21/how-can-a-big-gulp-look-so-small/

See also Dimensional comparison; How big?

The pyramid may be the most difficult dimensional form from which to perceive volume (not counting solids with more than six sides).

Below. The pyramid paradox is applicable also to cones. Although they lack the historical symbolism of the pyramid, cones have many of the pyramid's characteristics that make judging their volume difficult.

An article in The New York Times *states: "The human brain has a surprisingly tough time with geometry and often can't accurately gauge when an object has doubled or even tripled in size. It's even trickier when the object is a wide-mouth cup, larger on the top than the bottom. 'We tend to underestimate the increase in the size of any object,' said Professor Chandon [Pierre Chandon, director of the Insead Social Science Research Center in Paris]. 'When you double the size of something, it really looks just 50 to 70 percent bigger, not twice as big.'"*

The cups below have been inverted in order to more closely mirror cones and the pyramids on this spread.

A playful (and intentionally essentially meaningless) use of pyramids in The New York Times Magazine, *which has for some time been using more informational graphics, including metaphorical illustrations, to generally good effect.*

ANALYTICS: The five most viewed articles online from the April 3 issue.

Eat: Broiled, Sautéed, Roasted, Poached

Domains: Laura Bush Is Back at the Ranch

① How Slavery Really Ended in America

On Libya's Revolutionary Road

The Phillies' Four Aces

8 ounces 22 ounces 44 ounces 64 ounces

Every silver lining has a cloud. In the late 1980s, Katz Wheeler Design was engaged by an important textbook publisher (see page 5), from which we were fired for recommending untraditional typographic and cartographic standards.

One of our cartographic contributions before the contract was terminated was the idea of showing every country other than the United States compared to a map of Texas, on the assumption, described on the facing page, that eighth graders (as well as the rest of us) would be much more likely to have at least a rudimentary sense of the size of Texas (especially compared to the size of their own state) than of a scale of miles and kilometers.

The concept has lived on, even though the contract didn't. (The mockups at right are not from the book.)

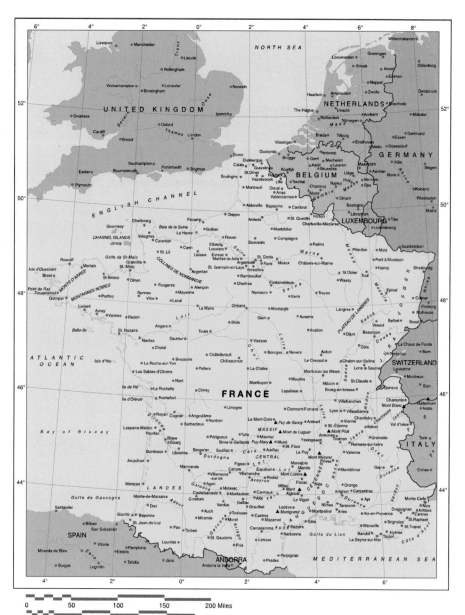

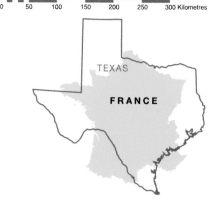

How big?

We all know and are comfortable with certain measures of size, length, and distance, regardless of our system of measurement. We all know how wide or long an inch, a foot, a yard, or a centimeter and a meter are. Hikers and drivers are probably good with miles and kilometers, shoppers with pounds and kilos, seamen with nautical miles and fathoms. Realtors, architects, and landscape architects are comfortable with acres, hectares, maybe square miles. But for most of us, the size of unfamiliar places larger than our own human scale—not a numerical or academic size, but a real sense of area or volume—is probably quite difficult to grasp.

Many atlases (and particularly road atlases) have not made things any easier, as we can see on pages 158–159. The same is also true of many middle-school geography textbooks, both U.S. and world geography, which attach a scale to all maps, but scales that are largely meaningless due to the magnitude of the non-human-scale numbers involved (France is more than 400 miles east to west, from Brest to Strasbourg, which is nothing like the distance from St. Petersburg to Alaska (4,100 miles).

Who among us, particularly an eighth grader, has a meaningful, experiential sense of 400 miles in real distance, not in driving or flying time? Comparison can come to a partial rescue, at least theoretically: compare the size of France to something with which a large number of people are somewhat familiar. How about Texas?

Comparison supporting the viability of Texas as a comparison for other countries around the world. Using Massachusetts would not be helpful.

What does Texas offer, other than, coincidentally, being about the same size as France? Texas would work for a comparison with China, which is much larger, as well as with Ireland, which is much smaller. Additionally, many of us are more familiar with Texas than with a lot of other states (other than the state we live in). It has a lot of history—there's the Texas Revolution and the Battle of the Alamo; four presidents were born there, all of whom served after 1950; the football Cowboys are from there; John F. Kennedy was assassinated there. And so on. It has a distinctive shape (unlike Colorado and Wyoming); it isn't too small (like Massachusetts, which has a distinctive shape, too).

The point is that when hundreds of miles and kilometers extend beyond our ability to image them in a meaningful way, a comparison to something familiar can't hurt.

How was China?
Very large, China.
And Japan?
Very…small, Japan.
Christopher Durang
The Actor's Nightmare

Geographic comparisons are difficult at best; it helps to compare something unfamiliar in size to something more familiar in size.

See also Substitution; Numerical integrity. Page 201 left center.

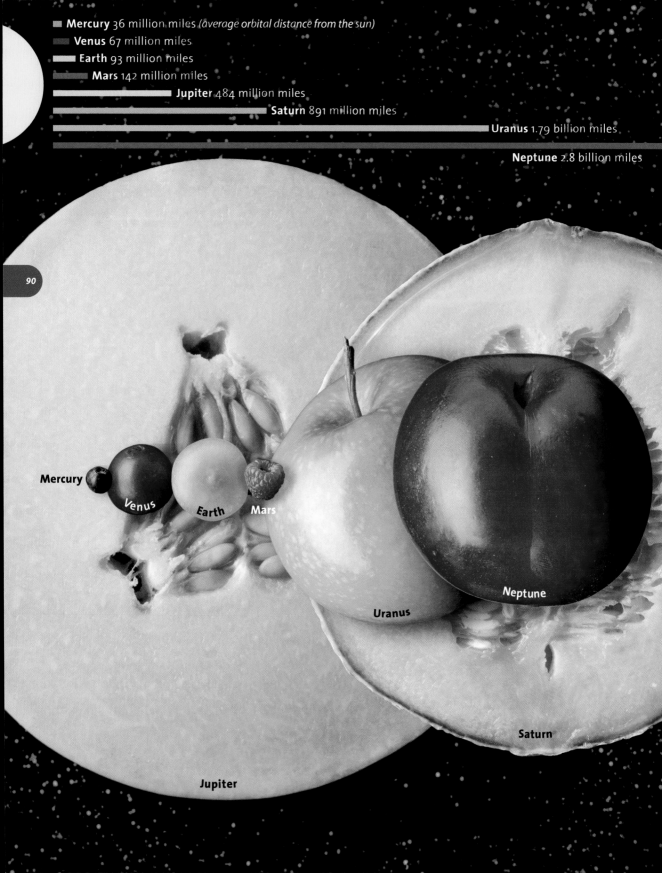

Mercury 36 million miles *(average orbital distance from the sun)*
Venus 67 million miles
Earth 93 million miles
Mars 142 million miles
Jupiter 484 million miles
Saturn 891 million miles
Uranus 1.79 billion miles
Neptune 2.8 billion miles

90

Mercury
Venus
Earth
Mars
Uranus
Neptune
Saturn
Jupiter

Substitution

We may not be able to visualize the difference between a 5,000-mile diameter planet (Mercury) and a 143,000-mile diameter planet (Jupiter), but we can visualize the size difference between a blueberry and a honeydew.

As a child, I was always frustrated by the inability of the astronomy books I read to communicate a sense of the planets' relative sizes and their (average) orbital distance from the sun. It was impossible for one diagram to show *both* the sizes of the planets relative to each other *and* those sizes relative to their orbits: when their orbital relationships were correct, the planets were too small; when the planets were large enough to compare, even a schoolchild could sense that if the planets were that large their orbits were impossibly small. It is not an easily solvable problem.

There have been many efforts to deal with communicating these two comparisons, one of size, the other of distance. It's the opposite problem from rail maps, where you want to communicate experiential units of measurement with efficiency. With the planets, you want to communicate exact differences in size and distance.

And the sizes and distances are unimaginably huge: Jupiter is 143,000 miles in diameter; Neptune is 2.8 billion miles from the sun. How can you imagine numbers like that? Most of us know that earth is about 8,000 miles in diameter and about 25,000 miles in circumference (π times d). Difficult enough. How about distance from the sun: about *93 million miles.* How about its volume: *260 billion cubic miles.*

There are many instances where the number—260 billion—or the unit—cubic miles—defeat us. But in matters of comparison, we can create similes that give us a better chance of grasping very large sizes or ungraspable distances.

This ad for Southwest Airlines uses an orrery simile.

If we possessed an atlas of our galaxy that devoted but a single page to each star system in the Milky Way…, that atlas would run to more than ten million volumes of ten thousand pages each…. [To] merely flip through it, at the rate of a page per second, would require over ten thousand years.

Timothy Ferris

Many concepts and relationships are difficult to grasp because of enormous or microscopic sizes and distances or because of huge disparities of scale. Representing these things with objects with which we have all had experience is a way to start working on the problem.

Read Timothy Ferris. *Coming of Age in the Milky Way.*

Go to http://www.dynamic diagrams.com/work/orrery

See also Too many numbers; Page 200 right.

The Planets on Astrolite, a promotion for Monadnock Paper Mills. In the spread at right, a die cut shows the size of the planet relative to Earth; for planets larger than Earth, a blind emboss was used, with the Earth-square in its center. At the top, a bar shows the planet's distance from the sun. The bar for Pluto—Pluto was a planet then—took three pages.

0 250 500 750 1,000 1250 1,500 1,750 2,000

Four bars at their true comparative (arbitrary) lengths.

0 750 1,000 1250 1,500 1,750 2,000

The same four bars utilizing break lines, scaled so that the shortest bars align. The relationships among the bars are distorted and the use of space is inefficient.

475 500 750 1,000 1250 1,500 1,750 2,00

The same four bars with a non-zero base line, with the same result.

Change in scale. Below. Both zero-based and without break lines, these two graphs use different scales. It could be argued that this makes it easier to see the year-to-year variation in Camden, and to compare that variation to Philadelphia's but in return it makes the number of Camden's homicides look 10 times greater than it actually is.

Phila. homicides by year

After declining between 2006 and 2009, the number of homicides ticked upward for the second straight year.

2011 318*

500
406
288
306

'90 '95 '00 '05 '10

* Figures do not include the eight deaths from the Jan. 19, 2011, grand jury indictment charging abortion doctor Kermit Gosnell with murder. The Police Department adds these deaths to the 2011 total, even though they occurred in previous years, because the FBI requires homicides to be counted in the year in which they become known to the police.

Camden homicides by year

Camden homicides have also risen for the last two years.

2011 49
58

'90 '95 '00 '05 '10

A Doonesbury comic strip by Garry Trudeau pokes fun at a news network that, in this strip, is willing to distort facts and numbers in support of its own political agenda.

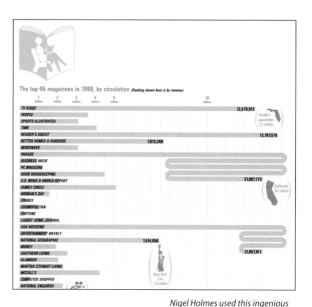

The top 45 magazines in 1998, by circulation *(Ranking shown here is by revenue)*

TV GUIDE — 12,578,912
PEOPLE
SPORTS ILLUSTRATED
TIME
READER'S DIGEST — 13,767,575
BETTER HOMES & GARDENS — 7,613,249
NEWSWEEK
PARADE
BUSINESS WEEK
PC MAGAZINE
GOOD HOUSEKEEPING
U.S. NEWS & WORLD REPORT — 37,097,772
FAMILY CIRCLE
WOMAN'S DAY
FORBES
COSMOPOLITAN
FORTUNE
LADIES' HOME JOURNAL
USA WEEKEND
ENTERTAINMENT WEEKLY
NATIONAL GEOGRAPHIC — 7,414,056
MONEY — 21,857,811
SOUTHERN LIVING
GLAMOUR
MARTHA STEWART LIVING
McCALL'S
COMPUTER SHOPPER
NATIONAL ENQUIRER

Florida's population 13 million
California 30 million
New York City 15 million

Nigel Holmes used this ingenious way to maintain a linear comparison among a set of numbers with great disparity between smallest and largest. His "snake" maintains, even emphasizes, a clear comparison without resorting to two or three dimensions.

Doonesbury

... AND I WANT TO BE ABLE TO ARGUE ON MY SHOW THAT OBAMA'S STIMULUS CREATED **ZERO JOBS!**

OKAY, THAT COULD BE TRICKY, SIR. THE CONGRESSIONAL BUDGET OFFICE REPORTED THE STIMULUS CREATED UP TO 3.3 MILLION NEW JOBS...

WHEN WE CUSTOMIZE DATA SETS, WE PRIDE OURSELVES ON PLAUSIBILITY. TO BE FRANK, I'M NOT LOVING OUR CURRENT PRODUCT — IT MAY NOT HUNT FOR YOU.

BUT IT'S ONLY FOR FOX NEWS.

OH, YOU SHOULD HAVE SAID SO, SIR! I'LL GET IT RIGHT OFF TO YOU!

Numerical integrity

This "comparative overview of important rivers and mountains" (Germany, date unknown) is characteristic of a host of similar maps in 19th-century atlases and textbooks. Interestingly, in this print, the rivers have a "zero base" but the mountains do not. These picturesque and engaging presentations surely encouraged the study of geography.

Two of four graphs published in The New York Times Magazine that use a non-zero base.

TALKING 'BOUT MY GENERATION:

A look at the decline in teenage risk behavior over the past three decades

60%
50%
40%

'80 '90 '00 '10

△ Percentage of high-school seniors who have ever tried pot.

70%
60%
50%
40%

'80 '90 '00 '10

○ Alcohol use by high-school seniors over time.

Not lying in diagrams is different than telling the truth in life, and contains many categories within which are shadings of intent. Some people tell the truth; some people misstate the truth accidentally; some people lie deliberately. See pages 14–15.

The architect or engineer who invented break lines had a rational objective: to show the beginning and end of something—probably quite long—whose middle was of no interest or consequence because it was the same as the beginning and the end of the object. No meaningful information is distorted or lost; efficiency is gained.

Break lines and non-zero-base bar graphs, however, *misstate* information. Bar graphs are used to *compare* information expressed by the length of the bar. If the relationship between the length of the bars is distorted, the graphic is misleading. By definition, these techniques make the relationship of the smallest quantity and the largest quantity much greater than it actually is.

A graph with break lines provides at least an acknowledgment that important information is missing. Non-zero-base graphs count on our assumption that the base of the graph is zero and on the expectation that we will not look too closely. Both of these techniques are often used to inflate the appearance of financial gains and in political reports. It is lying; or, at the very least, visual misinformation.

It can be argued that both devices use space efficiently, which is not untrue, as far as it goes. There are other ways to use space efficiently that are less misleading—particularly important when the value disparities are large—such as scale reduction, two-dimensionality (though harder to compare), and Nigel Holmes' snake technique.

Maintaining integrity (and lack thereof) in information design has many aspects: be sure the data are complete; be sure the data are accurate; be sure the data are pertinent; be sure the data all address the same issue in the same way; be sure the visual representation of the data meets all these criteria and discourages mininterpretation.

Read Daniel Boorstin. *The Image: A Guide to Pseudo-Events in America.*

Go to http://www.seqair.com/WildTools/BreakLines/BreakLines.html More about break lines than you ever dreamed.

See also Interpretation; Too many numbers; Page 201 top.

Every man has a right to be wrong in his opinions. But no man has a right to be wrong in his facts.
Bernard M. Baruch (American economist and adviser to U.S. presidents, 1870-1965)

Everyone is entitled to his own opinion, but not to his own facts.
Daniel Patrick Moynihan, quoted in Robert Sobel's review of *Past Imperfect: History According to the Movies*, edited by Mark C. Carnes

Facts are stupid things.
Ronald Reagan

There are no facts in Italy.
American expatriate artist living in Rome

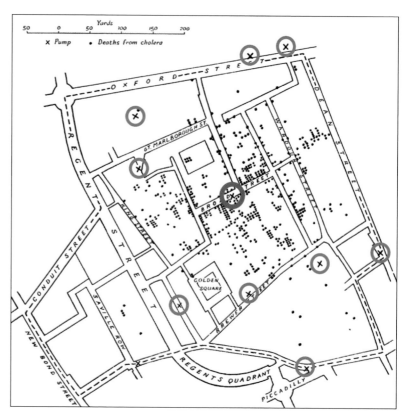

Old maps and diagrams, with their elaborate cartouches, elegant typography, and carto-graphic flourishes appeal to us as doorways to a different time. We often look at early examples of information design with a sense of nostalgia and an appreciation of their history, both of the time they were made and the impor-tance of the information and ideas they communicated, often for the first time.

Elegance and nostalgia, however, do not necessarily contribute to clear information design. By making the streets white against a gray background, the deaths pop against the background and the streets, and the pump loca-tions stand out, even in grayscale.

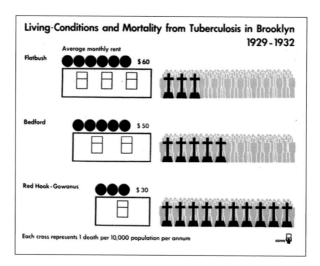

Isotype (an acronym standing for International System Of Typographic Picture Education) is a system of pictograms for visualizing and communicating social statistics for a broad gen-eral audience. Developed by Otto Neurath in Vienna in the 1920s, the graphic quality of the work was enhanced by graphic artist Gerd Arntz.

In this graphic, Neurath's graphic powerfully shows the inverse rela-tionship between home rental cost and death from tuberculosis.

One of these things is not like the other. But why is that one— the page that you're on—the least eye-catching?

Meaningful numbers

Connections are not always or necessarily about relationships between people. Often, the relationships revealed by mapping connections are a matter of life and death.

Take the case of London's cholera epidemic of 1854. At the time, diseases such as cholera and plague were attributed to miasma, or bad air (in medieval Italian, malaria). So prevalent was the miasmic theory at the time that germ theory awaited the work of Louis Pasteur in the 1860s. (The cholera bacillus, discovered in Italy in 1854, was completely ignored at the time and was rediscovered 30 years later.)

Dr. John Snow, suspicious of the airborne transmission theory, mapped cholera deaths and public water pumps, clearly revealing that the Broad Street pump was the source of the contamination.

Numbers have power. Numbers have meaning. The meaningful visualization of numbers in particular circumstances has helped save lives cut short by disease, identified the ramifications of social inequalities, and in at least one instance masked a major scientific problem for years, the hole in the ozone layer.

Snow proved his theory of water-borne cholera contamination by mapping the location of deaths in London's Soho district. At the time, people got their drinking water from public pumps. Snow's map clearly showed a significant majority of deaths centered on a pump on Broad (now Broadwick) Street. When the handle of the pump was removed (amid loud protests), cholera deaths in the neighborhood declined.

Many maps, especially older ones, that are conceptually intelligent and notationally or historically important are, in many cases, not the most visually strong. Much of this, certainly in historic maps, is due to conventions of vocabulary and notation that existed at the time. As a result, many of them are extremely elegant and quite beautiful, in some cases masking their information and its power.

[Playfair] was the first in a series of economists, statisticians, and social reformers who wanted to use data not only to inform but also to persuade and even campaign—and who understood that when the eye comprehends, the heart often follows.

Unattributed article in _The Economist_—"Worth a Thousand Words"—19 December 2007

Go to http://dd.dynamicdiagrams.com/2008/01/nightingales-rose

http://www.economist.com/node/10278643?story_id=10278643

See also Learning from Minard; Numerical integrity; Page 192 top left; Page 201 center and bottom.

95

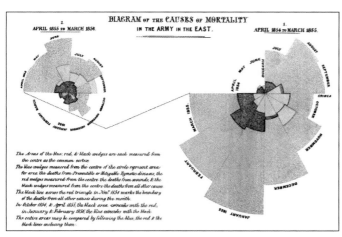

In the so-called "Nightingale Rose"—"Diagram of the Causes of Mortality in the Army in the East"—Florence Nightingale (1820–1910) unintentionally overdramatized the facts. She developed this type of diagram—known as the polar area—in 1858. (The pie chart was developed by William Playfair.)

The errors in this diagram are discussed and illustrated by Piotr Kaczmarek of Dynamic Diagrams.

The American Profile Poster, first published in 1986, used Isotype-like icons to visualize demographics in the United States. Many subsequent updated versions are available.

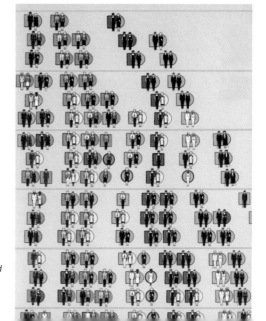

Left. A geographically accurate but typically misleading map of the 2008 U.S. presidential election. Many densely populated states are geographically small; many sparsely populated states are geographically large. As a result, President Obama's victory is counterindicated by the graphic.

Advantages
Greatest recognizability of each state.

Able to compare states with different data.

Disadvantage
The geographic size of the state has no correlation to statewide quantitative data.

Right center. The same information expressed in a cartogram by Mark Newman at the University of Michigan. This cartogram references the familiar shape of the states, but the degree of distortion renders some of that very familiarity problematic. It clearly shows, however, the extent of Obama's electoral victory.

Advantage
Shows true quantitative data maintaining some recognizable geographic familiarity.

Disadvantages
Difficult to compare quantities by state;

Some states difficult to recognize without labels;

Small changes in data can be seen only with difficulty.

Left. A diagram redrawn from the original in The New York Times for the 2002 presidential election, in which the area of each state is proportional to its number of electoral votes. The compromise between geographic shape and a more uniform vocabulary tends to permit finding particular states easily and comparing their relative electoral strength.

Advantages
Retains shape and relative location of individual states;

Quantities can be approximately compared.

Disadvantage
Will not adjust to changes in data without redrawing the entire map, both time-consuming and confusing.

The map below appeared after the 2002 Pennsylvania Democratic gubernatorial primary, strongly suggesting that it was won by (now Senator) Bob Casey over former Philadelphia Mayor Ed Rendell.

Wrong.

The future governor won only ten of the state's 67 counties but easily won the popular vote (an example of where the popular vote actually counts) with over 56% of the vote.

Using the dreaded pie chart (actually, quite effective with no more than two or three wedges) on each county, proportioned in size to the number of votes cast, the picture becomes clear. The counties Rendell won were five of the state's 10 largest (in terms of votes cast), and he won in those counties by extremely large majorities, especially in Philadelphia, which alone gave Rendell more than half the votes Casey received in the entire state.

Pennsylvania Democratic govenor's election by county

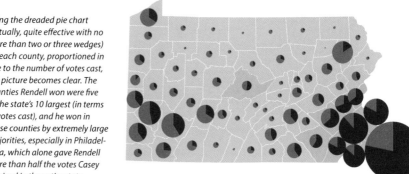

Perils of geography

This map of the United States by Chris Pullman was made with stones found on a beach in Maine. All states are shown actual size in relation to their neighbors.

BACHMANN ACHIEVES ORBIT WITH IOWA STRAW POLL.

A wry comment on attaching disproportionate importance—in this case, media frenzy—to events with inconsequential samples.

Geography—both shape and area—contradict our ability to compare and contrast what goes on within those irregular shapes.

Consider the United States Electoral College, created with the Twelfth Amendment and ratified in 1804 (Washington, DC, was added with the Twenty-Third Amendment in 1961). This amendment, in the election for President and Vice President of the United States, gives each state the number of electors (electoral votes) that is the sum of that state's U.S. senators and representatives. The minimum number of electoral votes a state can have is, therefore, three. This formula was a compromise between election by popular vote and election by the states.

Since each state's number of U.S. representatives is determined by the most recent decennial census, states with greater population have more electoral votes. However, states with smaller populations have more electoral votes than proportional to their population.

On the facing page are two techniques for showing the results of the 2008 presidential election cartographically, with a geographic map of the United States for comparison. Note that the geographic map suggests that the Republicans won the election, when we know that the Democrats won both the popular and Electoral College vote. This is due to the fact that many geographically large states have small populations and many states that are small in area are densely settled and have comparatively large populations.

Another example of geographic depiction masquerading truth is the 2002 Pennsylvania Democratic gubernatorial primary, geographically represented with a map of the state's 67 counties without regard to population. Exactly as in the skewed geographic representation of the U.S. presidential election, geography masks the truth: the Democratic candidate won just 10 of Pennsylvania's 67 counties, but bested his opponent 56% to 44%.

One of the prevailing orthodoxies…— one to which I wholeheartedly subscribe—is that pie charts are bad and that the only thing worse than one pie chart is lots of them.

Edward Tufte
http://www.edwardtufte.com/bboard/q-and-a-fetch-msg?msg_id=00018S

Go to http://www-personal.umich.edu/~mejn/election/2008 http://kottke.org/plus/2008-election-maps

See also Escaping geography; Data and form.

The cartograms below were based on a combination of coincidence and intention: coincidence in that the United States is organized geographically in a way that permits groupings that divide the country into five generally north-south regions. To a large extent these sections correspond to regions as they are often described, with the exception of a "southern tier" of states running from east to west.

In all these cartograms, the overall size of the country remains constant. This makes it possible to compare different data sets if the new cartogram is placed below (or above) or to the right (or left) of the original or earlier data set.

Advantages
Smaller changes can be seen when comparing data sets that have changed over time.

It is not difficult to discern change among "regions" between two of the cartograms placed one over the other.

Disadvantage
Without the familiarity of geographic shape and size, it is likely to be initially difficult to recognize individual states.

The 2008 presidential election (also shown for comparison on facing page at top) using the author's cartogrammic format. It is possible that this rectangular format makes it easiest to sense the relationship of Obama's electoral college victory most accurately.

Newman's cartogram based on population (bottom) rather than on electoral votes (top). Subtle changes are generally difficult to see and compare. Wyoming has become noticeably smaller, along with Rhode Island; Texas has become larger. The difficulty is that irregular shapes are notoriusly difficult to compare, even when adjacent to each other. In this comparison, the overall outlines of the continental United States are almost indistinguishable from each other.

This is really qualitative but it was hard to resist. We are so tied into red for Republicans that the designer used three inadequately different hues of red to distinguish three Republican candidates vying for convention delegates. As is so often the case, the geographic size of the individual states masks the important data of delegate votes, which are proportional to population.

Escaping geography

Above. Approximately the same information as at left, here in the author's format. Wyoming—the state with the most electoral power in 2008—is now a third of its electoral size; Texas—the state with the least electoral power in 2008—is now appropriately larger. Electoral power is described on the following spread.

An advantage of a cartographic device that uses (with just a few exceptions) only rectangles is that any cartograms being compared can be scaled (together) in any way and the comparison will remain clear, since familiar and irregular geographic shapes have been removed.

The addition of two electoral votes (representing each state's two U.S. senators), makes the Electoral College unfair by definition, if by "fairness" is meant the one-person, one-vote concept of American democracy as it is generally implied and understood.

While the obvious solution is to elect our President and Vice President by popular vote, that is not likely to happen anytime soon, if ever; nor is reform of the Electoral College, which favors states with smaller populations. But it helps to understand the distortions and inequities created by the Electoral College and its dependence on a census that takes place only once every 10 years. Since geographic maps reveal nothing more than physical size, we must turn to some other cartographic device to communicate that information.

When attempting to compare variation within a constant set of data, I found reducing distractions (in this example, shape and exact geographic location) helpful. This cartographic formula was developed to:

- Eliminate all distractions and misrepresentations created by shape, with the (optional) exception of Virginia/West Virginia, North Carolina/South Carolina, and Nevada/California, where I felt that the addition of diagonals would help orient the user);

- Separate the country into five regions that can be compared, as well as comparing variations by individual state;

- Maintain a constant size, arbitrarily set at 20 units high, that can correspond to 538 electoral vote units, making it possible to see comparisons among different data sets, such as population and relative electoral power;

- Allow for the inclusion of Alaska and Hawaii, at a size reflecting their population or number of electoral votes, as part of the Pacific region.

Choosing the best cartographic format depends on the hierarchy of importance of the various data sets.

Go to http://style.org/iowacaucus

See also Perils of Geography; Per capita; Data and form.

99

The census giveth and the census taketh away. This cartogram shows which states have gained (green) and lost (red) electoral votes as a result of the 2010 census.

In this cartogram, states with too much electoral power are shown in green, states with too little electoral power are shown in orange. The cartogram is based on the electoral votes that each state should have based on its population (in other words, its number of representatives).

Conflicting conventions. While red in general denotes the negative ("stop," "danger") and green positive ("go"), these two cartograms substituted orange for red to avoid confusion with another connotation of red in politics— the Republican party.

This electoral power map (estimated for the 2008 election, based on the 2000 census) shows the relative electoral power of each person in every state relative to each person in every other state (including Washington, DC, which has 3 electoral votes, as if it had representation in Congress).

Several factors result in the huge disparity between population-determined electoral votes depicted immediately above and real electoral power:

• The electoral vote formula that includes each state's two senators added to its number of representatives to determine its number of electoral votes;

• The rounding necessary to provide each state with a small population at least one representative;

• General rounding to the nearest whole number.

The form of an information graphic that works, as we have continually reiterated, is a response to data.

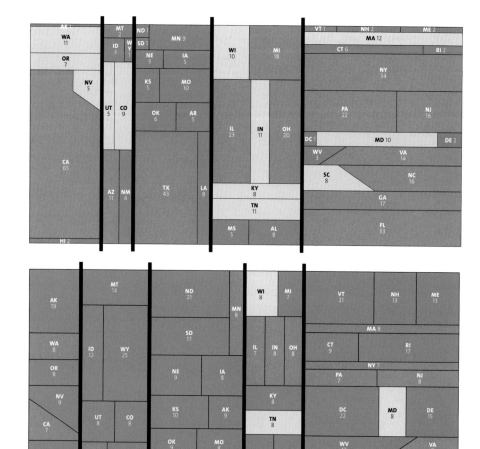

This cartogram assigns the results of the electoral power cartogram immediately above with the current electoral vote assignment cartogram.

Interestingly, disparities in electoral power—based as they are on state population size—appear to have discriminated equally between Republican-leaning states and Democratic-leaning states in the 2008 election. President Obama would have won the election by whatever calculation is used—including, of course, the popular vote, the only truly fair way to have an election.

Per capita

The cartograms at the left show:

- *More states have "too much" electoral power than too little (since the states with too little power are the most populous states); more people have "too little" electoral power.*

- *The states with the least electoral power are likely to change every 10 years. From 2001–2010 the states whose citizens had the least electoral power were Texas and Florida; between 2011 and 2020 they are California and New York. In both censuses, the entities with the most electoral power per citizen are Wyoming and Washington, DC.*

- *Between 2000 and 2010 the residents of Wyoming had more than four times the electoral power of the residents of Texas. The 2010 census changed things, but not very much: for the next 10 years, the residents of Wyoming—the least populous state—will have more than three-and-a-half times the electoral power of those of California, the most populous.*

- *The number of persons with too little electoral power is over 197,000,000—almost 64% of the population.*

- *The number of persons with too much electoral power is almost 95,000,000—over 30% of the population.*

- *The number of persons with about the right amount of electoral power is fewer than 18,000,000—less than 6% of the U.S. population.*

The five states whose inhabitants now have the least electoral power are, beginning with the least: California (up from third); New York (up from fifth); Texas (down from first); Florida (down from second); and Illinois (up from seventh).

The five states whose inhabitants now have the most electoral power are, beginning with the most: Wyoming, Washington, DC; Vermont; North Dakota; and Alaska (no change).

Like current and constant currencies, and like percentages of change, per capita is also a ratio: a number—such as electoral votes—divided by the number of persons in the equation. Per capita is applicable in many areas that require a meaningful understanding of numbers.

Texas has almost three times the number of residents as New Jersey, but New Jersey has the greatest number of persons per square mile, more than 12 times as many. Per capita per square mile (or any other unit of area) is a measure of density. The geographic size of Texas compared to that of New Jersey is not particularly relevant in this case.

Tennessee receives a hypothetical Federal education grant for $30,000,000, while Maine receives one for $10,000,000. Tennessee's grant is three times the amount in dollars as Maine's, but Maine's represents $7.50 per person, while Tennessee's only $4.70 per person.

In 1997, 767,000 Hispanic female heads of households lived in poverty, 48% of that demographic. At that time, 193,000 white males aged 55–59 lived in poverty, less than 4%. The disparity per capita of the two demographics is 12 times.

Wyoming has three electoral votes in the presidential election. California has 55. Each electoral vote in California represents 679,000 persons; each electoral vote in Wyoming represents 189,000 persons. Therefore, each person in Wyoming has more than three-and-a-half times the electoral power as each Californian. Until the 2010 census made California the state with the least electoral power per person, the honor belonged to Texas. During the 2000 decade, Wyoming had more than four times the electoral power per person as Texas. The state with the least electoral power per capita may change, but the state with the most appears to be Wyoming for the imaginable future.

See also Perils of geography; Escaping geography; Data and form; Relative and absolute.

Per capita (from the Latin, "for each head," or per person) is the only way of understanding numerical relationships among groups of people.

The number of U.S. citizens with too little electoral power is 197,000,000—almost 64% of the population.

Gerrymandering is the practice of creating an advantage for a particular politician or political party by manipulating district geographic boundaries. Gerrymandering was named for governor Elbridge Gerry (1744–1814) of Massachusetts, who signed a bill to redistrict the state to benefit his Democratic-Republican party. One district in the Boston area was thought to resemble a salamander, and the combination name was coined by a person unknown. The electoral college represents a kind of numerical gerrymandering.

Cartograms by Mark Newman et al., similar to the U.S. electoral cartograms on pages 96 and 98. These use an earlier version of his algorithm than the cartogram shown below and are from the Worldmapper website. My own feeling is that, while these clearly suffer from the "bloated slug" syndrome, the more recent one (this page, bottom left), more elegant in its distortion, is compromised by the distractions of land relief and ocean depth.

The cartogram at the left shows forest depletion; at the right, earthquakes.

These two data maps are from Virginie Raisson's 2033: Atlas des Futurs du Monde. Like the two cartograms above, they were selected to show how this approach to quantitative mapping can vary so dramatically depending on the data set. At left, the distribution of global wealth; at right, lack of access to running water.

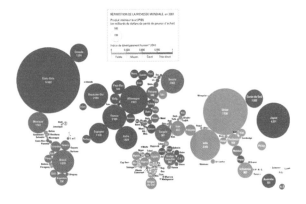

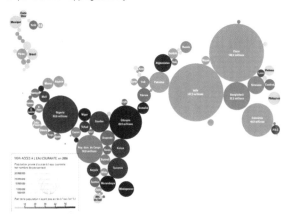

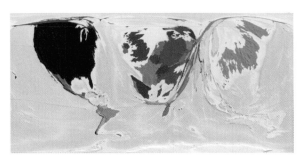

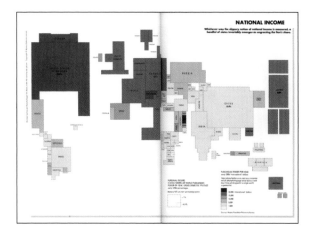

Choose the compromise you prefer. The Newman cartogram above benefits from the recognition of familiar geographic shapes—such as the United States and the United Kingdom—but only if they are not overly distorted, as is Africa.

In The State of the World Atlas cartogram at right on the identical subject—national income per capita—the familiarity of countries' geographic form is compromised but the quantitative comparisons are much easier to make.

Data and form

While quantitative data is usually geographically specific, geography is not inclined to be cooperative, so the designer must select compromises that are least damaging to the presentation and understanding of the data.

In a comparison of the top two maps and the one at the bottom left on the facing page, the difference between them represents a question less of compromise than of choice: on the one hand, the cartographer developed a more pleasing and effective algorithm between the top and bottom; on the other hand, the addition of land relief and ocean depth just complicates areas that do not pertain to the data and make the map busier. Both, in which country shapes are grossly distorted, nevertheless dramatically reveal by that distortion comparative characteristics of both countries and continents. The degree of distortion, of course, makes exact data impossible to calculate without the accompanying tables.

In the center pair of maps, while the area of circles in general may not be as easy to perceive as squares or rectangles, these diagrams work well, and the individual countries can be surmised by their location. The greater the number of diagrams in the series, the easier it is to have a sense of the countries being mapped.

The cartogram in the lower right uses a rectangular vocabulary to reference country shapes. While not completely successful, it appeals to me because of the relative ease of comparing quantities.

Read Daniel Dorling, Mark Newman, Anna Barford. *The Atlas of the Real World: Mapping the Way We Live.*

Michael Kidron and Ronald Segal. *The State of the World Atlas* (1995; out of print). Heavy and effective use of cartograms. The newer editions in this publisher's series, by Dan Smith, are far less cartographically inventive.

Go to http://www.worldmapper.org, a site for many of *The Atlas of the Real World*'s maps, using an earlier algorithm.

http://hci.usask.ca/publications/view.php?id=173

http://www.gapminder.org

http://www.mapsofwar.com/images/EMPIRE17.swf

See also Perils of geography; Escaping geography; Relative and absolute.

Perils of geography. The data maps below, in an article in The New York Times— *"Understanding the European Crisis Now," illustrate the compromises and difficulties inherent in using geographic forms to make quantitative comparisons:*

- *Out of their normal context and position relative to each other— required by the distortions of size—not all of the countries may be easily recognizable.*

- *The irregular geographic shapes make comparing the shapes to each other and the change in data from one data map to the next difficult. They also make extracting the quantitative data extremely difficult.*

Mapping data is inevitably an exercise in compromise.

Let the data determine the form, not the other way around.

Would a little humor hurt? This chart by Nigel Holmes, which appeared in Time *magazine (originally in two colors) in 1982, was savaged by Edward Tufte in* Envisioning Information *(1990):*

"Consider this unsavory exhibit… chockablock with cliché and stereotype, coarse humor, and a content-empty third dimension. It is the product of a visual sensitivity in which a thigh-graph with a fishnet stocking grid counts as a Creative Concept."

Since then, many have come to the defense of Holmes' ability to make data inviting as well as clear. One of these, a paper by five authors from the Department of Computer Science at the University of Saskatchewan, states: "The added visual imagery in a Holmes style chart could draw the reader's eye, could help convey a specific message, or could make the chart more memorable." I agree.

In Urban Atlas: 20 American Cities, *Joseph R. Passonneau and Richard Saul Wurman clearly demonstrated the advantage— actually, the necessity—of using the same scale to make meaningful comparisons among different geographical locations. In general, finding a broad range of maps at the same scale world-wide is not an easy task.*

Cities: Comparisons in Form and Scale *is a 1974 reissue in book form of the original portfolio of 50 cities modeled at the same scale by 61 architecture students at North Carolina State University at Raleigh in 1963. In addition to the often surprising informa-tion about the size of different cities, the photography of the models, accompanied by many of the students' drawings, is quite beautiful.*

Apples to apples: data scale consistency

Facing page, left to right.

A USGS map of Center City and South Philadelphia, including the Schuylkill and Delaware Rivers.

Residential population density, ranging from 60–200 (open circle) to over 3,600 (closed circle). The outline circle, regardless of the size of the data circle, maintains the integrity of the grid.

Personal income, ranging from 0–$250,000 (open circle) to over $7,500,000 (closed circle).

Facing page, left to right.

A superimposition of the density and personal income maps above—unfortunately, a bit out of register;

Residential density combined with land use, showing four categories of open space and two of commercial-industrial development.

In 1967, The MIT Press published Joseph R. Passoneau and Richard Saul Wurman's *Urban Atlas: 20 American Cities, A Communication Study Notating Selected Urban Data,* a large atlas with a long title that, as its name implies, compares geography, land use, income, and population density for 20 American cities *at the same scale.* Unlike traditional road atlases (see pages 158–159), where the scale of any given state was whatever would fill the page (either horizontally or vertically), *Urban Atlas: 20 American Cities* shows the cities (or their central portions) at a constant scale and with a uniform data grid. This makes it possible to compare the many aspects of these cities both overall (by sensing the density of the colors or patterns) and by a particular location.

Uniformity of data and wayshowing scale have been a characteristic of Wurman's work for more than 45 years, and one to which he has often introduced his occasional architecture students. In 1963, at North Carolina State University in Raleigh, his students built models of fifty cities, many of historical importance, at a constant scale (1"=600'), which, like *Urban Atlas: 20 American Cities,* permitted previously difficult or impossible comparisons to be easily made.

Van Susteren and Grooten's *Metropolitan World Atlas,* below, carries this to the ultimate extreme, with the result that the book's consistency becomes a bit deadening. The book is further compromised by the weakness of the pale ochre holding circle.

Consistent scale is the only way to compare different statistic aspects of the same place, whether city, state, or country.

Read Richard Saul Wurman. *Cities: Comparisons in Form and Scale.*

Go to http://style.org/iowacaucus

See also Constant and mnemonic notation; Data and form; Scale and adjacency.

105

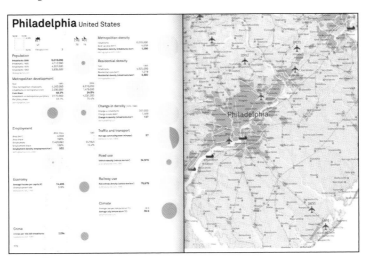

3 : QUANTITATIVE ISSUES

$383,367 in **1800** =
$525,000,000 in **2012**

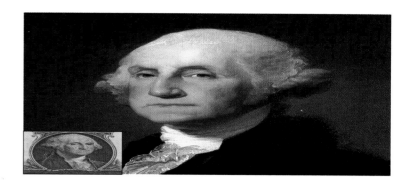

$1.00 in **2012** =
$13.69 in **1800**

2002
10,000 persons

Group **A**: 1,000 persons = 10% of the total
Group **B**: 9,000 = 90% of the total

2012
20,000 persons

Group **A**: 8,000 persons = 40% of the total
Group **B**: 12,000 = 60% of the total

Group **A** has grown 800%
Group **B** has grown 33%

Group **A** has grown more than 24 times as fast
 as Group **B** in 10 years

Group **A** now has four times the percentage of
 the total as it had 10 years earlier

Relative and absolute: ratios of change

When is a dollar not a dollar? When is a dollar really a dollar? What's a dollar, anyway?

Easy enough questions when you're talking about comparing a dollar with another dollar today, maybe yesterday, or tomorrow. But next year? That's a different story. Why? Inflation. Today's dollar is worth less than last year's dollar: prices go up. If income goes up, everything's fine (well, maybe not fine; but at least not worse). The only reliable measure of a dollar (or any currency) is what you can buy with it.

It's important to know, then, when comparing the cost of things over time what the comparison—what the units of currency—really means. A dollar in 1965 (the year I started college) was worth $6.00 in 2004, the year our son started college. Quite a change.

A current dollar (also called nominal, or arbitrary) makes no adjustment for its value: the $5,000 tuition in 1965 is compared to the $35,000 tuition today, interesting but essentially meaningless; the cost of tuition did not really go up 700% in real terms. A constant dollar reflects its value, most often calculated by using the Consumer Price Index, or CPI. (Tuition and ancillary education costs have increased at a rate greater than the rate of inflation.)

Inflation—the eroding value of a particular unit of currency—is an example of a ratio: the value of something today is a certain percentage of what it was last year or a century ago. (Rarely, it is worth more—deflation—which is another issue with different consequences.) For the purposes of comparison, if a dollar was worth 100 cents in 1992 and 80 cents in 2012, that represents a decline in value of 20%; and, conversely, the value of a dollar was 25% more 20 years ago.

Very often, we miss the mathematical basis by which we understand what percentages really mean and how to compare the changes that percentages express, because the data may seem counterintuitive or because we are emphasizing incomplete data. Some examples, visualized on the facing page, might help:

In a hypothetical district or county are two ethnic groups. In 2002, with a total population of 10,000, there were 1,000 persons in group A and 9,000 persons in group B. Ten years later, in 2012, there were 8,000 persons in groups A and 12,000 persons in group B.

In those 10 years, group B retained its majority, but group A grew at a markedly different rate. While group B grew from 8,000 to 12,000 persons—that's 33.33% in 10 years, or 3.33% on average per year, group A grew from 1,000 persons to 8,000 persons, 800%, or an average of 80% a year.

So, as we look at numbers, whether widgets or currency or people, it is important to keep in mind that the meaning of those numbers is almost always in relationship to some other number—1912 dollars (or any currency) to 2012 dollars; dollars to numbers of people, or numbers of people to dollars; percentage of change over time between one data set and another.

Go to http://www.theatlantic.com/business/archive/2010/05/the-net-worth-of-the-us-presidents-from-washington-to-obama/57020. A calculation of the net worth of all U.S. presidents in constant dollars. I have used the site below to extrapolate Washington's worth in 1800 dollars:

http://www.minneapolisfed.org/community_education/teacher/calc/hist1800.cfm

See also Per capita; Data and form.

Current dollars (or any currency): contemporaneous dollars not adjusted for inflation, the currency's evolving value, or its worth at the present time.

Constant dollars: dollars adjusted to their real worth in the present or the specific period under discussion.

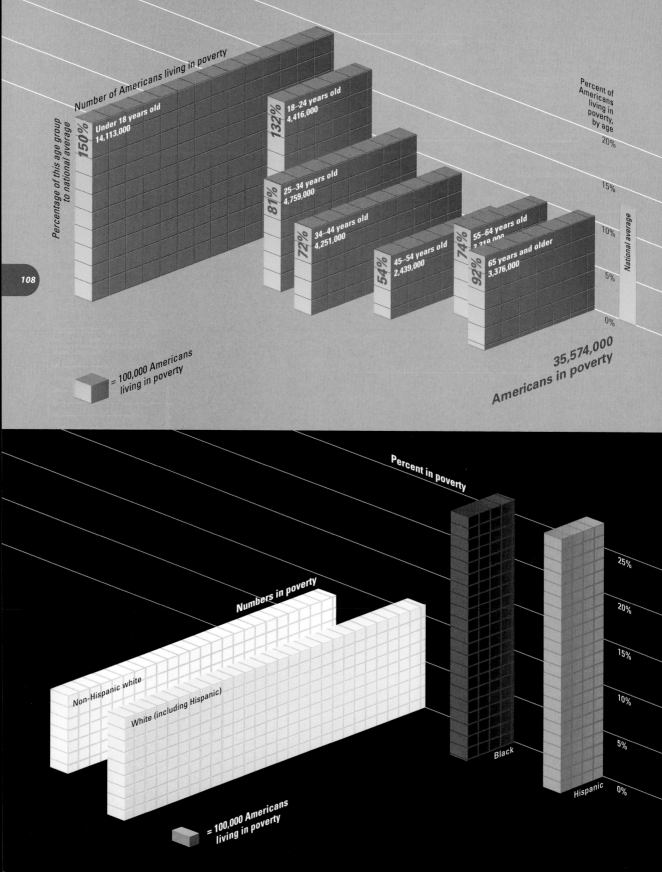

Number of Americans living in poverty

Percentage of this age group to national average

Percent of Americans living in poverty, by age

Under 18 years old
14,113,000

150%

18–24 years old
4,416,000

132%

25–34 years old
4,759,000

81%

34–44 years old
4,251,000

72%

45–54 years old
2,439,000

54%

55–64 years old
2,219,000

74%

65 years and older
3,376,000

92%

20%

15%

10%

5%

0%

National average

= 100,000 Americans living in poverty

35,574,000
Americans in poverty

Percent in poverty

Numbers in poverty

Non-Hispanic white

White (including Hispanic)

Black

Hispanic

25%

20%

15%

10%

5%

0%

= 100,000 Americans living in poverty

Multi-axiality

A longstanding practice in graphing has been the use of more than the standard two axes, or the modification of the usual two axes; in some cases, the z-axis, adding dimension, and in other cases the use of more than one y-axis. Using more than one y-axis can work in different ways.

For example, having two y-axes that are categorically different shows the relationship between two sets of quantities. This has the effect of eliminating time, often the function of the x-axis, and showing the relationship between the two y-axes at a single point in time. Another approach is to have two (or more) y-axes that are also categorically different—for example, with their plots shown in different colors, thereby showing the relationship, over time, between the categories. In both cases, it is necessary to choose the values assigned to the y-axes so that comparisons are meaningful—either by plotting them so that the graphs of both categories have the same visual starting point or by using parallel increments that are meaningful and truthful. The graph at the right is a successful example.

Read William Playfair's *Commercial and Political Atlas and Statistical Breviary.*

Richard Saul Wurman. *Understanding USA.*

Go to http://www.nytimes.com/2012/04/22/magazine/who-made-that-pie-chart.html?_r=1

See also Data and form; Per capita; Ratios of change.

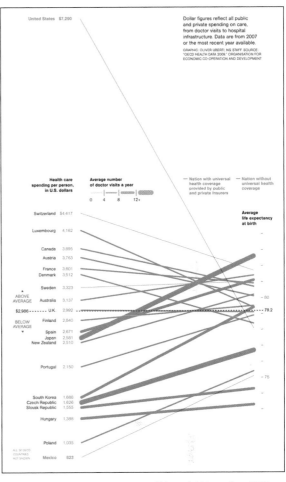

109

This graph (data are from 2007) with a double y-axis reveals the relationship between health care spending, average number of doctor visits per person per year, and average life expectancy. The United States, with by far the highest health care costs per person, is extremely low in doctor visits and below average in life expectancy; it is one of two countries in the survey without universal health coverage (the other is Mexico).

Facing page. Two graphs from Understanding USA *presented at the TED-X Conference dealing with poverty in the United States (data from 1997). The top graph deals with poverty by age group, the bottom with poverty by race. In the top graphic, the y-axis deals with the percentage of poverty in the age group and states its relationship to the national average; the z-axis is determined by the number of Americans in poverty in each age group. The bottom graph is similar but based on race rather than age.*

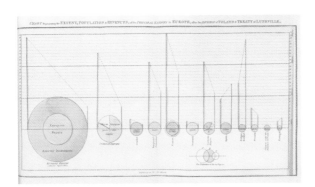

"Statistical Chart showing the Extent of the Population & Revenues of the Principal Nations of Europe in the order of their Magnitude," by William Playfair (1759–1823). Playfair invented four diagram types: the line graph and bar chart of economic data; the pie chart; and the circle graph.

3 : QUANTITATIVE ISSUES

Right. A graphic showing relationships among English system measurements of length, divided vertically by the metric categories in which they fall.

If one is used to measuring in 10ths, it is easy to think in halves and 5ths, less easy to think in 3rds and 4ths, the consequence of nothing more than the intuitive desire to work in whole numbers; conversely, if one is used to thinking in 12ths, it is easy to think in 3rds, 4ths, and 6ths (the pica) and less easy to think in 5ths and 10ths.

The turquoise squares are divided into 12ths, 6ths, 4ths, 3rds, and halves.

The lavender squares are divided into 10ths, 5ths, and halves.

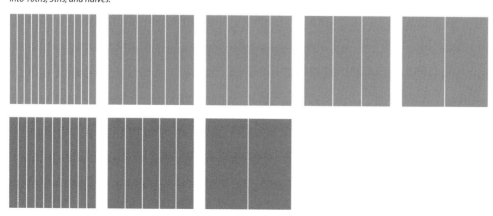

Measurement and proportion

Egyptian origins of the palm and cubit, comparable to the English foot.

Leonardo's Vitruvian Man, *ca. 1487, based on Vitruvius's correlation of ideal human proportions to geometry in Book III of* De Architectura, *which Leonardo summarizes thus: a palm is 4 fingers; a foot is 4 palms; a cubit is 6 palms; 4 cubits make a man; a pace is 4 cubits; a man is 24 palms.*

There are two main kinds of measuring: literal—mathematical—and experiential. The latter has only fairly recently come into general use (although John Ogilby's *Britannia* of 1675 utilized it, although not dramatically).

Measurement systems inevitably influence the way designers use proportion in their work.

Almost all the world uses an intellectually determined, rational, constructed system of measurement: the metric system, first adopted by France in 1791. Using the earth as its "yardstick," the meter was defined as one ten-millionth of the distance from the Equator to the North Pole. Measurements for area, weight, and volume were similarly rational. Most important, it is a decimal system, in which every unit of measurement is related to every other by a multiple of 10.

The United States is one of only four countries in the world to use the English system of measurement (Liberia, Myanmar, and sometimes the United Kingdom are the others). The English system has a much longer history and is irrational in the sense that larger units of measure do not bear a fixed relationship to smaller units of measure. It is also irrational in the other sense of the word: in some ways, it is experiential, with units of measure based on human anatomy, experience, and familiar containers. The digit, palm, and cubit, for example, all date from the Old Kingdom in Egypt (3rd millennium BCE).

These two very different systems of measurement inevitably affect their users' sense of proportion. If one is used to thinking in tenths, it is difficult to think in thirds and fourths; if one is used to thinking in twelfths, it is difficult to think in fifths.

Read Philip and Phylis Morrison (and the Office of Charles and Ray Eames). *Powers of Ten: A Book About the Relative Size of Things in the Universe and the Effect of Adding Another Zero.*

Vitruvius: *Ten Books on Architecture.*

For without symmetry and proportion no temple can have a regular plan; that is, it must have an exact proportion worked out after the fashion of the members of a finely shaped human body.
Vitruvius

To measure it is to think about it.
Bruno Martin

4

Structure, Organization, Type

Hierarchy and visual grammar

The most important thing about printing is that it conveys thought, ideas, images, from one mind to other minds.

Beatrice Warde (1900–1969): *The Crystal Goblet*

Any man who would letterspace blackletter would shag sheep.

Frederic Goudy (1865–1947)

Type at the Concorde métro station in Paris.

Skeletal Grid

1.
I have ever had pleasure in obtaining any little anecdotes of my ancestors.

2.
You may remember the inquiries I made among the remains of my relations when you were with me in England, and the journey I undertook for that purpose.

3.
Imagining it may be equally agreeable to (1) you to know the circumstances of my life, many of which you are yet unacquainted with, and expecting the enjoyment of a week's uninterrupted leisure in my present country retirement, I sit down to write them for you.

4.
To which I have besides some other inducements.

5.
Having emerged from the poverty and obscurity in which I was born and bred, to a state of affluence and some degree of reputation in the world, and having gone so far through life with a considerable share of

Interval Grid

1.
I have ever had pleasure in obtaining any little anecdotes of my ancestors.

2.
You may remember the inquiries I made among the remains of my relations when you were with me in England, and the journey I undertook for that purpose.

3.
Imagining it may be equally agreeable to (1) you to know the circumstances of my life, many of which you are yet unacquainted with, and expecting the enjoyment of a week's uninterrupted leisure in my present country retirement, I sit down to write them for you.

4.
To which I have besides some other inducements.

5.
Having emerged from the poverty and obscurity in which I was born and bred, to a state of affluence and some degree of reputation in the world, and having gone so far through life with a considerable share of felicity, the conducing means I made use of, which with the blessing of God so well succeeded, my posterity may like to know, as they may find some of them

The grid

Every designer knows about grids. Not every designer knows how to use them.

Grids are useful in information design because they provide an armature for the structure and organization of information. Rectangular grids are of two principal types, which—in terms of their vertical organization—I'll call skeletal and interval.

A skeletal grid is a fixed structure that you may liken to a building of (usually) uniformly spaced floors, studs, and joists. An interval grid permits floors of any measurement, separated by a space, or joist, of fixed measurement. Not unlike the uniform space between paragraphs (if you put space between paragraphs), it is totally content- and typography-governed, with few fixed horizontal hanglines.

The number of vertical columns in any grid permits a variety of typographic and visual organizations. Up to the point of compromises in legibility because of line lengths that are too narrow or too wide, more columns can offer more flexibility and the possibility of interesting asymmetry.

Read Timothy Samara. *Making and Breaking the Grid: A Graphic Design Layout Workshop.*

Jan Tschichold. *The Form of the Book: Essays on the Morality of Good Design.*

Go to http://www.goldennumber.net/fibonser.htm, for some basic information on the Golden Section and the Fibonacci Series.

See also Measurement and proportion; Page 204 top; page 205 top.

Appropriate line length is a function of type size: I was taught that two alphabets (52 characters) is the maximum line length for legibility. (That, of course, suggests a narrower maximum measure for Garamond than for Helvetica of the same nominal point size.)

A page from a French book on the Paris Métro, utilizing a five-column grid, with two columns of text each two of the five columns wide, and a one-column caption column, which can move anywhere on the page.

The grid structures on the facing page show the schematic application of a skeletal (left) and an interval grid.

The Talmud (from the Hebrew, meaning "learning") is a central text of Judaism, taking the form of rabbinic discussions on Jewish law, ethics, philosophy, and history, and presenting the thoughts of different scholars on a particular subject on the same page. This Talmud was printed by Daniel Bomberg, 1520–1523, in Venice, the city that gave us the word "ghetto."

In classical book design, many layouts were based on the Golden Ratio or Golden Section (1:1.61803…), mathematically defined as (a+b) is to a as a is to b, represented by the Greek letter phi (φ). The Golden Ratio has wide application in mathematics, natural science, and numerology.

4 Married or single in 2006 (Registered partnership counts as married)

4a Is [initials and surname of spouse/partner], born on [date], sofi number [number], your spouse as at 1 January 2006?

☐ Yes ☐ No

Continue with question 5a. However, if your spouse as at 1 January 2006 is different, complete questions 4b-4f.

The Tax Authority estimates this co-occupant's 2006 assessment income to be € [amount]. Is this estimate correct?

☐ Yes ☐ No

Continue with question 4d. Your spouse is your allowance partner.

Continue with question 4e. Your spouse is your allowance partner.

4b Initials and surname of your allowance partner
4c Date of birth Sofi number
(Indicated as dd mm yyyy)
4d Use the calculation aid on pages 6 and 7 of the Notes and estimate your allowance partner's assessment income for 2006. Use the amount from the calculation aid. € [] , 0 0
4e Does your allowance partner have Dutch healthcare insurance for healthcare expenses as at 1 January 2006? ☐ Yes ☐ No
4f Allowance partner's signature.
Sign inside the box.

5 Co-occupant 1

5a Is [initials and surname of co-occupant 1], born on [date], sofi number [number], still living with you as at 1 January 2006?

☐ Yes ☐ No

Continue with question 6a

The Tax Authority estimates this co-occupant's 2006 assessment income to be € [amount]. Is this estimate correct?

☐ No ☐ Yes

Continue with question 6a

Continue with question 5d

5b Initials and surname of this co-occupant
5c Date of birth Sofi number
(Indicated as dd mm yyyy)
5d Use the calculation aid on pages 6 and 7 of the Notes and estimate this co-occupant's assessment income for 2006. Use the amount from the calculation aid. € [] , 0 0

5e Review pages 4 and 5 of the Notes.
Is this co-occupant your allowance partner as at 1 January 2006? ☐ Yes ☐ No, *skip question 5f*
Note: There can be only one allowance partner
5f Does this co-occupant have Dutch healthcare insurance for healthcare expenses as at 1 January 2006? ☐ Yes ☐ No

5g Co-occupant's signature. *Not required if the co-occupant is less than 18 years old. Sign inside the box.*

116

Page 3 of a Dutch tax form, 2006, designed by Eden Design since 1987.

U.S. Form 1040 (front page) from 2005, 2007, and 2011. The use of white boxes in a colored field, no color, and colored boxes represents an interesting evolution.

Organizing response

We are all familiar—perhaps too familiar—with filling out forms: at the doctor's office, job and school applications, paying for a purchase online, and—everybody's favorite—filling out our tax return.

The form is at once impersonal and intimate, brusque and exploratory, indifferent and empathetic. Which it is depends on the form's intent and—parallel but separate—its design.

The IRS really doesn't care about you very much, if at all, and seeks a purely numerical relationship. You tell them how much you earned, claim your deductions, and they will tell you how much money to send them. It is a transaction but not a relationship. The same is pretty much true of credit card applications and buying online.

Virtually all school and some job applications are at the other extreme. They want to know enough about you so that they can ascertain whether you meet their criteria and, more important, whether you have the personal and intellectual qualities to be part of a class, a team, a workforce. Are you interested and interesting? Do you have anger management issues? Can you do the job, whether stacking shelves, waitering, or completing a program of study?

Most forms are somewhere in-between, a combination of writing and check-offs, and many of these risk failure by their very effort to be easy to fill out and efficient. Medical history forms often provide too little opportunity for qualitative aspects of historical medical problems, and hospital discharge forms often lack the structure and hierarchy helpful, even essential, to self-manage care after a minor or major physician, emergency room, or hospital experience.

Read Borries Schwesinger. *The Form Book: Creating Forms for Printed and Online Use.* If you like forms, this is the only book you'll ever need.

Go to http://www.taxhistory.org./www/website.nsf/Web/1040 TaxForms?OpenDocument

See also Measurement and proportion.

Several ways of highlighting where to fill in a form.

Forms are frameworks for communication, comprised of text and graphics, and including fixed and variable pieces of information.

Borries Schwesinger,
The Form Book

In addition to flush left–flush right there is also top-to-bottom alignment.

In a quick scan of the menu below left, we want to read the English translations with the Italian descriptions to which they are closest. Fortunately, it doesn't take a knowledge of Italian to know that "tomatoes" and "olive" are not the same.

It appears at first glance at the menu below right that the prices are (sensibly) immediately to the left of the menu item, until a scan of the overall menu and the misalignment of the prices with the menu items to their immediate right give the game away.

Menu Speciale

Antipasto a Scelta
One Appetizer of Your Choice

BRUSCHETTA AI CARCIOFI
Bruschetta with Artichokes
BRUSCHETTA AL PROSCIUTTO
Bruschetta with Parma Ham

BRUSCHETTA AL POMODORO
Bruschetta with Tomato
BRUSCHETTA ALLE OLIVE
Bruschetta with Olives

BRUSCHETTA ALLA DIAVOLA
Bruschetta with Spicy Sauce
BRUSCHETTA AI FUNGHI PORCINI
Bruschetta with Porcini Mushrooms

INSALATA MISTA CON POMODORO
Mixed Green Salad with Tomatoes

Secondi di mare / Sea second courses

Grigliata mista di pesce con calamari, gamberi e orata.
€ 13,00 **Mixed grilled fish with calamari, crayfish and golden maid.**
Gamberoni rossi in fascia di pancetta croccante.
€ 9,00 **Big red crayfish wrapped in crisp bacon.**
Filetto di tonno sul letto di rucola riduzione di aceto balsamico.
€ 9,00 **Tuna filet in rocket bed with a balsamic vinegar reduction.**
Bocconcini di tonno con granella di mandorle e pinoli.
Tuna bits with almonds and pine-seed grain.
Filetti di rombo in crosta di patate dorate.
€ 9,00 **Rhombus filet in golden potatoes crust.**

Dolci / sweetne

Elogio al cioccolato
€ 20,00 **Praise to the hot ch**
Cestino di frolla con
€ 18,00 **Puff pastry basket w**
Tiramisù classico al c
€ 19,00 **Classic tiramisu.**
Sorpresa di millefogl
€ 20,00 **Milfoil surprise with**
Delicata mousse ai 3
€ 18,00 **3 chocolates delicate**

Far left. A recreated (with dummy text) table of contents from a well-known book on design. The page numbers are very far from the titles to which they refer.

Center left. Compounding visual ambiguity with the annoying technique of connecting the titles to their page numbers with leader dots.

Left. The use of flush right folios and flush left titles makes the table of contents easier to use and uses space economically.

(Dis)organization and proximity

Cesena	v	Juventus
Lecce	0-2	Napoli
Milan	v	Genoa
Novara	2-1	Lazio
Palermo	1-2	Parma
Roma	1-1	Fiorentina
Siena	1-1	Bologna
Udinese	1-3	Internatzionale

Maybe not perfect, but close enough, the "football" scores on BBC-World. While it does not conform to everyone's way of describing a score, the centered panel gives an immediate overview of the match—almost without regard to the partici-pants, who are second in the hierarchy—in an efficient, intui-tive way: "Novara 2–1 Lazio." I would like to see the winner always on the left, unless this arrangement is a clue to home and away teams.

Justified typesetting has been a longstanding convention since the invention of moveable type (and, in calligraphy, even earlier) for no better reasons than it being easier to lock up a justified form in letterpress and the opinion (not mine) that it looks better. Esthetics notwithstanding, the preference for rivers of white space in the body of a column rather than a ragged right edge (in Western languages) is in most cases not an important issue, regardless of the high level of pas-sion attached to it.

However, in tables of contents (print or screen), lists, menus, stock quotes, sports scores, and—in the past—telephone directories, flush left–flush right has real implications.

In any arrangement of text or groups of text, there is figure and ground, positive and negative, information and empty space. How that information and that empty space is con-figured makes it easier or more difficult to see relationships and to understand the information. White space often has the unintended consequence of separating text items that should be read together and grouping items together that belong in different categories or relate to text in different columns.

The long tradition of flush left–flush right is often the cause of ambiguity and confusion, in the horizontal displays of sports scores—where there is often very little time to relate the numerical score to the team to which it belongs—and in tables of contents with multiple columns. Illogical vertical spacing can impede the correct association of elements with each other, in menus with multiple languages, for example.

Leader rules—those annoying strings of dots often seen in tables of contents—recognize the inherent problem of certain flush left–flush right situations without solving it: they make each connection marginally clearer but do nothing to enhance the overall sense of order and logic of the page and reduce reading time.

Read Jan Tschichold. *Asymmetric Typography.*

See also Too many numbers.

We tend to group like with like; careful spacing, both horizontal and vertical, and the careful use of rules can aid in communicating how the compo-nents of information sets are grouped.

119

The Museum of Modern Art has recently placed labels for art on the walls a bit away from the art itself, presumably to reduce distraction. At the same time, the label for free-standing sculpture is immediately adja-cent to the painting's label. One may assume that the two labels both refer to the painting on the wall.

A page from the students' explanation of their analysis and thought process, this page dealing with a leaflet for Coumadin prepared in Microsoft Word. The original document is shown in the lower left corner, and the callouts describe their analysis and enhancements.

An analysis of a commercial pharmacy chain's medical leaflet for Lexapro, finding redundancy and an absence of rational structure.

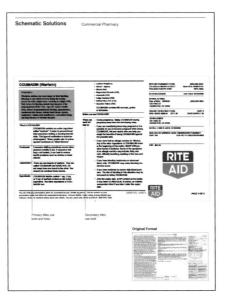

The students' solution for the commercial chain's medical leaflet analyzed at far left. Information has been prioritized, and the hierarchical sequence is legible and clear. Their use of a two-column grid reduces unreadably wide lines of type.

Rational hierarchies

The students' final proposed medical leaflet for Coumadin, designed in Microsoft Word with fonts available on every PC and Mac.

When you fill a prescription at a pharmacy, accompanying the drug will be a medical leaflet that carries the usual prescription information that's on the bottle (your name, prescribing doctor's name, name of drug, strength of drug, quantity, number of times per day, and—if the drug is a soporific—a small label not to operate heavy machinery), as well as up to several pages of detailed information, not particularly well organized, really repetitive, boring, and with only the most rudimentary sense of a hierarchy of importance. Inasmuch as these leaflets (also called patient information leaflets) are required so that the patient uses the drug correctly and understands dosages, side effects, and what to do in case of a negative drug reaction, it would stand to reason that they be designed to be clear, legible and easily readable, and with a clear sense of a hierarchy of importance.

Redesigning these brochures is not as easy as it may seem, if one is designing to the world's reality rather than a typographer's esthetic. Although these leaflets are written by the pharmaceutical manufacturer using what seems to be a somewhat unsophisticated template, their design and production are extremely constrained. The students discovered at least three variants of size, form, output device, and font, and they designed to those three, without any confidence that there aren't additional templates and output devices waiting to be addressed.

Information design is the application of form appropriate to content and user. So the students acted as copy editors as well as designers (if there's really a difference), rewriting the words, creating a textual as well as visual hierarchy, and staging the information so that it would have the greatest usefulness. They designed three specific formats for three pharmaceuticals of varying complexity and potential risk.

See also Worlds in collision; An intelligible ballot; Understanding audience needs; Staging information.

We can be overwhelmed by the typographic options available to us when we can control them. Designing in the real world, where font choice (and cut) are often extremely constrained, requires discipline, commitment, and imagination.

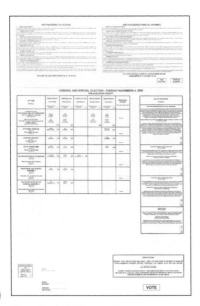

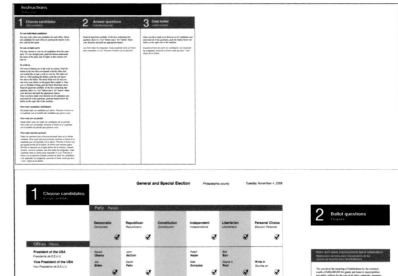

Above. The ballot in use in the autumn of 2008.

Right. The same ballot redesigned by the students.

Revised instructions

Each step in the ballot is labeled with a number that corresponds to the instructions.

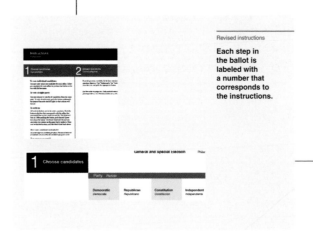

Right. A frame from the students' digital presentation of their ballot analysis and an explanation of their solutions.

Below right. A spread from the students' print presentation.

Every silver lining has a cloud. The Committee of Seventy, a voting watchdog group, made an effort to have this design adopted in future Philadelphia elections, but it was determined that the city's voting machines have an integrated unchangeable ballot format.

An intelligible ballot

In their analysis, which they prepared in both digital and print form, the students identified and addressed the following issues:

- A difficult-to-understand grid because of the visual similarity of rows and columns;

- Inadequate distinction between office, party, and candidates' names;

- Redundant information;

- The square indication for the button does not look like a button, which is usually round;

- Confusing instructions because they are not clearly worded, set in too small a font, and containing useless noninformation;

- Ballot questions are aligned center, making them difficult to read, and there is no typographic differentiation between English and Spanish;

- The vote button is out of the user's normal field of vision.

The students perceived that voting is a three-step process:

- Choose and select your candidates;

- Read and select your answers to the questions;

- Push the "vote" button to register your vote.

We all learned what a dysfuctional ballot is in the 2000 presidential election. That is unlikely to happen again anytime soon, but ballot designs in the United States—and certainly in Philadelphia—are not likely to win any prizes for clarity and intuitiveness. There are a number of reasons, and it is hard to assign blame, but—not completely unlike Philadelphia's parking signs, discussed on pages 26–27—one suspects a combination of the absence of designer input upstream, the impracticality of frequent hardware updates, the costs of making changes to off-the-shelf software bundled with expensive hardware, and—let's not forget this one—politics.

The existing voting machines in Philadelphia are not new and come fully equipped with an extremely constraining application utilizing a rigid grid and painful uniformity of type fonts and sizes. This prevents both communicative typography and the use of effective negative space to communicate a hierarchy of information; so, rather than being able to create different relationships between rows and columns, one is left with a structure of uniform boxes with identical horizontal and vertical bounding lines.

Add to this (and this is no one's fault, unless you count human nature) the fact that the importance of a candidate's placement on the ballot is documented. As a result, each candidate's position on the grid is chosen by lot (not unlike the drawing for dorm rooms and roommates in college), rather than by any sensible or logical order.

It's not the voting that's democracy, it's the counting.

Tom Stoppard
Jumpers

When integrating instructions and a grid of choices, it is helpful to break the process into simple, discrete, sequential steps.

Read Marcia Lausen. *Design for Democracy: Ballot and Election Design.*

See also Worlds in collision; Rational hierarchies; Understanding audience needs.

123

Far left. An analysis of reasons for likely voter confusion in Florida in the 2000 presidential election.

Left. The infamous Florida butterfly ballot of 2000.

Below. A cartoon accurately showing the impact of the butterfly ballot.

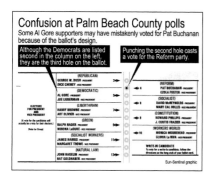

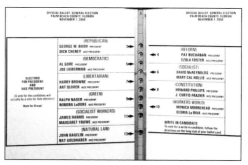

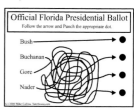

4 : STRUCTURE, ORGANIZATION, TYPE

THE SCHOOL DISTRICT OF PHILADELPHIA
440 N. Broad Street
Philadelphia, PA 19130

Evaluation Report

Student Name: Ronald
Current School Assignment:
School
Student ID:
Regional Office:
PA SecureID:
County of Residence: Philadelphia
DOB
Grade:
School Address:
School Phone:
Philadelphia, PA
Age:

Date of Report: 12/02/2009
Date Report Provided to Parent/Guardian/Surrogate: 12/02/2009
Local Education Agency (LEA): The School District of Philadelphia
Current Educational Program: General Education

Name and Address of
Phone (Home):
Parent/Guardian/Surrogate:

Phone (Work):

Complete Sections 1 through 6 for all students.
If determining eligibility for Specific Learning Disability (SLD), the SLD component near the end of this document must be completed and used to complete sections 5 and 6.

1. **REASON(S) FOR REFERRAL:**
Recommendation of CSAP Team following Tier I & Tier II interventions. Behavioral and academic difficulties.

2. **SOURCES OF EVALUATION DATA:** In interpreting evaluation data, the school must draw upon a variety of data sources, including those listed below, and carefully consider the information obtained. Document the information obtained from the sources below.

A. Evaluations and information provided by the parent of the student (or documentation of LEA's attempts to obtain parental input):
A Parent/Guardian Input Form completed by on 11/4/09:
Ronald's strengths were described as: Ronald is a fast learner in subjects that interest him.
Ronald is believed to be on target for his age/grade in reading and math.
Ronald's learning problems in writing/spelling are describe as: Ronald will not write at all. He refuses to even try to print.
Ronald's behavior problems are described as: To numerous to list here. Ronald is having a very hard time acclimating in school.
Outside individuals/agencies providing services to Ronald are described a: Ronald is receiving therapy at Empowermentville & scheduled for an evaluation there on 11/19/09.

Evaluation Report

About this report

The Evaluation Report is completed to document the process in which an evaluation team, defined in Federal and State regulations as a group of qualified professionals and the parent of the student, determine if the student is a student with a disability and in need of special education services. This form is used only when evaluating a student who is not yet identified as a school age special education student.

Under Pennsylvania regulations, a certified school psychologist is a required member of the evaluation team when evaluating a student for autism, emotional disturbance, mental retardation, multiple disabilities, other health impairments, specific learning disability, or traumatic brain injury.

Student information

Student Name: Christopher Jones
Date of Report: 01/15/2010
Student Birth Date: 01/01/2003
Age: 7 Grade: 2
Local Education Agency (LEA):
The School District of Philadelphia
School Student is Attending:
Philadelphia Elementary School
Current Educational Program:
General Education
County of Residence: Philadelphia

Name of Parent/Guardian/Surrogate:
Harriet Jones
Date Report Given to Parent/Guardian/
Surrogate: 2/01/2010
Address of Parent/Guardian/Surrogate:
1234 N 5th Street
Philadelphia, PA 19100
Phone (home): (215) 555-7693
Phone (work): (267) 555-8532

The Six W's
Basic answers for simple questions.

WHY — Why was my child referred for evaluation?
Christopher was referred due to behavioral and academic difficulties.

WHO — Who provided input about my child?
Parents, teachers, school psychologists, etc.
See pages 3-8 for the detailed input.

WHEN — When was my child evaluated?
Christopher was tested on separate occasions between November 5th and December 12th, 2010.

WHAT — What were the evaluation results?
Christopher was diagnosed with Autism and speech/language impairment.
See page 17 for more information

WILL — Will my child be eligible for special education?
YES. Christopher is in need of specially designed instruction and is eligible for special education.

WHERE — Where can I learn my rights?
A detailed packet accompanying this evaluation report will have the information needed to learn about you and your child's rights. You can also call (800) 555-5555 to be connected to the School District of Philadelphia education hotline.

Overall scores

Standard scores are based on a scale of 0-130.

- Mentally Gifted — 130
- Above Average — 100
- (50)
- Average
- (25)
- Below Average — 16
- Learning Disabled
- Intellectual Disability — 2 / 0

Column headers: Standard scores · Cognitive Ability RIAS · Visual Performance BEERY-VMI · Academic Achievement WIAT-II · Autism Rating Scale GARS-2 · Speech & Language TELD-3 · Speech & Language TACL-3 · Speech & Language OWLS

Cognitive ability continued

Composite Norm-Referenced Interpretations

Christopher's RIAS percentiles

On testing with the RIAS, Christopher earned a Composite Intelligence Index (CIX) of 68. On the RIAS, this level of performance falls within the range of scores designated as significantly below average and exceeds the performance of 2% of individuals at Christopher's age. The chances are 90 out of 100 that Christopher's true CIX falls within the range of scores from 65 to 74.

Christopher earned a Verbal Intelligence Index (VIX) of 51, which falls within the significantly below average range of verbal intelligence skills and exceeds the performance of less than one percent of individuals Christopher's age. The chances are 90 out of 100 that Christopher's true VIX falls within the range of scores from 48 to 60.

Christopher earned a Nonverbal Intelligence Index (NIX) of 92, which falls within the average range of nonverbal intelligence skills and exceeds the performance of 30% of individuals Christopher's age. The chances are 90 out of 100 that Christopher's true NIX falls within the range of scores from 87 to 96.

Christopher earned a Composite Memory Index (CMX) of 91, which falls within the average range of working memory skills. This exceeds Christopher's performance of 27% of individual Christopher's age. The chances are 90 out of 100 that Christopher's true CMX falls within the range of scores from 86 to 97.

CIX VIX NIX CMX

THE SCHOOL DISTRICT OF PHILADELPHIA
440 N. Broad Street
Philadelphia, PA 19130

Evaluation Report

standard conditions used

4. **DETERMINING FACTORS** - A student must not be found to be eligible for special education and related services if the determining factor for the student's disability is any of those listed below. Respond Yes or No to, and provide evidence for, each determining factor below.

[] Yes [X] No Lack of appropriate instruction in reading, including the essential components of reading instruction:
Provide Evidence:
Core curriculum used.

[] Yes [X] No Lack of appropriate instruction in math:
Provide Evidence:
Core curriculum used.

[] Yes [X] No Limited English proficiency:
Provide Evidence:
English-speaking only.

NOTE: IF DETERMINING ELIGIBILITY FOR SPECIFIC LEARNING DISABILITY, COMPLETE THE DETERMINATION OF SPECIFIC LEARNING DISABILITY COMPONENT AT THE END OF THIS DOCUMENT BEFORE COMPLETING SECTIONS 5 and 6.

Complete Sections 5 and 6 for all students.

5. **SUMMARY OF FINDINGS/INTERPRETATION OF EVALUATION RESULTS** - Considering all available evaluation data, record the team's analyses of the student's functioning levels.

A. **PRESENT LEVELS OF ACADEMIC ACHIEVEMENT** - Describe the student's present levels, strengths, and the resulting academic needs, when appropriate. Include communicative status, motor abilities, and transition needs as appropriate. For students with limited English proficiency (LEP), include current level(s) of English language proficiency in reading, writing, speaking and understanding/listening:
_____ is a 6-year-old boy at _____ appears to have a relative strength for problem-solving/abstract reasoning and short-term visual memory when presented with less verbally loaded material, reaching the average/above average range, and a relative weakness on verbally-loaded knowledge and tasks (e.g., vocabulary words). His weaknesses in verbally related tasks appear hampered by social and communication difficulties. Such difficulties (e.g., echolalia, eye contact, limited gestures) are supported by observed and measured rating scale. Collectively, _____ appears to display characteristic features of autism. His need for specially designed instruction to address his related needs appears necessary. Particular areas that would benefit from special attention should include writing, social, communication and behavioral skills.

B. **PRESENT LEVELS OF FUNCTIONAL PERFORMANCE** - Describe the student's present levels, strengths, and the resulting functional and developmental needs, when appropriate:
SEe notes above.

Understanding audience needs

Facing page, top row left. The existing form has nothing that can be called a cover: it just starts.

Top row center. The students' design for the cover clearly sets out the nature and substance of the report.

Top row right. One of many innovations by the students was to explain in very simple language why the evaluation was ordered, what it means, and what the options for parent and student are. A navigational running header displays where the reader is in the report by section.

Facing page, center row. An extremely important aspect of the students' design is a series of graphs that visually shows the scores of the tests and simultaneously positions the evaluated child in the context of his peers.

"Special needs" is one of the euphemistic descriptions for children (and adults) who have difficulty functioning in the world occupied by—and meeting the expectations of—the majority of us. Each child's particular personality characteristic that leads to difficulty and corresponding educational need must be communicated to his parent or guardian in an understandable, meaningful, and effective way. Often, the parent, too, has difficulty understanding this information for any number of reasons, such as concern and anxiety for the child, limited educational attainment, language skills, jargon used in the report, and the form's intimidating density and complexity. It is well known that students whose teachers request a special needs evaluation are disproportionately male and of racial or ethnic minorities.

The current form used by the School District of Philadelphia appears to be written for, as well as by, the evaluators who gave and analyzed the tests and the teachers who initiated the evaluation.

The design students approached this form by thinking of the user and what would help parents understand information about their child that at best is complex, terminologically arcane, and carries with it highly emotional baggage. Their solution, compared to the form currently in use, utilizes rational and transparent organization, typographic hierarchy, and the visualization of numbers—absent in the current evaluation template—especially important in a report where tests are scored on the basis of 130 rather than the familiar 100.

Trying to understand the needs of the user and the context in which the design is used will foster a deeper understanding of design function and empathy with the user.

Read Diane Ravitch. *The Death and Life of the Great American School System: How Testing and Choice Are Undermining Education.*

See also Worlds in collision; Rational hierarchies; An intelligible ballot; Staging information.

125

Facing page bottom row. The existing conclusions page is disorganized and lacks appropriate emphasis.

Left. The students' design of this page makes the conclusions clear.

The original hospital dashboard in use at the time—with simulated data—is characterized by inconsistent and counterintuitive bar charts and other ambiguities.

An alternative solution, using a horizontal rather than a vertical "0" line. Forcing the type into a nearly vertical orientation was felt to make reading difficult and constrain ease of use, although the vertical bars were a helpful element related to our conventions for the y-axis..

The final proposed dashboard, featuring a rational organizational structure and an absolutely clear visual explanation of performance relative to target goals.

The detail for each category is accessed by mousing over the category and clicking.

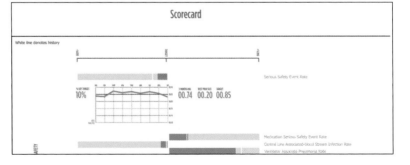

Staging information

It is extremely important for hospitals to maintain and communicate a wide range of performance issues on a regular and frequent basis, with the least amount of lag between the period of analysis and internal posting. A hospital agreed to let a team of students tackle its "dashboard," the internal document to which all physicians and staff have access, and which is used to gauge continued improvement, progress toward goals, and revised performance benchmarks.

The existing dashboard exhibited serious symptoms of information overload, and was characterized by ambiguous and inconsistent notation and too many numbers. One of the most confusing aspects was that good performance and bad performance relative to goals was sometimes on the left and sometimes on the right of the bar graph, depending on whether the target performance was a high number or a low number. The first change the students made was to set a hypothetical vertical target line (not unlike a "0") from which a negative performance bar (always red) moved to the left and a positive performance bar (always green) moved to the right. Type was legibly and uniformly structured, with data categories and subcategories clearly differentiated.

Recognizing that different user segments needed different depths of detail, the students placed the trend graph and related numerical data on a category-specific pop-up activated by a rollover. This maintained an accessible and unthreatening overall appearance to the dashboard while providing access to the same amount of detail that existed on the original.

Many of the characteristics of screen interactivity permit hierarchies of information to be layered corresponding to the size of each audience segment. Waterfall menus and drop-down windows can add important functionality to accessing large quantities of data.

See also Worlds in collision; Information overload; Too much information; Too many numbers; Rational hierarchies; An intelligible ballot; Understanding audience needs.

Alternative typography that was explored.

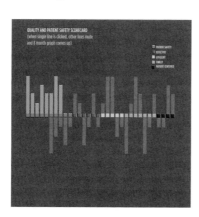

Different color palettes were investigated. For ease in printing and updating, a white-background option was selected.

Top row. Between 1974 and 1979, the AIGA, in collaboration with the U.S. Department of Transportation, produced 50 standard symbols to be used on signs.

From the perspective of 2012, the symbols with people appear stiff and clunky. In recent years, institutions, notably museums, have redrawn these pictogram sets so that the people are less blocky and more animated. In the center row is the set of pictograms from the Museum of Modern Art in New York. The person in the wheelchair is particularly animated, instead of sitting passively and motionless. Additionally, MOMA has added a family pictogram.

Bottom row. Le Centre Pompidou in Paris uses its own family of pictograms, characterized by the upper body rendered as negative space. As is true for many sets of symbols utilizing the human figure, interpretation becomes more difficult as activities are added (later, it appears). The Pompidou pictograms often work, and sometimes they work less well; sometimes their subjects appear to be in bathing suits.

The pictograms at far left are used in the Museo d'Arte Contemporanea Donnaregina in Naples. Within their restricted applications, they are both elegant and appropriate for their environment. It would be interesting to see efforts to broaden the pictogram set using the same vocabulary.

Near left. At the MACRO in Rome: Italian enthusiasm, brio, and really little heads.

Synechdoche

Two of the more interesting toileting pictograms that have come my way over the years, sources unknown.

An illustration rather than a pictographic men's bathroom sign at a favorite Paris restaurant.

A particularly imaginative and entertaining use of the inverted heart shape on a temporary portable bathroom at a construction site in Paris.

Bathroom pictograms are an excellent example of synecdoche, where the entire human figure—specific to gender (always), age (sometimes), and disability (always)—is used to describe the location of toilets. This custom of synecdoche is universal, notwithstanding designer jokes using sexual organs or other gender toileting differences.

Between 1974 and 1979, the AIGA, in collaboration with the U.S. Department of Transportation, produced 50 standard symbols to be used on signs, among them man, woman, baby, and wheelchair. The pictograms were clear, used a minimum of geometrically drawn shapes, made a harmonious "alphabet," and appeared to be culturally universal (a monumental achievement). They were also of their time, a bit static, clunky, and lacking in elegance. Consequently, and not surprisingly, subtle rogue and enhanced redesigns began to arise, often by museums and cultural institutions, perhaps in an effort to individualize their vocabulary of visual symbols.

The choice of a visual vocabulary for bathroom pictograms carries the risk that it will not be adequately adaptable to an expanded symbol set unanticipated when the vocabulary was originally developed: there is a significant difference between developing a pictographic vocabulary of four people who are standing or in a wheelchair and a set of symbols of people doing things (holding the escalator rail, pushing strollers). The complete breadth of the symbol set for the Olympic games is known in advance, as was the extent of the Mexico City subway in 1968, so the designer can develop a vocabulary that will work in every component pictogram.

Read Rayan Abdullah. *Pictograms, Icons, and Signs.*

Go to http://www.toegankelijk brugge.be/en/pictogrammen.htm

http://signitecture.blogspot. com/2011/02/tracing-accessibility. html

http://www.aiga.org/symbol-signs/

See also Emotional power; Is a picture worth 1,000 words?; Page 204 center.

Quaint pictograms on the bathrooms at Père-Lachaise cemetery in Paris.

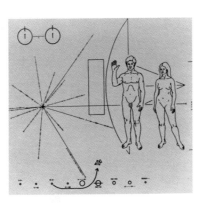

The Pioneer F spacecraft, destined to be the first man-made object to escape from the solar system into interstellar space and launched in 1972, carries a pictorial plaque (a detail is shown at left). Suggested by Eric Burgess, the graphics were devised by Carl Sagan and Frank Drake in only three weeks. Some opposition was directed at the portrayal of a naked man and woman, described by one critic as "sending smut to the stars."

The David H. Koch Hall of Human Origins in Washington includes this 30,000-year-old handprint from France.

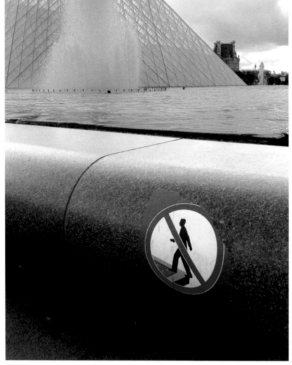

No walking on water.

The meaning of this pictogram in Barcelona is not difficult to figure out, given the limited number of options. Its drawing, however, might suggest something very different if taken out of context. For example, if your dog poops, smash your fist into it; or, if walking with a dog, stop to admire piles of little cannonballs.

Olympic pictogram sets are a fascinating study in design intelligence, design playfulness, and every designer's desire to create something new, better, and at the very least different from what was designed four years previously.

Some sets are clearly better than others—with a more coherent vocabulary, an absence of excessive decoration, and the sense of movement and action characteristic of almost all sports.

Below is a comparison of five sports from 11 of the Olympic pictogram sets.

This pictograph is one of a set of medical facility pictograms developed by a partnership between Hablamos Juntos and SEGD. The review committee—just as the review committee for AIGA Symbol Sign some 35 years earlier—reads like a Who's Who of information design. That said, and with all due respect, many of them don't work for me, including this one, for Outpatient Services. Although I've never had a broken arm, my guess that it would be set at the Emergency Room.

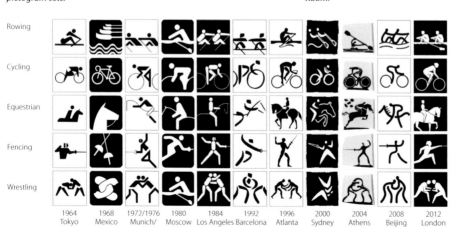

	1964 Tokyo	1968 Mexico	1972/1976 Munich/ Montreal	1980 Moscow	1984 Los Angeles	1992 Barcelona	1996 Atlanta	2000 Sydney	2004 Athens	2008 Beijing	2012 London
Rowing											
Cycling											
Equestrian											
Fencing											
Wrestling											

Could there be a greater joy than designing a set of pictograms for an Olympics? It's a win-win:

All the human figures are the same;

The audience knows the actions being depicted;

The designer knows all the variations before beginning the set;

The set is complete when the designer finishes it;

No surprises. (Well, there are always surprises, but not by definition in this case.)

Is a picture worth 1,000 words?

This pictogram (from Paris) is problematic for two reasons: the frontal view attempts to illustrate walking by making one leg appear shorter than the other; the holding of hands may be ambiguously suggestive of an improper relationship. I have always described this graphic as "Men with one leg shorter than the other may not kidnap young girls with one leg shorter than the other."

Many more recent signs with the same message show the two figures no longer holding hands.

This joke pictogram is one of 15 appearing in Print Magazine *sometime in the '80s, date and designer untraceable. This one is "Village made entirely from soap, 5 kilometers." The bathroom pictograms in this set are exactly what you would expect.*

Pictograms have always been used to compensate for an absence of text because of illiteracy or language differences (or, in the case of cave paintings—the original pictograms—the absence of written language altogether). The efficacy of pictograms can be compromised by multiple factors:

- Ambiguity or misinterpretation due to weak drawing or unrecognizable simplification (not looking like what it's supposed to mean);

- Ambiguity or misinterpretation due to simplification (looking like something different in the user's experience than in the designer's experience);

- Offense or confusion caused by misinterpretation due to cultural or religious differences or beliefs.

We have all received e-mails or links that show pictograms so absurd that we have no idea whether they are real or not. The pictographic movement (if you will) is based on the need to communicate across language, literacy, and cultural differences as the world becomes more international and travel to lands with different languages—even different alphabets—is continually increasing.

Like many design movements, this one's reach may exceed its grasp. Original pictographic and ideographic writing and drawing was developed and used within a homogeneous and comparatively small cultural universe, in ancient and medieval times made even smaller by literacy limited to upper and priestly classes. The concern for the safety and comfort of travelers that gave us the USDOT pictograms in the 1970s utilized a simple visual vocabulary to communicate simple concepts: a wheelchair, a baby, a flight of stairs, an escalator, a fork and knife, a cup of coffee. Nothing unfamiliar or conceptually challenging there.

Pictographs are now applied to increasingly complex actions and movements. Some of these require complete frontal and side views of people doing things and interacting with others and with objects and equipment that may not be recognizable in other countries and cultures (or even in our own). As a result, the pictography movement, particularly in health care contexts, may be approaching (or in some cases have exceeded) the limits of its communicative abilities.

The universal intelligibility of a pictogram is inversely proportional to its complexity and potential for interpretive ambiguity.

As the complexity of our world increases, along with the need to communicate more complex ideas, regulations, services, objects, and processes, the risk of compromised intelligibility increases proportionately if not exponentially. A pictogram that has to be learned is not intuitive enough to transcend language barriers; how and where will the learning take place?

Read Catherine Davidson. *The Directory of Signs and Symbols.*

Ultimate Symbol. *Official Signs & Icons 2.*

Pictogram and Icon Graphics.

Go to http://www.segd.org/learning/hablamos-juntos.html

See also Emotional power; Synecdoche.

307 Protruding Objects

307.1 General. Protruding objects shall comply with 307.

307.2 Protrusion Limits. Objects with leading edges more than 27 inches (685 mm) and not more than 80 inches (2030 mm) above the finish floor or ground shall protrude 4 inches (100 mm) maximum horizontally into the *circulation path*.

EXCEPTION: Handrails shall be permitted to protrude 4½ inches (115 mm) maximum.

Advisory 307.2 Protrusion Limits. When a cane is used and the element is in the detectable range, it gives a person sufficient time to detect the element with the cane before there is body contact. Elements located on circulation paths, including operable elements, must comply with requirements for protruding objects. For example, awnings and their supporting structures cannot reduce the minimum required vertical clearance. Similarly, casement windows, when open, cannot encroach more than 4 inches (100 mm) into circulation paths above 27 inches (685 mm).

Figure 307.2 Limits of Protruding Objects

307.3 Post-Mounted Objects. Free-standing objects mounted on posts or pylons shall overhang *circulation paths* 12 inches (305 mm) maximum when located 27 inches (685 mm) minimum and 80 inches (2030 mm) maximum above the finish floor or ground. Where a sign or other obstruction is mounted between posts or pylons and the clear distance between the posts or pylons is greater than 12 inches (305 mm), the lowest edge of such sign or obstruction shall be 27 inches (685 mm) maximum or 80 inches (2030 mm) minimum above the finish floor or ground.

EXCEPTION: The sloping portions of handrails serving stairs and *ramps* shall not be required to comply with 307.3.

Figure 307.3 Post-Mounted Protruding Objects

307.4 Vertical Clearance. Vertical clearance shall be 80 inches (2030 mm) high minimum. Guardrails or other barriers shall be provided where the vertical clearance is less than 80 inches (2030 mm) high. The leading edge of such guardrail or barrier shall be located 27 inches (685 mm) maximum above the finish floor or ground.

EXCEPTION: Door closers and door stops shall be permitted to be 78 inches (1980 mm) minimum above the finish floor or ground.

Figure 307.4 Vertical Clearance

307.5 Required Clear Width. Protruding objects shall not reduce the clear width required for *accessible* routes.

132

Summary diagram for 307 Protruding Objects

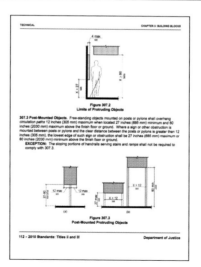

Overhead objects.
The bottom edge of an overhead object may not protrude below 80"

80" (2030 mm)

⚠ **Regulated projection zone: 27" to 80"**

Max. 4" (100 mm) protrusion of leading edge for wall-mounted objects

Max. 4 ½" (115 mm) protrusion for handrails

27" (685 mm)

Feet

Max. 12" (305 mm)

Max. 12"

Max. 12"

Over 12"

Over 12"

Scale 1/2" = 1'-0"

Freestanding objects in circulation paths
A freestanding object with either one or two posts must not project more than 12" from the side of the post if the object's bottom edge is between 27" and 80" above the finished floor and in a circulation path.

If a sign includes two posts and the bottom sign edge is between 27" and 80" above the finished floor, then the space between posts must not exceed 12" in width.

Luminant Design note: Placing a bar inside two posts with the bottom edge at or below 27" would make compliant an over-width sign whose bottom edge is in the regulated projection zone. Similarly, adding a suitably-sized projecting strike bar at or below 27" on an over-width single post sign would make it compliant.

Version 2.1 Click here to verify if up to date

Page 9

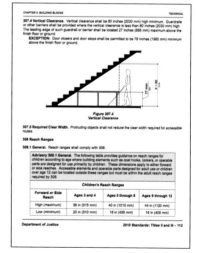

Top. A page from Luminant Design's re-presentation of the 2010 ADA Standards for Accessible Design. *William Bardel writes:*

"'Signage and the 2010 ADA Standards for Accessible Design' is a document conceived out of the frustration of having to process too much complicated text. Designers, architects, engineers, and other planners tend to be visually oriented people. From napkin sketches to architectural plans and shop drawings, we think and speak in a visual language as we imagine and build visual things—even for the use of those with vision impairment. The document is an experiment in making a text-heavy code easier to read and use by aligning its visual form with how designers think and work (visually). The intended goal is facilitating the design process to better facilitate answering the needs of people with disabilities."

Above. The pages dealing with the same material in the ADA document.

Visualizing regulations

How much do you want the government helping you design? ADA guidelines and the MUTCD (Manual on Uniform Traffic Control Devices, *published by the Federal Highway Administration) both offer rational guidelines that have been exhaustively researched and tested. They are valuable tools that, respectively, help promote the integration of the disabled into our society, and ensure legibility and consistency in our country's network of interstate highways.*

An example of the FHWA's diligence is partially adopting the Clearview Hwy font—developed by independent researchers with the assistance of the Texas Transportation Institute and the Pennsylvania Transportation Institute under FWHA supervisions—for use on positive contrast road signs.

Bureaucracies are by definition self-perpetuating and, like the universe, expanding. Bureaucrats maintain their jobs by expanding their areas of oversight, developing standards and guidelines, and writing manuals of continually increasing length to communicate them.

The public needs to be protected from less than competent design; really good designers (even moderately good designers) need to be able to design for the public good with both baseline performance and place specificity that contribute so much to the surprise and delight of travel.

How do you design performance guidelines that communicate the performance without the necessity of designing examples that communities (and states) will interpret as designs rather than as examples of performance criteria?

Problems arise, I believe, when examples illustrating performance criteria and objectives become confused with mandated, or even recommended, designs themselves. At this point community vehicular wayfinding signs in Omaha will look the same as they do in New Hampshire, which, regardless of quality, will get boring quickly. Any designer of information needs to seriously consider how to distinguish the performance criteria from the design, and so do the FHWA and state departments of transportation.

Design is intelligence having fun.

Lou Danziger

Design is the intelligent response to uncertainty.

Gregorio Rivera in conversation with Nathan Felde

Go to and read http://www.ada .gov/ (an amazing beast of a home page; fair warning)

http://mutcd.fhwa.dot.gov/ pdfs/2009/mutcd2009edition.pdf

Go to http://www.luminantde- sign.com/studies/adastudy.html

See also Signs and arrows; Sans serif (for Ckearview Hwy).

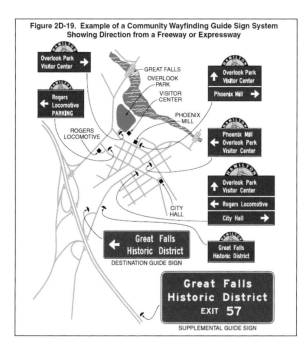

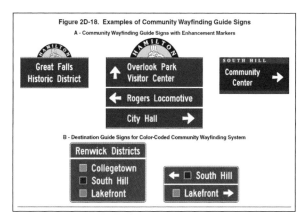

Left and above. Two pages from the most recent Manual of Uniform Traffic Control Devices.

When the visual and the aural conflict. *The audience can listen to a speaker only if it is not distracted by trying to read a complicated slide full of words.*

Focus and distraction

Multitasking is an activity that—bombarded by an ever-increasing amount of stimuli—we seem to be getting better at, at the very least as a survival strategy. The inability to multitask used to be described, in a simpler day, as being unable to walk and chew gum at the same time. For many of us, certain kinds of multitasking is simple—reading with music in the background, for example; other kinds of multitasking are more difficult.

One of the more challenging examples of multitasking is to read text and listen to a lecture at the same time, and to absorb and understand both fully. Yet, we continue to create and attend presentations with text heavy slides and/or complex graphics on the screen while the speaker is reading those words (or others) and then expounding on them in detail. How do the members of the audience comprehend both simultaneously? The answer is, they don't.

Much has been written about the constraints on Powerpoint-like slideshows required for effective communication, yet slides with a mind-numbing number of words keep being projected while the presenter's voice drones on.

In a room not so dark that it encourages the audience to fall asleep, a subject-only slide, or only a graph needing visualization, are reasonable limitations to help the audience understand complementary information being presented orally and visually simultaneously, reducing the risk of mutual interference.

Read Edward R. Tufte. *The Cognitive Style of PowerPoint: Pitching Out Corrupts Within* (2nd edition).

Go to www.edwardtufte.com/tufte/powerpoint

See also Generations of labeling; Too much information.

> Get rid of half the words on each page, then get rid of half of what's left.
> **Steve Krug**
> *Don't Make Me Think*

> How many words are appropriate for a PowerPoint slide?

> As few as absolutely possible.

Moving targets. What do you do when the word you're trying to select runs away from you? These three captures deal with the relationships among characters in Greek mythology. You get more information when you select a name—if you can catch it.

Apostrophe

Foot mark or prime mark;
NOT an apostrophe

Acute accent
(*Accent aigu,
accento chiuso*);
also NOT an apostrophe

Grave accent
(*Accent grave,
accento aperto*);
also NOT an apostrophe

Quotation marks

Inch marks or double
prime marks;
NOT quotation marks

Comma

Italic prime or foot
mark pretending to be a
comma, which it is NOT

Hyphen;
NOT a dash

En, or "nut" dash;
NOT a hyphen

Em dash;
definitely NOT a hyphen

Some of the confusion in typesetting by computer in unsophisticated applications or by unsophisticated typists.

Please Ring
Bell For
Assistants

"Don't write naughty words on walls if you can't spell," Tom Lehrer sang. One might question whether this is an accidental misspelling or a joke appropriate for an Irish pub. Our waitress suggested it is an unintentional mistake.

The Protean (non)apostrophe.

Language and grammar

When typesetters set our type, they were trained to know the difference between a foot mark and an apostrophe, between an apostrophe and a beginning single quote, and between a hyphen and a dash (en or em).

The computer has rendered some of those distinctions moot, often depending on the knowledge and education of the typist and the sophistication of the application (which the typist has to know how to control). Word completion software has not made life any easier for those texts on a complicated subject with its own specific (and generally unfamiliar, at least to the application) vocabulary.

Paul Rand's work—even at its most corporate—displayed intelligence, wit, and a lively sense of humor. Much of his work for IBM could be endearingly playful as well as visually sophisticated.

Read *The Chicago Manual of Style* (16th edition).

William Strunk and E. B. White. *The Elements of Style* (4th edition).

William Strunk Jr. and Maira Kalman. *The Elements of Style Illustrated.*

See also Page 205 bottom left.

Below top. Paul Rand's iconic visual pun for IBM.

Below bottom. When I was asked by AIGA Philadelphia to design the poster for Paul Rand's visit to Philadelphia, I had nightmares that he marched to the podium and savaged it in front of the entire audience. Actually, he was quite gracious, more so than when he was my professor at Yale.

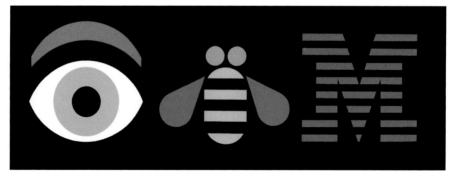

Politeness and fascism. There are many ways to express a prohibition. "Interdite" and "vietato"—forbidden, prohibited—are on the familiarly strong side. The pictogram is neutral and engaging. The British are always polite. My favorite, second from the top, is in the Place des Vosges in Paris—"The grass is resting."

The ubiquitous Helvetica, by Max Miedinger and Eduard Hoffman, Univers, by Adran Frutiger, and Akzidenz all have a large x-height and relatively short ascenders and descenders; Univers is a little more eccentric in design. Arial was developed by Frutiger for the computer screen.

The quick brown fox jumped HamburgefonsLIiltja

15 Helvetica Neue 55

The quick brown fox jumped HamburgefonsLIiltj

15 Univers 55

The quick brown fox jumped HamburgefonsLIiltja

15 Arial

The quick brown fox jumped HamburgefonsLIiltja

15 Akzidenz Grotesque Roman

The quick brown fox jumped HamburgefonsLIiltja

15 Meta Plus Book

The quick brown fox jumped HamburgefonsLIiltja

15 Thesis Sans

Futura is a Bauhaus-modernist, geometrically constructed font designed by Paul Renner in 1927; Avenir was designed in 1988 by Adrian Frutiger to adapt Futura to the screen and improve its overall legibility. Note the double story a, which improves legibility compared to Futura's single-story a.

The quick brown fox jumped HamburgefonsLIiltja

15 Futura Medium

The quick brown fox jumped HamburgefonsLIiltja

15 Avenir Medium

The quick brown fox jumped HamburgefonsLIiltja

15 Franklin Gothic ITC Book

The quick brown fox jumped HamburgefonsLIiltja

15 P22 Johnston Underground Regular

The quick brown fox jumped HamburgefonsLIiltja

15 Parisine Ptf

Clearview Hwy was developed by Donald Meeker et al. to improve upon and replace Highway Gothic, which had been the USDOT's highway signage font since the '40s. It was approved for interim use by the FHWA in 2004.

The quick brown fox jumped HamburgefonsLIiltja

15 Clearview Hwy 2W

g g

Helvetica Neue 55 — Meta Plus Book

l l

Helvetica Neue 55 — Meta Plus Book

a a a

Helvetica Neue 55 — Meta Plus Book — Futura Medium

Thtp Thtp

Helvetica Neue 55 — The Sans

Sans serif

Fonts have many characteristics; some of them contribute to legibility and some don't. In all cases, legibility is determined by the font's use and by its context.

The sans serif fonts shown here, a selection including some recent variants of earlier classics, and one font recently developed for highway use, reveal different relationships:

- of x-height—the height of a lowercase *x*—to nominal size—the size in points of the font, originally the height of the lead slug on which the letter was positioned;

- of x-height relative to ascenders and descenders;

- of letter width relative to both x-height and nominal size;

- of stylistic attributes visible in lowercase *a, g* (single and double story) *e, j, l,* and *t*;

- the way the font is letterspaced using its normal spacing tables;

- the way the characters are drawn so that they are not confused with each other under less than optimal circumstances.

Sans serif fonts are often considered to be more appropriate in larger sizes and less appropriate for large quantities of text than serif fonts.

Read Walter Tracy. *Letters of Credit.*
Lars Müller. *Helvetica: Homage to a Typeface.*

Meta and Thesis, more recently designed fonts (by Erik Spiekermann and Lucas de Groot, respectively), have a hint of a calligraphic quality, and use a double-story (looptail) g.

Franklin Gothic was designed by Morris Fuller Benton in 1902, named in honor of Benjamin Franklin. The use of the word "Gothic" is archaic, formerly used to mean sans serif. Some of its noticeable characteristics are its double-story g and the ear of that letter. Johnston Underground (Edward Johnston) and Parisine (Jean-François Porchez) are used by London Transport and RATP (Paris), respectively.

Many think, in general, that serif fonts work better at book size and that sans serif fonts work better at headline, or poster, size. This sweeping generalization, while not entirely without merit, reveals the crucial importance of context.

Counters—the centers of closed forms—are always at risk. This sign is from the main train station, Termini, in Rome.

Sans serif and serif font comparison. Helvetica has a large x-height and short ascenders and shoulders; Garamond 3 has a small x-height, tall ascenders, and large shoulders.

The green rectangles represent the nominal font size, or slug size, 72 points (1 inch).

72 Helvetica Neue 55 72 Garamond 3

Garamond 3—based on a font by Jean Jannon cut in 1621— was made by Thomas Maitland Cleland and Morris Fuller Benton for American Type Founders in 1919. Minion was designed as a digital font for Adobe in 1990 by Robert Slimbach; it has some of the old face characteristics of Garamond 3, but it has a larger x-height.

A quick jump HamburgefonsLIiltja
18 Garamond 3 (Old Face)

A quick jump HamburgefonsLIiltja
18 Minion Regular (Transitional)

A quick jump HamburgefonsLIiltja
18 Caslon 540 (Transitional)

A quick jump HamburgefonsLIiltja
18 Baskerville (Transitional)

Giambattista Bodoni (1740–1813) lends his name to a large variety of fonts influenced by Baskerville's work—but with greater extremes of thick and thin—and the fonts of Firmin Didot. Many digital fonts with this characteristic exhibit "dazzle" on-screen at text sizes, of which Didot is a perfect example.

A quick jump HamburgefonsLIiltja
18 Bodoni Book (Didone Modern)

A quick jump HamburgefonsLIiltja
18 Linotype Didot (Didone Modern)

A quick jump HamburgefonsLIiltja
18 Walbaum MT (Modern)

Palatino, originally designed by Hermann Zapf in 1948, is named after the 16th-century master of calligraphy Giambattista Palatino. Renaissance in inspiration, Palatino is more calligraphic in feeling than many similar fonts.

A quick jump HamburgefonsLIiltja
18 Palatino Linotype (Old Face)

A quick jump HamburgefonsLIiltja
18 Century Expanded

A quick jump HamburgefonsLIiltja
18 Clarendon Light (Slab Serif)

Melior, designed by Hermann Zapf in 1952, expresses his ideas about the squared-off circle. Times Roman was designed in 1932 by Cameron S. Latham of Monotype (England), commissioned by The Times of London in response to a critical article by Stanley Morison about the newspaper's typography. Morison supervised the design, based on Plantin, which The Times had used for 40 years. Times's ubiquity has made it unpopular in typophile circles at different times. It was used to dramatic effect by Dugald Stermer in the '60s in Ramparts and other New Left publications.

A quick jump HamburgefonsLIiltja
18 Melior (Slab Serif)

A quick jump HamburgefonsLIiltja
18 Times Roman (Transitional)

The uppercase T is usually an excellent font identifier. The difference between serif fonts is often more dramatic than sans serif fonts.

T T T T T T

60 Garamond 3 60 Caslon 540 60 Baskerville 60 Bodoni Book 60 Didot 60 Walbaum

Serif

Serif fonts—originating with the Roman alphabet—are widely considered to be more legible than sans serif fonts for large quantities of text, especially in small sizes and more decisively in print than on screen. Better screen technology and more careful typesetting are mitigating the arguable differences, and it has long been clear that sloppy and careless typesetting can damage the legibility of even the most well-drawn typefaces. Serif fonts offer a broader range of stylistic opportunity to the font designer, as the almost inexhaustible range of serif treatments reveals.

With their long history, serif fonts are thought to have a richer palette of connotations than sans serif fonts.

Note that the font specimens on this page are 18 point and, for the most part, are smaller than the sans serif font specimens on the preceding spread, which are 15 point.

Read Georges Jean. *Writing: The Story of Alphabets and Scripts.*

Andrew Robinson. *The Story of Writing: Alphabets, Hieroglyphs, & Pictograms, Second Edition.*

Beatrice Warde. *The Crystal Goblet: Sixteen Essays on Typography.*

Stephan Füssel. *Bodoni: Manual of Typography.*

Go to http://codex99.com/typography/21.html

Caslon 540 was designed by the staff of American Type Founders in 1902 based on the work of William Caslon (1692–1766), much of whose work is based on the fonts of Christoffel Van Dyck. It exists in many variants for metal, phototype, and the web. Baskerville represents John Baskerville's (1706–1775) attempt to improve on Caslon's work.

Walbaum, originally designed in 1800 by Justus Erich Walbaum, is an eccentric font in the Bodoni family, with a large x-height, wide letterspacing, and quirks in, for example, lowercase b, k, *and* q.

Century Expanded was designed by Linn Boyd Benton in 1894 for The Century Magazine, *which needed a more legible typeface. Century has a large x-height and slightly condensed proportions. Named for the Clarendon Press in Oxford, Clarendon was created by Robert Besley in 1845. Reworked in 1935 by Monotype and in 1953 by Hermann Eidenbenz, it was used by the U.S. National Park Service on signs until 2008, and can be seen in the logos of Sony, Wells Fargo, and the Spanish newspaper* El Pais.

[The letters on Trajan's Column represent] the best roman letter designed in the Western world, and the one which most nearly approaches an alphabetic ideal.

Edward Catich
The Origin of the Serif

141

A logo made entirely out of serifs, *for Eastern Press in New Haven, CT, by Norman Ives (1923–1978), ca. 1960.*

Complete inscription and detail from Trajan's Column, Rome, ca.113 CE. These letterforms are the basis of modern serif typography.

T
60 Century Expd

T
60 Clarendon Lt

T
60 Times Roman

4 : STRUCTURE, ORGANIZATION, TYPE

Font width at a given point size. Nominal point size has become a misnomer. When letters were made from brass punches or cast in lines from matrices, the nominal size of the font—e.g., 10 point—was the size of the length of the metal "slug" from top to bottom. Depending on the font, the total letter height—from the top of the ascender to the bottom of the descender—may or may not have filled the slug. The space on the slug that is not used for ascender or descender is called the "shoulder."

The quick brown HamburgefonsLIiltj
18 Helvetica Neue 75

The quick brown HamburgefonsLIiltj
18 Univers 65

The quick brown HamburgefonsLIiltj
18 Meta Plus Bold

The quick brown HamburgefonsLIiltj
18 Thesis Sans Bold

The quick brown HamburgefonsLIiltj
18 Garamond 3

The quick brown HamburgefonsLIiltj
18 Times New Roman

The quick brown HamburgefonsLIiltj
18 Helvetica Neue 75

The quick brown HamburgefonsLIiltj
18.5 Univers 65

The quick brown HamburgefonsLIiltj
17.5 Meta Plus Bold

The quick brown HamburgefonsLIiltj
18.25 Thesis Sans Bold

The quick brown HamburgefonsLIiltj
20.5 Times Roman

The quick brown HamburgefonsLIiltj

Efficiency—font size at a given line width for the same number of characters.

The quick brown HamburgefonsLIiltj
18 Helvetica Neue 75

The quick brown HamburgefonsLIiltj
18.06 Univers 65

The quick brown HamburgefonsLIiltj
20.15 Meta Plus Bold

The quick brown HamburgefonsLIiltj
19.77 Thesis Sans Bold

The quick brown HamburgefonsLIiltj
21.5 Garamond 3

The quick brown HamburgefonsLIiltj
20.75 Times Roman

Font efficiency

Different fonts allow a different number of characters to fit in a given amount of space.

Some of the font characteristics that determine a font's efficiency—other things being equal— are:

- Character width: a narrower character width will accommodate more characters in a given measure.
- X-height: a smaller x-height will accommodate more characters in a given measure.
- Type size relative to slug size: a typeface whose total height (ascender to descender) is smaller on the slug height (nominal font size, e.g., 10 points) will accommodate more characters in a given measure.

Read Andrew Robinson. *The Story of Writing: Alphabets, Hieroglyphs, & Pictograms, Second Edition.*

Font efficiency is no guarantee of overall legibility or general suitability for the purpose.

Facing page center. Font size at a given x-height.

Broad Street Line

Meta Plus Bold:
shorter line length

Broad Street Line

Helvetica Bold

Comparison of Meta Plus Bold and Helvetica Bold with the same cap height.

Some observations on particular fonts:

- *Helvetica is relatively expanded (wide), has a large x-height, and is very large on its slug.*
- *Meta is relatively condensed.*
- *Garamond 3 is relatively expanded and has a small x-height, with tall ascenders; it is very small, ascender to descender, on its slug.*
- *Times Roman is somewhat condensed but has a large x-height with short ascenders and descenders.*

Broad Street Line

Meta Plus Bold:
shorter line length

Broad Street Line

Helvetica Bold

Comparison of Meta Plus Bold and Helvetica Bold with the same lowercase x-height.

Broad Street Line

Meta Plus Bold:
larger type size

Broad Street Line

Helvetica Bold

Comparison of Meta Plus Bold and Helvetica Bold with the same line length.

4 : STRUCTURE, ORGANIZATION, TYPE

Hamburgefons123
Hamburgefons123
Hamburgefons123
Hamburgefons123
Hamburgefons123
Hamburgefons123
Hamburgefons123
Hamburgefons123
Hamburgefons123
Hamburgefons123
Hamburgefons123
Hamburgefons123
Hamburgefons123
Hamburgefons123
Hamburgefons123
Hamburgefons123
Hamburgefons123
Hamburgefons123
Hamburgefons123
Hamburgefons123
Hamburgefons123
Hamburgefons123
Hamburgefons123
Hamburgefons123
Hamburgefons123
Hamburgefons123
Hamburgefons123

144

HAMBURGEFONS12
HAMBURGEFONS12
HAMBURGEFONS12
HAMBURGEFONS12
HAMBURGEFONS12
HAMBURGEFONS12
HAMBURGEFONS12
HAMBURGEFONS12
HAMBURGEFONS12
HAMBURGEFONS12
HAMBURGEFONS12
HAMBURGEFONS12
HAMBURGEFONS12
HAMBURGEFONS12
HAMBURGEFONS12

Hamburgefons123
Hamburgefons123
Hamburgefons123
Hamburgefons123
Hamburgefons123
Hamburgefons123
Hamburgefons123
Hamburgefons123
HAMBURGEFONS123
Hamburgefons123
Hamburgefons123
Hamburgefons123
Hamburgefons123
Hamburgefons123
Hamburgefons123
Hamburgefons123
Hamburgefons123
Hamburgefons123
Hamburgefons123
Hamburgefons123
Hamburgefons123
Hamburgefons123
Hamburgefons123
Hamburgefons123
Hamburgefons123
Hamburgefons123
Hamburgefons123
Hamburgefons123
Hamburgefons123
Hamburgefons123
Hamburgefons123
Hamburgefons123
Hamburgefons123

Typographic differentiation

Just has colors have characteristics of differentiation—hue, value, chroma, pattern—so do typefaces have size, slant, weight, width, and caps.

- Size: The smaller a font is used, the more letterspacing (tracking) may be desirable for legibility.

- Italics: It is important to use true italic rather than computer-generated italic (skewed roman), as the drawing of the characters is significantly different.

- Weight: In type design (as in life), you can only get so bold before the character of the font begins to change. Some fonts are more legible in extremely bold and extremely light weights than others.

- Condensed fonts are efficient but often need extra tracking for legibility. Extended fonts are not shown in this book because, as they are neither efficient nor particularly legible, their role in information design is limited.

- A body of text set in all caps, caps/small caps, or all small caps will always be less legible than text set in caps/lowercase. Worthy of consideration is whether lining (uppercase) figures will be more effective in context than old-style (lowercase) figures or the opposite.

"True" small caps—drawn as part of the font—are different in proportion as well as in size. They are proportionately wider than full caps scaled down uniformly.

Legible small, a bit swollen large. Named for 16th-century punchcutter Claude Garamond, Garamond 3 has a long history of redrawings, misattributions, and revivals. Garamond 3 is particularly legible at book sizes. As it gets larger, the very idiosyncrasies that contribute to its elegance at smaller sizes make its serifs look chunky and soft.

Elegant large, not too legible small. Didot was developed by Firmin Didot (1764–1836) in the late 18th century. It is characterized by bold thick strokes and hairline thin strokes, not unlike some Bodonis. Used large and sparingly, Didot is the pinnacle of elegance. At book scale, the sparkling fineness of the thin strokes, especially when they are not thickened by the letterpress process, makes it less legible.

Legible light, only semi-legible ultra bold. Gill Sans, designed by sculptor, graphic artist, and type designer Eric Gill, was released in 1928. Inspired by Johnston Underground (shown on page 138), Gill Sans is more eccentric in its inconsistencies and between light and ultra bold, than most sans serif fonts. Gill's desire was to make an extremely legible typeface for both text and display, but its Ultra Bold is barely legible at book sizes.

Legible bold, not very legible really thin. Now a film star in its own right, Helvetica was designed in 1957 by Max Miedinger with Eduard Hoffmann at the Haas type foundry in Münchenstein, Switzerland. Originally named Neue Haas Grotesk, its name was changed in 1960 to the word meaning "Swiss." The intent was to create a typeface that had great clarity and no intrinsic formal meaning. Recent weight additions, particularly its two lightest weights, are difficult to read and are "normally" packed much too tight.

Size

9/10.5 Garamond 3

I have ever had pleasure in obtaining any little anecdotes of my ancestors. You may remember the inquiries I made among the remains of my relations when you were with me in England, and the journey I undertook for that purpose.... I sit down to write them for you. To which I have besides some other inducements.

48 Gar 3

8/10.5 Didot Regular

I have ever had pleasure in obtaining any little anecdotes of my ancestors. You may remember the inquiries I made among the remains of my relations when you were with me in England, and the journey I undertook for that purpose.... I sit down to write them for you. To which I have besides some other inducements.

48 Didot

Weight

8/11 Gill Sans Light

I have ever had pleasure in obtaining any little anecdotes of my ancestors. You may remember the inquiries I made among the remains of my relations when you were with me in England, and the journey I undertook for that purpose.... I sit down to write them for you. To which I have besides some other inducements.

8/11 Gill Sans Ultra Bold
I have ever had pleasure in obtaining any little anecdotes of my ancestors. You may remember the inquiries I made among the remains of my relations when you were with me in England, and the journey I undertook for that purpose.

8/11 Helvetica Neue 85 Heavy
I have ever had pleasure in obtaining any little anecdotes of my ancestors. You may remember the inquiries I made among the remains of my relations when you were with me in England, and the journey I undertook for that purpose.

8/11 Helvetica Neue 25 Light
I have ever had pleasure in obtaining any little anecdotes of my ancestors. You may remember the inquiries I made among the remains of my relations when you were with me in England, and the journey I undertook for that purpose.

Full disclosure. None of these examples has been tracked or kerned.

When type was made from hand-cut brass punches, it was by definition redrawn at each size.

Now that type is generated from a digital master, extremely subtle compensations for font size are largely non-existent. Also gone is the swelling of the thin strokes of type when a letterpress form physically struck the surface of pulpy, absorbent paper. And in many cases the very characteristics of the way a font was or is designed makes it more elegant and legible at some sizes than at others.

Weight also matters in font legibility. Some fonts are too thin at their thinnest; some are too eccentric at their boldest. This is more often the case with serif fonts. Sans serif fonts, with their essentially regular stroke width, more comfortably move from light to bold and from small to large with little sacrifice in legibility. Gill Sans, at left, is one exception. This is not to say that Gill Sans Ultra Bold, Neuland, Kabel, and other fonts are not beautiful and interesting in the way they resolve their eccentricities as they get bolder, just that those eccentricities that compromise legibility only marginally at text weights are more difficult to resolve as the typeface becomes bolder.

Read Eric Gill. *An Essay on Typography.*

Timothy Samara. *Typography Workbook: A Real-World Guide to Using Type in Graphic Design.*

Go to http://www.squidspot.com/Periodic_Table_of_Typefaces.html

Font legibility is the function of many factors in addition to the way the font is designed and drawn, among which are: size at which used, letterspacing (tracking and kerning), leading, color, value, and especially context.

147

Cam Wilde has over the years been expanding the applications of his Periodic Table of Typefaces, which one often sees on design students' screen savers. Cam clearly has a delightful sense of humor that does not extend to a warning that inclusion does not confer an endorsement of font quality. I guess that's what we instructors do.

A poster by Chris Pullman that plays with references to highlighting and editing letters and manuscripts.

Text type packed too tight (undertracked) is difficult to read. I have ever had pleasure in obtaining any little anecdotes of my ancestors. You may remember the inquiries I made. Garamond 3

Upper and lower case type set too loose is also difficult to read. "Anyone who would letterspace lowercase would steal sheep," a misquote of Frederic W. Goudy. Goudy Old Style

BUT SMALL CAPS LETTERSPACED (TRACKED) ARE OFTEN EXTREMELY EFFECTIVE AND LEGIBLE. Garamond 3

Lines of text without enough space between the lines is difficult to read. I have ever had pleasure in obtaining any anecdotes of my ancestors. You may remember the inquiries I made. The Sans Light

Flush right text is difficult to read because the eye cannot easily find the beginning of the line but has to search for it.

Centered text is difficult to read because the eye cannot easily find the beginning of the line.

Bodoni Book

ALL CAPS ARE LESS LEGIBLE THAN UPPER AND LOWER CASE BECAUSE OF FAMILIAR WORD SHAPES made by ascenders and descenders. I have ever had pleasure in obtaining any little anecdotes of my ancestors. You may remember the inquiries I made. Garamond 3

SMALL CAPS ARE PROPORTIONED DIFFERENTLY THAN FULL CAPS; THEY ARE WIDER PROPORTIONAL TO THEIR HEIGHT. I HAVE EVER HAD PLEASURE IN OBTAINING ANY LITTLE ANECDOTES OF MY ANCESTORS. YOU MAY REMEMBER THE INQUIRIES I MADE.

The Sans Semi Bold

To avoid halation (the optical illusion of a soft halo around the letterform) when projecting white type on a black background, consider making the type 5 or 10% black. The advantage of this cannot be seen on the printed page.

The quick brown fo

The quick brown f

Justified type creates awkward white rivers if the line length is too short. I have ever had pleasure in obtaining any little anecdotes of my ancestors.

The Sans Semi Bold

Legibility

This spread represents an effort to assemble and demonstrate many of the issues that affect legibility in typesetting. While some examples are exaggerated, they represent a reasonably fair collection of issues that affect basic use of type. In information design, where data may be dense, complex, and require careful study, clear, legible typography is extremely important.

Read Erik Spiekermann. *Stop Stealing Sheep.*

Students: Your other instructors will never tell you that the size at which type looks its most elegant is just a little too small to read comfortably.

Type reversed out of a dark color tends to look bolder.
The Sans Extra Bold

The quick brown fox jumped over the dog.

The quick brown fox jumped over the dog.

Very thin strokes reversed out of a dark color tend to fill in and appear to sparkle.
Didot

Old12345style Garamond figures blend seam67 890lessly in text, while lining fig12345ures tend to67890stand out in text.

Old12345style Thesis figures blend seam67 890lessly in text, while lining fig12345ures tend to67890stand out in text.

Old-style (or lowercase) figures have ascenders and descenders and an x-height. They increase legibility compared to lining (upper-case) figures for the same reason that text in upper and lowercase is more legible than text in all caps: readers identify words and groups of numbers by their non-uniform profile. Old-style figs (as they are called) also call less attention to themselves in a block of text set in caps-lowercase.

It is interesting that to a large degree, especially in sans serif fonts, the old-style numerals 3–9 are essentially lining figures positioned relative to the baseline so as to have ascenders and descenders. The numerals, 1, 2, and 0, however, are significantly different from their lining counterparts and have a height equal to the font's x-height.

Garamond 3, above left, is unusual in that its lowercase 1 looks like a roman numeral, and its lowercase 0 (zero) has no stroke weight differentiation.

Many fonts do not have old-style figures.

Paula Scher, with her finely tuned sense of historical typography, has long channeled vernacular design.

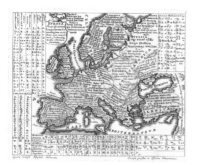

This 1949 English boxing poster represents a genre of vernacular design that flourished on both sides of the Atlantic for many decades. Derived from 19th-century wood type, it reveals an unexpected typographic sensibility.

This recent poster (2004) by Ralph Schraivogel, while clearly utilizing opportunities afforded by digital technology, has much of the same feeling of Dada and other pre-Modernist typography.

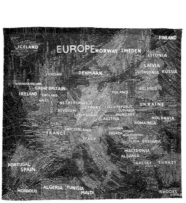

Far left. A word map of Europe, ca. 1750.

Left. Paula Scher's word map of a virtually identical area.

Garamond 1532
Bodoni 1788
Century
Expanded 1900
Futura 1930
Times Roman 1931
Helvetica 1957

Massimo Vignelli's answer to font choice is to limit himself to the six "best" typefaces. Michael Bierut, who worked with Vignelli, describes the point of view:

"For the first ten years of my career, I worked for Massimo Vignelli, a designer who is leg-endary for using a very limited number of typefaces....

"For me, it became a time-saving device. Why spend hours choosing between Bembo, Sabon, and Garamond No. 3 every time you needed a Venetian Roman?...

"Then, after a decade, I left my first job. Suddenly, I could use any typeface I wanted, and I went nuts. On one of my first projects, I used 37 different fonts on 16 pages. My wife, who had attended Catholic school herself, found this all too familiar.... She said, looking at one of my multiple font demolition derbies, 'You've become a real slut, haven't you?'"

During a seminar a few years ago, a student asked me, totally out of context, "What font should I use?"

Apalled, but conscious of being gracious, I answered, "The right one for the job," and took another question.

Choosing a font can be a difficult decision, and the "right font" will combine the characteristics of legibility, context, connotation, and appropriateness. Beyond all that, there are fonts that are "drawn well" and those that are not. Well-drawn fonts—always a matter of opinion—meet those criteria. There are always cases, however, where "badly drawn" (in the conventional sense), grotesque (not Grotesk), semi-legible fonts serve a useful and effective purpose.

It took far too long for the MLA to recognize, after the widespread adoption of the computer, that there was no longer any need to double space after periods. The same holds true for underlining bibliographic citations, e.g., Designing Information. Both were responses to the constraints of the typewriter. By the early '90s, even lower-school students were setting type with a facility that Gutenberg would have respected, and were able to italicize book titles, e.g., *Designing Information.*

The right font will often be a balance of choosing between criteria that a particular font meets—for example, boldness, connotation, shock value, and the like.

Read Massimo Vignelli: *The Vignelli Canon.*

Michael Bierut. *Seventy-nine Short Essays on Design.*

Paula Scher. *Maps.*

Go to http://observatory.designobserver.com/entry.html?entry=5497

http://www.emigre.com/EMagView.php

See also Page 203; 204 bottom right; 205 center right; 205 bottom right.

Tibor Kalman was fascinated with boring typefaces. "No, this one is too clever, this one is too interesting," he kept saying when I showed him the fonts I was proposing for his monograph. Anything but a boring typeface, he felt, got in the way of the ideas.

Michael Bierut

151

Footnotes need to be legible, too. In this (excellent) book, the footnote notations in text are virtually illegible, due to their small size and extremely light weight.

A bad font is a bad font (this is Mistral), even engraved in wood, here in l'Institut du Monde Arabe, Paris.

ᚠᚨᚢᚼ ᚼᛖᛒᚱᛖᚥ FAUX HEBREW

One of the many entertaining fonts that mimic languages that use non-Roman characters.

THAT FELICITY, when I reflected on it, has induced me sometimes to say, that were it offered to my choice, I should have no objection to a repetition of the same life from its beginning, only asking the advantages authors have in a second edition to correct some faults of the first. So I might, besides correcting the faults, change some sinister accidents and events of it for others more favorable. But though this were denied, I should still accept the offer. Since such a repetition is not to be expected, the next thing most like living one's life over again seems to be a recollection of that life, and to make that recollection as durable as possible by putting it down in writing.

Hereby, too, I shall indulge the inclination so natural.

So I might, besides correcting the faults, change some sinister accidents and events of it for others more favorable.

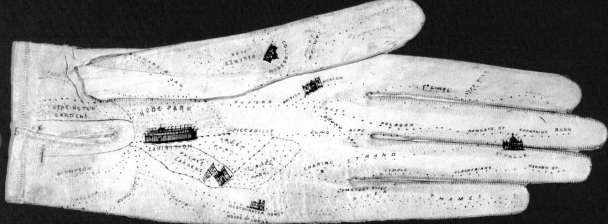

George Shove. Map of London on Glove *for the Great Exhibition of 1851, ca. 1851. Printed map on leather.*

5

Finding Your Way?

Movement, orientation, situational geography

I went to the zoo, and then I walked until I came here. Have I been walking north?

Edward Albee: *The Zoo Story*, 1958

No matter where you go, there you are.

Thomas à Kempis, *Imitation of Christ*, ca. 1440
Buckaroo Banzai, 1984

How many Californians does it take to get directions?

Five. One to tell you where you're going and four to tell you where you're coming from.

Anonymous

Walk!Philadelphia, a comprehensive pedestrian wayfinding system, currently numbers over 2,300 sign and map faces covering all of Center City Philadelphia and University City. The "diskmaps" are all heads up, and their circular form suggests their rotation oriented to the user's direction of travel.

A heads-up automobile navigation unit by Garmin.

Below. A heads-up pedestrian map prototype for downtown Omaha. Because the project area is strongly rectangular, the maps could only be oriented east-up and west-up.

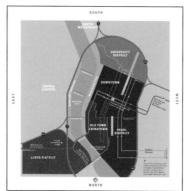

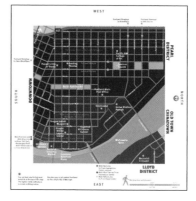

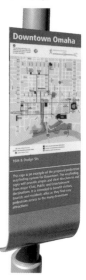

Left and above. Pylon, overall heads-up glyph map, and heads-up district map for Portland, OR. The overall glyph map shown is south-up, the district map west-up.

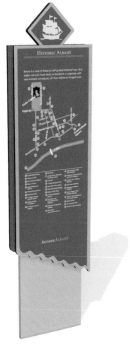

Originally developed for use in military aircraft during World War II, and referring to a pilot's being able to look forward with his head up (rather than down at instruments), "heads up" now also connotes a map in which the direction in which the viewer is facing is positioned at the top of the map. This enables the user to correlate directions on the map to the direction in which he is walking and needs to turn. Want to go somewhere that's ahead and to the right on the map? Walk straight and to the right.

This is especially important in environmental maps (as opposed to printed maps that can stay with the user and be consulted frequently), as the retention time for maps in the environment is very short.

Heads-up displays (HUDs) were introduced into automobiles by General Motors in 1988. Now, of course, essentially all automotive navigation system are heads-up. Many of us can remember the frustration of trying to read a paper map (north-up, of course) upside down or at a 90° angle, turned so that the direction of travel was at the top. And that was easy compared to rotating a sign fixed to a wall or pole or standing on your head. Even then, if the map isn't heads up, there's a 75% chance that the type will not be easy to read.

Heads-up pedestrian mapping has been a little longer in coming, and the author's maps for Walk!Philadelphia in 1996 were a reasonably early example.

Read Craig Berger. *Wayfinding: Designing and Implementing Graphic Navigational Systems.*

Go to www.segd.org

See also Signs and arrows; Map or diagram? Page 206.

You are here—but which way are you facing?

The circle—the only totally non-directional geometric shape—is a poor choice for "You are here" indicators on non-heads-up maps.

155

A heads-up historical pedestrian marker prototype for downtown Albany, NY (never implemented).

A visual explanation of the rationale for and benefits of heads-up mapping for pedestrian sign systems.

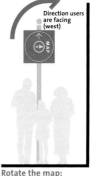

Visitors in Paris trying to find where they are. All these maps are north-up. They also use a circle as the "You are here" indicator.

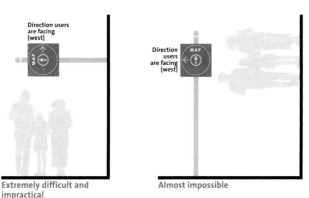

Not helpful

Extremely difficult and impractical

Almost impossible

Rotate the map: simple and efficient

5 : FINDING YOUR WAY?

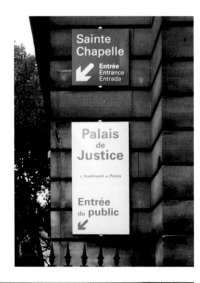

These destination are neither down nor to the left. American wayfinding designers would use arrows pointing up, meaning straight ahead, confident that the pedestrians looking for these destinations would not walk into a fence.

No, no, not down, you're already underground. There is no further down in this location, although there may be stairs down to maintenance spaces. The down arrows in front of the up stair are particularly amusing.

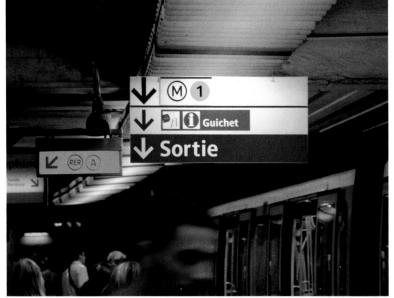

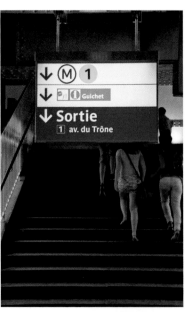

Entebbe airport, 1964. North is to the right in the photograph at near right.

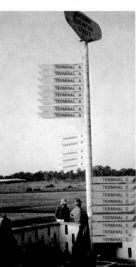

Signs and arrows

Completed in 1989, Carbone Smolen Agency's wayfinding plan for the Louvre used an ingenious gridded "neighborhood" concept to accomplish the following objectives:

"Easily locate the 'greatest hits'; make an enormously complicated piece of architecture understandable; and accommodate the movement of art as collections were relocated over time.

"To help visitors find the right 'neighborhood,' an architecturally based numerical sign system keyed to a paper guide. The concept expanded to geographic zones or numbered 'arrondissements' (like Paris itself) and included clusters of galleries...."

Recently, Ken Carbone wrote: "This down arrow meaning straight confounds me and is the only thing I don't love about Paris."

Unfortunately, CSA's system was replaced, and the Louvre's current wayfinding system is confusing and ambiguous, notwithstanding its delightful and entertaining prohibitory signs.

Arrows in wayfinding have two intrinsic meanings, the literal and the theoretical.

Literal arrows mean that if you walk or drive in this direction you will be on your way to your destination, or at least to the next sign. This is practical information.

Theoretical arrows reference that some destination you may (or may not) be interested in is in a particular direction. It may be very distant, and your ability to get there on your own is very likely between difficult and impossible. The image at the bottom left of the facing page is an example.

Every culture has its own approach to arrows, which can be very confusing in a place that is not your own. For as long as I can remember, France and Italy used road signs whose arrow was the shape of the sign: directions were either to the left or to the right. This required turning the sign at much as 45° from your line of sight to indicate that you were to continue straight, thereby significantly decreasing the functionality of the information. The U.K. loves roundabouts, and there is at least one example of a roundabout with five sub-roundabouts.

By definition, the arrow meaning straight ahead has to be either up or down. In the U.S., of course, the up-arrow means straight ahead; in France, however, it means the opposite. A long time ago I got completely lost in the Louvre, looking for the Nike of Samothrace, continually searching for down stairways (and taking them) instead of just walking straight ahead.

Theoretical arrows—not to be used either because of travel mode or the distances involved—on signposts these days are often intended to be playful, although at one time they were functional. Since the advent of ubiquitous air travel, they have become something of a nonfunctioning throwback: quaint, but in a way contradictory to experience. At any airport, all destinations lie in only one direction: the terminal.

Read David Gibson. *The Wayfinding Handbook: Information Design for Public Places.*

See also What's up?; Map or diagram?; Page 208 center left; Page 209 bottom right.

It is sad but true today that most of us take our surroundings for granted.... Direction signs and street names...are as vital as a drop of oil in an engine, without which the moving parts would seize up.

Jock Kinneir

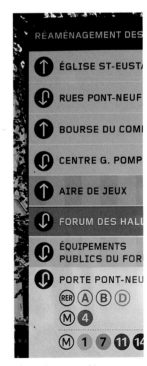

The 180° arrow on this temporary sign in Paris at Les Halles addresses and solves the problem of guiding people to destinations behind them.

Scale and adjacency

Who knew that South Carolina was next to South Dakota, and the same size?

Actually, we know better. But as you drive south or west from South Carolina, you're in Georgia; if you drive north, you're in North Carolina. Is the practice of organizing by alphabetization a remnant of an era when people drove across state lines less often; or of an era when one's native state had more importance than it does now? Forty-eight of the United States' fifty states are contiguous; you drive from one to the next regardless of its name. In fact, only seven states (Florida-Georgia; Illinois-Indiana-Iowa; Michigan-Minnesota) are adjacent to a state that precedes or follows it in alphabetical order.

Similarly confusing is that the scale of the South Carolina map is almost 50% larger than the map of South Dakota; in other words, South Dakota is almost 50% larger relative to South Carolina than it appears on these adjacent pages in the atlas on the facing page. So just how does one get an intuitive idea, without measuring and calculating, how long it would take to drive across one of these states?

The matter is complicated further by the fact that, in many road atlases, the thickness of the roads and the size of the type are the same regardless of the scale of the map. So, in the example at the left, if you enlarged South Dakota to the scale of South Carolina, the roads would be 50% thicker.

Read Richard Saul Wurman. *USAtlas*; any of the early Access books.

Go to http://www.wurman.com/publications.html

See also Too much information; How big?; Apples to apples; (Ir)rational innovation.

Scales (as opposed to "scale") can be helpful, if you're good at visualizing the experiential nature of distances expressed numerically, or if you have a good ruler and calculator handy. Large numbers, whether they are the national debt or the length of time it takes to drive across Russia, become increasingly abstract in direct proportion to their size.

159

In 1989, Richard Saul Wurman published USAtlas, *a 10¼" square atlas that addressed many of the problems with conventional road atlases:*

It was organized north-to-south, east-to-west, beginning in Washington state (but preceded by Alaska, Hawaii, and Puerto Rico) in spreads 250 x 500 miles—states are often split into as many as four spreads;

Following this were maps 25 miles square of major urban areas, which in turn were

followed by maps 5 x 5 miles focused on 10 of the country's major cities (you had to rotate the book for Manhattan, something I noticed only recently).

Why did USAtlas *go out of print so quickly? My guess is that is was better in theory than in practice: there simply wasn't enough information in it for drivers to use confidently. Used to road atlases with too much information to be read comfortably, perhaps drivers felt they needed to have everything possible available—just*

in case. They may have been confused by the absence of road shields: route numbers are indicated in USAtlas *in a way that resemble segment distances in conventional road maps.*

That said, imagine a road atlas that combined all the positive qualities of USAtlas*— uniform scale and rational pagination—with a richness of information that would make users confident that they had all the information they could possibly need.*

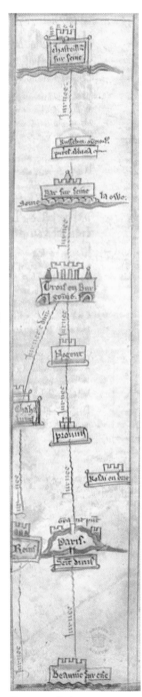

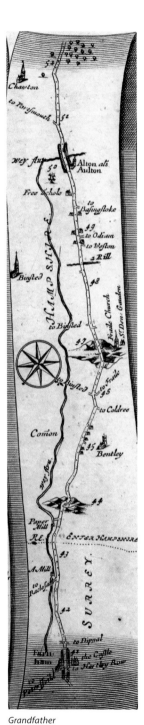

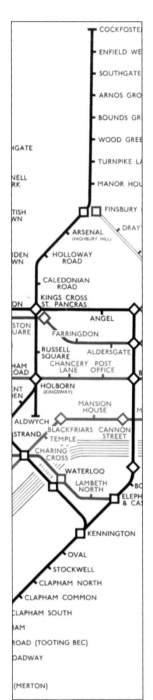

Great-grandfather
Matthew Paris (ca. 1200–1259)
This map ca. 1250

Grandfather
John Ogilby (1600–1676)
This map 1698

Father
Harry Beck (1902–1974)
This map 1933

Son
Massimo Vignelli (1931–)
This map 2008

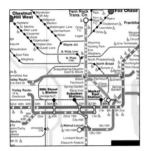

Detail of the SEPTA (Southeastern Pennsylvania Transportation Authority) current system map.

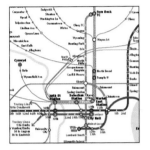

Detail of a proposed revision by Joel Katz Design Associates, 2011.

Detail of a study for an improved, interactive SEPTA System Map by Alex Yampolsky, BrandQue, 2011.

What Lily Tomlin's quote means to me in the context of information design is that certain familiar aspects of reality, such as geographic configurations, direction, and distance, do not regularly correspond to the varied experiences of walking, bicycling, driving, taking public transit, or flying.

It is the challenge and responsibility of the information designer to design maps and other navigational aids with an understanding of the different ways in which movement modes are experienced and perceived.

Different movement modes are capable of upending our understanding and experience of units of measure. The foot is an example of a human-scale measure. As we walk further and further distances, we begin to think in other units: the block, the neighborhood, the district.

As we change modes, units of measure become mode-specific. When we ride a bus that doesn't stop in pedestrian-scale units, we think of stops. The same is true of above-ground rapid transit and trains, on which we also have some sense of time. We intuitively know that the distance between some stops is longer than between others: our sense of time, which we translate into distance, is aided by our view of the passing landscape.

All this changes when we go underground, which gets us back to Harry Beck and his departure from his spiritual father, John Ogilby, whose distance scale was relatively uniform. Beck realized that, without reference to the urban landscape, the distance between stops is experientially uniform, almost abstract. So, it is fair to say that as clues to geographic reality disappear, so does the sense of time and distance. Beck's map, therefore, its critics notwithstanding, was an early visualization of a truly modern (that is, beginning in the late 19th century) movement experience.

Realty is a crutch.
Lily Tomlin

Richard Saul Wurman's map of the Tokyo rail transportation system, 1984, described in some detail in an article by R. E. Wyllys, at http://www.ischool.utexas.edu/~l38613dw/readings/InfoArchitecture.html

Read Daniel K. Connolly. *The Maps of Matthew Paris: Medieval Journeys through Space, Time and Liturgy.*

Go to www.septa.org

http://brandque.com/septa.html

http://www.joelkatzdesign.com/maps.html
page 6

See also The road is really straight; Pages 208–213.

161

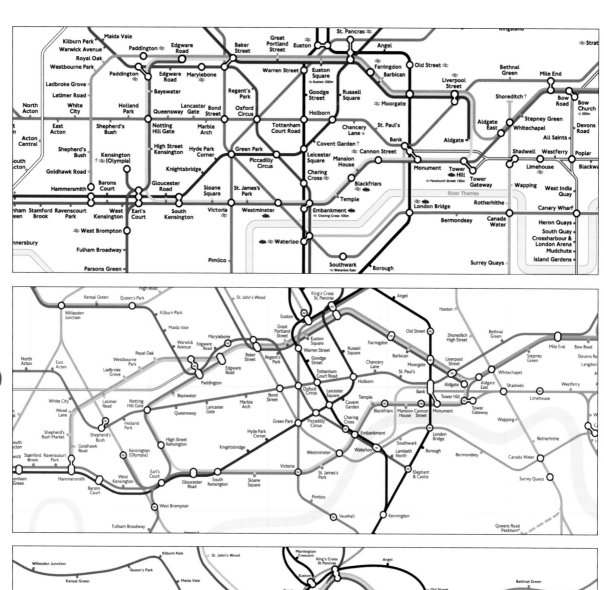

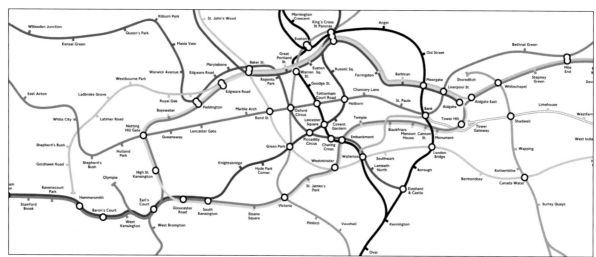

Map or diagram?

Facing page, top to bottom, in (in my view) descending order of clarity:

The current London Undergroud map, based on Beck's original concept;

Mark Noad's redesigned Underground map—or diagram;

A geographically accurate Underground map.

All three of these details are scaled to show the Circle Line (yellow) at the same size east-to-west.

What these three details do not show is the efficiency of the current map over geograhic accuracy. For that comparison, see page 210.

Zero Per Zero is a Korean design firm that is particularly strong in the design of rail system maps. The studio favors large radius corners, compared to the smaller radius corners of the Beckian and Vignelli maps. Occasionally, the designers are prone to visual excess, as in their map of London (detail above), which has a background of a Union Jack, and New York, which is in the shape of a heart. Their entertaining colors and backgrounds occasionally distract from the focus of the information, but are inventive and a lot of fun.

In early 2012 there was an energetic online debate, raised by the eminent Erik Spiekermann, about whether Mark Noad's redesigned London Underground map is a "map" or a "diagram." Why does it matter? The difference between a map and a diagram, as conventionally used, seems to do with intent. "Maps" are generally understood to describe geography—where things are. "Diagrams" are generally understood to show how things work or to visualize numerical and/or statistic relationships. Both maps and diagrams are intended to explain.

Making information understandable requires an understanding of how people process visual correlations of reality, the experiential nature of the reality that the designer is trying to communicate, and of course the needs of the design's users. Understanding a transit system is less about geography and more about how it moves you around.

What Harry Beck realized—although he was not the first—is that simpler diagrams are easier to understand and to retain in memory. What he also realized—perhaps more important—is that the experiential reality of London's Tube system is a different reality than walking around London, in terms of time, space, units of measurement, and user control. You need to know where you are starting, where want to go, and (in this case) which train to take. Unlike walking, you have limited choices and no orienting scenery; unlike flying, you can choose, within limits, when to get off.

What Noad did—and he deserves credit for trying to enhance some inherent limitations of the Beckian design still in use and make a map that corresponds more accurately to the city at grade—is to complicate and reduce a very memorable "image" of the system by making it more true to geography and less to experience. In doing so, he has compromised the system's coherent unit of measure: the stop. You never hear subway users ask how many feet (or miles) to their destination; they ask how many stops. The aspects of Beck's model that Noad is revising are appropriate to the mode: simplicity, clarity of use, and a memorable image are just more important than geographic accuracy; when you walk back up to grade, you are going to require another map, whether your Tube reference was Beck's or Noad's. Like the New York MTA's efforts to combine geography and functional accuracy, Noad's is a compromise that unfortunately adds little real value.

Geographic maps have the advantage of being true to scale—great for walking. Diagrams have the advantage of being easily imaged and remembered, often true to a non-pedestrian experience, and the ability to open up congestion, reduce empty space, and use real estate efficiently. Hybrids— "mapograms"?— often have the disadvantages of both map and diagram with none of the corresponding advantages.

Read Ken Garland. *Mr. Beck's Underground Map.*

Go to http://en.wikipedia.org/wiki/Tube_map

http://sheilapontis.wordpress.com/tag/zero-per-zero/

http://www.fastcode.sign.com/1664692/london-tube-map-sparks-furor-over-what-design-means

http://zeroperzero.com/

See also The road is really straight; Guiding the traveler, then and now; Pages 209–213.

163

5 : FINDING YOUR WAY?

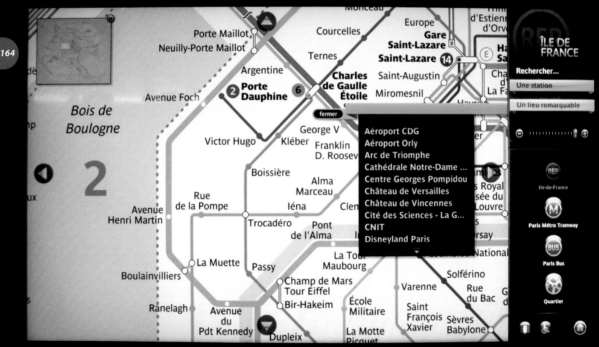

Top. An illuminated route on one of the few remaining PILI maps in the Paris Métro. One-handed photography required.

Above. A screen of the new CRT-screen interactive transportation and quartier guide (PLI) on the platform of Franklin D. Roosevelt station of the Métro 1 line.

Facing page, top. A Métro schedule; below it, a detail of the exquisitely machined and typographically elegant electro-mechnical PILI push-button panel.

Facing page, third from top. A zoomable, scalable map of the Paris Métro. Bottom, a map of the quartier directly above the station (Place Charles de Gaulle is in the center).

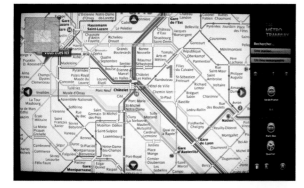

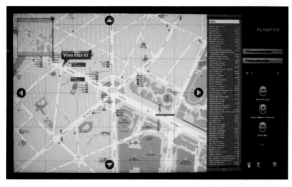

Movement networks can be expressed in any number of mediums, both static and interactive: print, signage, electrical, video.

Print is, of course, static by definition, but it has the advantage of portability, eliminating retention and memory issues characteristic of maps and guides that don't rotate or travel.

The eccentric PILI (*Plans Indicateurs Lumineux d'Itineraires*) map of the Paris Métro was introduced in 1937; there were 184 of them in use by 1961. Unlike today's interactive maps and apps, the PILI was limited and cumbersome, but charming nonetheless.

- The user could only get a route to a destination from the station he was in;

- There was no choice of routes offered, so if you wanted to stop somewhere on the way to your final destination, you would have to plan each segment separately and sequentially, from each departing station;

- The user had to keep his finger on the button of his destination station until he was finished looking; if he was making notes, he had to do it with one hand or have a friend nearby.

Nevertheless, it is an excellent example of information design before information design had a name: intelligent designers and engineers, using the best available technology, collaborating to make a complex system self-explanatory, comprehensible, usable, and beautiful.

Current technology now provides a dizzying array of options, exemplified by the new installation at Franklin D. Roosevelt station. Genuinely interactive, it offers an impressive array of customization, including mode (RER covering the Île-de-France area, Métro, and bus), above-ground maps, station information, variable display scale, and handicapped access information.

Read Mark Ovenden, Julian Pepinster, Peter B. Lloyd. *Paris Underground: The Maps, Stations, and Design of the Metro.*

Go to http://www.youtube.com/watch?v=eu4cfQatyHc

http://thinkvisible.blogspot.com/2011/08/pili-first-user-friendly-interactive.html

See also Navigation: page and screen; Map or diagram?; Information release sequence; Isochronics.

Side platform stations without crossover

Stations with unpaid area crossover

Center platform stations and stations with paid crossover

Transit decision

Offsite

Mode/line decision

Direction of travel/ platform decision

166

Direction of travel decision

Unpaid space

Pay fare decision

Direction of travel decision

Paid space

Platform decision

Information release sequence

Facing page. A diagram of the information release requirements for three types of subway stations in Philadelphia. In many cities with rapid transit, particularly when the lines and stations developed over a long period of time, paving, utility, basement, and foundation constraints have necessitated stations being set up in different ways. In Center City, the three different types of access to rapid underground rail require the release of different categories of information at different points in the ingress sequence.

The transition from pedestrian to bus or subway rider (and the reverse), just as the transition from driver to pedestrian (and the reverse), can be confusing and anxiety-provoking if the experience and the transitions of the modes and systems are unfamiliar.

The are several reasons for this:

- Changes of mode require the user's revising his context, units of measure, expectations, familiarity, and sense of control;

- The sequence is different for every modal change;

- Much of the time, particularly in rail transit, the information the user needs is in discrete steps, all of which may not be particularly simple.

As we have discussed, our retention of information that we are not carrying with us is limited: information needs to be released sequentially, in understandable sets of appropriate simplicity and at the appropriate point in the sequence.

The idea of information release hierarchy is very much like a typical information hierarchy except that it deals with time and place rather than with importance. It also corresponds to decision point theory, which deals with information being released at the point where it is needed for a decision to be made—only the information needed and only when it is needed.

The ingress and egress sequences on the following spread are for subsurface transit modes in Philadelphia and integrate three of the programs I have worked on: The SEPTA Master Plan, Murphy Levy Wurman, 1975; Walk!Philadelphia, a pedestrian wayfinding program begun in 1995, comprised of directional signs and diskmaps; and Ride!Philadelphia, which has two components: heads-up bus shelter maps and historical interpretive graphics, begun in 2005, and ingress and egress signs for Center City's entrances to underground rail, begun in 2007.

Successful information design in movement systems gives the user the information he needs—and *only* the information he needs—at every decision point.

The following information display point should be visible to the user.

Read Per Mollerup. *A Guide to Environmental Signage Principles and Practices.*

Go to http://losu.org/world/subway-systems-of-the-world

See also Interpretation; What's up?

167

Left and right. Ride!Philadelphia includes a series of bus maps on transit shelters. Because Center City Philadelphia is gridded, showing all bus routes would be essentially drawing a grid. This series of maps shows only the buses that can be accessed from *one of the buses that runs on the street the bus shelter is on. All maps are heads-up relative to the way the user is facing, and all buses on that street run from right to left.*

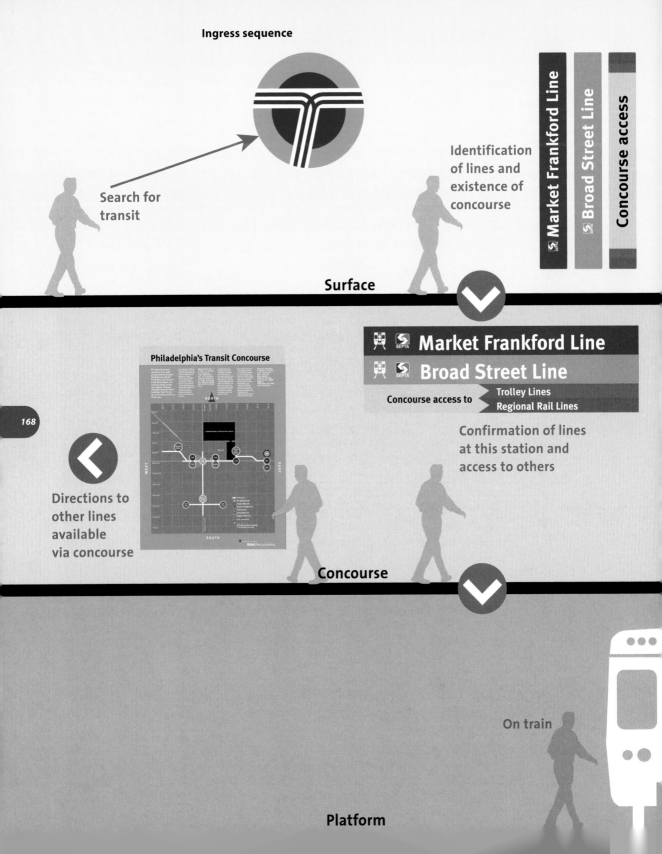

Ingress sequence

Search for transit

Identification of lines and existence of concourse

Market Frankford Line

Broad Street Line

Concourse access

Surface

Philadelphia's Transit Concourse

Market Frankford Line

Broad Street Line

Concourse access to
Trolley Lines
Regional Rail Lines

Confirmation of lines at this station and access to others

Directions to other lines available via concourse

Concourse

On train

Platform

168

Egress sequence

**Pedestrian wayfinding system:
directional signs at every corner;
diskmaps at every mid-block;
bus maps at every bus shelter**

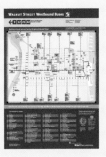

Surface

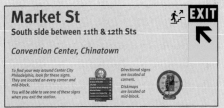

**Description of grade resources
and of pedestrian wayfinding
if there is a concourse level**

Concourse

Off train

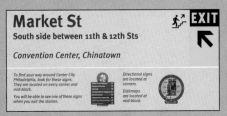

**Description of grade resources
and of pedestrian wayfinding
if no concourse level**

Platform

Isochronics

On previous pages we discussed the importance of uniform scale both for comparing data and for understanding the scale relationship among maps as parts of a whole; and, in road atlases, of contiguity and consistent orientation of maps of places adjacent to each other.

None of these valid and worthwhile arguments for consistent, geographic scale addresses the idea of using scale—and, by implication, measurement—to reflect the experience of movement using modes of movement that contradict fixed, geographic scale and measurement.

In thinking about the pedestrian experience, time and small units of distance are used almost interchangeably: it's three blocks that way; or, it's 10 minutes away. As the distances and times become greater, requiring driving, we often use different, larger, mode-appropriate units of measurement when the number of smaller measuring units becomes too large: take a left after five stoplights. Taking buses, we depend on the vehicle's automated announcements, try to read street signs, or ask another passenger.

As we transition to movement modes where references to the streetscape are lost—underground or in the air—new units of measurement emerge: the subway stop; the departing and arriving terminal. Time slips out of our control: in the subway, we can get on and off only at stops.

In our discussions of scale, we have assumed—as we all do, almost all the time—that the scale on any pedestrian map is consistent, just as it is usually safe to assume that, since Beck, the scale on any transit network map is variable. Whether the variability is a function of an efficient use of map real estate, or of experiential units of measure (in the case of rail transit, the stop), or of the designer's whim (which one hopes is responsible) will vary from map to map and context to context.

We do know, in any case, that the experience of the environment as a pedestrian is an experience of variable scale to the extent that movement and distance are related to time. It's no coincidence that subway stations are closer together in dense commercial areas and less so in less dense residential neighborhoods or suburbs. More people come and go to and from dense areas, and there is more of interest to catch their eye, attract them, and, consequently, slow them down.

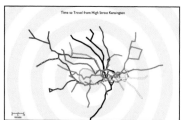

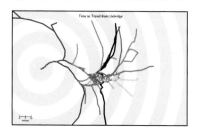

Facing page. Two isochronic maps for London's Underground. Fare zones tend to be based on geography. As a result, and a bit ironically, Noad's fare zone map, described less flatteringly on page 163, has more regular fare zone shapes than the map based on the current iteration of Beck's map, which uses the stop as its unit of measure.

Facing page. An experimental site by Tom Carden that shows time from any stop to any stop on the London Underground. It works by the user choosing a departure stop, which is then placed in the center of a time target. The project is not yet completed. His website cites notable sources of inspiration.

So the stop, as a unit of measure, in a way relates to experiential time: you move faster—distance being equal—when there is less to capture your attention.

Other factors are at work, too. When walking, topography plays a significant role: we can walk faster on the level than we can walking uphill; we can walk faster if our legs are longer. Most of us can walk faster when we're younger, or in a hurry. So the 5- or 10-minute walking circles in pedestrian maps in many cities are at best an average guesstimate and at worst misleading. They don't show the impact of topography, nor can they take into account the interests of the walker, or the density of interesting places or shops that will slow her down. Even though geographic mapping is appropriate for the pedestrian experience, constant geographic scale of a map rarely conforms to consistency of rate of movement.

Thinking about these issues led me to the world of fine art, which exhibits degrees of abstraction that can be seen as analogous not only to the movement experience but also to the aspects of cartography that reflect them. A matrix of these relationships appears on the following spread.

Walking is more like a realistic portrait, while flying is more like a simple abstraction (the Malevich on the following spread could also be a Rothko).

Read Chris Calori. *Signage and Wayfinding Design: A Complete Guide to Creating Environmental Graphic Design Systems.*

Go to http://www.tom-carden
.co.uk/p5/tube_map_travel_times/
applet

http://www.oskarlin.
com/2005/11/29/time-travel

http://www.wired.co.uk/news/
archive/2011-11/15/timemaps

See also A movement network geneology; Map or diagram?

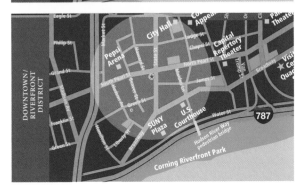

Unlike Center City Philadelphia, Albany rises steeply northwest of the Hudson River. These two maps show the impact of topography on a standard 5-minute walking circle. One can travel further in five minutes walking downhill than uphill.

Analogies in painting and sculpture

	Pedestrian	Local light rail or bus
Movement mode	Pedestrian	Local light rail or bus
Experiential characteristics	Geographically realistic Engaged with the environment Very much control	
Distance characteristics	Neighborhood walking distances	City or neighborhood distances
Map type	Geographically accurate map	Geographic map with diagrammatic characteristics
Unit of measure	Mile/kilometer, block, foot/meter, pace	Stop, street, block
Scale	Fixed	Relatively fixed
Compass orientation	North-up convention	Heads-up desirable
Map/diagram example	Map for an architectural walking tour 	Proposal for a new bus map for Rome
Artistic equivalent	Thomas Eakins Auguste Rodin 	Amedeo Modigliani Alberto Giacometti

This spread describes the characteristics of maps appropriate to five different movement modes, with examples of painting and sculpture that could be analogies for the same experiential characteristics.

Metro area rail or bus; rapid transit; main arterial roads	Long-distance (city-to-city) rail or bus; limited access highway or interstate	Commercial airplane or ship
		Abstract No environmental interaction No control
Regional or metro area distances	Long distances	Great distances
Diagrammatic map with geographic aspects	Diagram with cartographic aspects	Concept or functional diagram
Intersection, stop, street	Exit (interstate), city, stop (city)	Continent, country, airport
Flexible and modally appropriate	Extremely flexible/variable	Extremely flexible to nonexistent
Heads-up desirable but flexible	Optional	Unnecessary

Diagrammatic road and rail on a quasi-geographic base

Philadelphia rail system

Abstract map of ancient Egypt

Willem deKooning
 Pablo Picasso

Georges Braque
 Pablo Picasso

Kasimir Malevich
 Constantin Brancusi

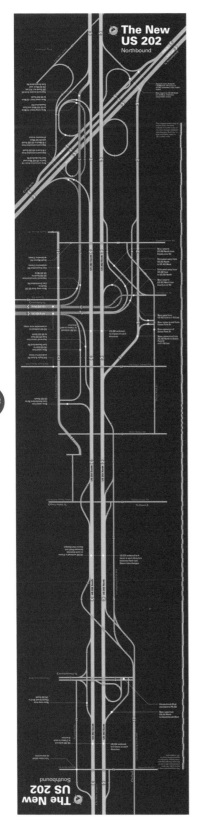

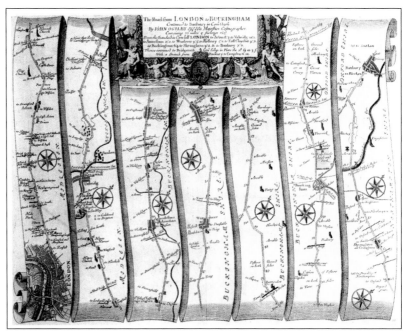

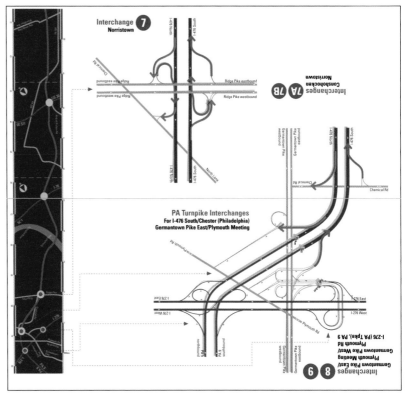

The road is really straight

Facing page, far left. A heads-up map for a reconstructed highway that is essentially north-south. The map, 8 x 36", can be rotated 180° so that the user can read the changes being made in the direction he will be driving.

Facing page, near left. John Ogilby's "The Road from London to Buckingham," 1675. The original, of course, was uncolored; the English tend to color old maps the minute they walk in the door, and it is difficult to find maps that haven't been recently colored for tourists.

I once asked a dealer about an Ogilby, "Is the color contemporary" (meaning "contemporaneous")? "Yes," the dealer replied. "When?" I asked. "Last week."

Facing page. Two pages from a horizontal brochure that, like two-in-one books in the 1950s (known as dos-à-dos—*back to back), can be opened from both sides. It was a way of addressing the fact that exit names and numbers can be different depending on the direction of travel.*

John Ogilby's 1675 (the year before his death) road atlas, *Britannia*, cited also on page 160, was notable for several innovations as well as its elegance of drawing:

- The use of a virtually constant scale (1"=1 mile, or 1:63,360);

- The scroll device; and

- For me the most important, his heads-up technique, in which he drew his roads essentially as straight lines and rotated the compass rose as necessary.

This device, as ingenious as it was to accommodate the necessary road length in an 18 x 14" format, articulated a fundamental observation of the movement experience: the road is straight! Imagine a 17th-century traveler in his horse-drawn carriage or wagon; unless directed otherwise, the horse just follows the road.

We can see how Ogilby's logic anticipates 20th-century transportation and cartographic innovations, from Beck's iconic map to the straight-line interstate maps of the '70s, to virtually every transit system map of the later part of the 20th century up to the present.

Of course, Ogilby's road atlas had one limitation: if you were going from London to Buckingham, all your information was heads-up; if you were going from Buckingham back to London, not so much. So, Ogilby created *half* of a heads-up map, certainly no small achievement.

Just as freestanding signs have two faces, an aspect of physics often forgotten, roads can usually be traversed in two directions. Many maps notwithstanding, the exits from high-speed limited access roads often have different exit numbers and access different destinations, an argument for maps of a scale adequate to recognize and reveal different information depending on direction of movement.

Read James R. Akerman. *Cartographies of Travel and Navigation.*

Go to http://www.fulltable.com/vts/m/map/ogilby/b/a.htm

http://www.gracegalleries.com/English_Road_Maps.htm

See also A movement network genealogy; Map or diagram? Transitions and familiarity; (Ir)rational innovation; Pages 208–213.

You can only drive in one direction at a time.

Detail of a group of strip maps created for ARCO in the 1960s by the H. M. Gousha company, back in the days when maps were free at gas stations. The "strip maps" feature a rotating north and, unlike Ogilby, a changing scale based on the density of cartographic information.

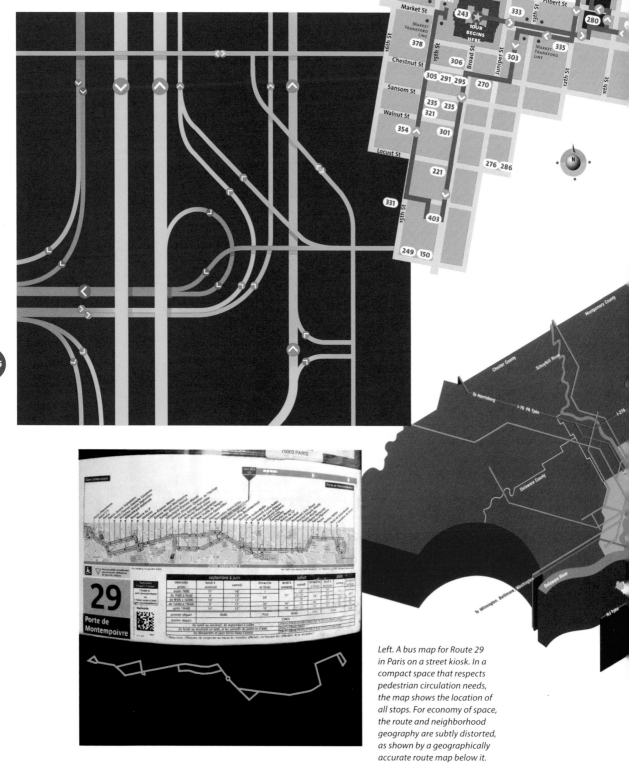

Left. A bus map for Route 29 in Paris on a street kiosk. In a compact space that respects pedestrian circulation needs, the map shows the location of all stops. For economy of space, the route and neighborhood geography are subtly distorted, as shown by a geographically accurate route map below it.

Transitions and familiarity

Facing page, far left. Detail of a highway map (shown on the previous spread) that uses color to denote road type and name (blue, violet, and yellow for limited access highways, green for local roads) and gradation to show the transition from one highway or road type to another.

Facing page, near left. A typical and appropriate map for pedestrians, geographically accurate.

Having it both ways. *A map that shows man made features (road and rail) in a diagrammatic vocabulary and natural features and county boundaries in a geographic vocabulary with variable scale. To accommodate all the road and rail activity, Philadelphia city-county (in gray) is shown twice a big as it really is, but the geographic vocabulary masks this discrepancy and the map is geographically convincing.*

The significant differences between the transit experience (particularly underground) and the pedestrian experience notwithstanding, the transit rider, the driver, and the pedestrian unfamiliar with where he is, where he is going, and how he is getting there are united by their need for maps and the need, very often, to switch from one map to another with a minimum of anxiety and confusion.

Most road atlases and pedestrian guides are rigidly geographic; most rail transit maps are not. Moving from one type of map to another as one changes movement modes—from airplane passenger to subway rider to driver to pedestrian—can be difficult. There are, both in theory and in practice, ways of dealing with this fundamental conflict between a map that works best for a particular mode and maps that play nicely with each other.

- Distort a geographic map to only an insignificant degree so that the user either doesn't notice or doesn't care that its geographic accuracy is somewhat "adjusted." Paris bus maps do this on a universal (and imaginative) basis in order to simplify the map, to have room for the stop names, and to fit the map into a limited space on pole-mounted kiosks on sidewalks.

- Consider that humans have built sidewalks, roads, subways, and rail lines, but nature (for the most part) created rivers and shorelines. A river or coastline with a recognizable shape and path, even if simplified and modestly distorted, may help a user move from diagrammatic to geographic maps and back.

- Highways don't collide or run into each other, they transition to and from what Los Angelenos picturesquely call "surface" streets. As one drives onto or off an expressway, he is transitioning not merely from a larger or a smaller road but experientially to a different mode, a difference in kind as well as degree. Traditional road maps use weight and notation to denote changes in road type, but they don't often reflect the transitional nature of the change.

Read John Andrew Gallery. *Philadelphia Architecture: A Guide to the City, Third Edition.*

Go to http://attoma-tm.com/activite/cartographie/2011-07-28/sytral-systeme-d-information-voyageurs-du-reseau-tcl-lyon (in French)

See also A movement network genealogy; Map or diagram?; The road is really straight; Pages 211–212.

The layout and naming of transit lines or city streets is an important part of a city's personality, how it is perceived, how it is used, and how easy or difficult it is to map. Streets and routes are a city's arteries and veins, and understanding and identifying them is not unlike visualizing and understanding the organs of the human body and their function. As a directionally challenged person, I do fine in Philadelphia and Manhattan but horribly in Paris and Rome, and maps for me are not just an avocation but also a survival strategy.

The more recently a city developed, the more likely it is that its layout and nomenclature may have some order and logic. Manhattan is a prime example, having an orthogonal grid with numbers for the street names on both axes; so is Center City Philadelphia to a less pure extent (and slipping), and Washington, DC, still less but not without good intentions. London, Paris, and Rome are the opposite—chaos, due to their accretion over time and the vision of leaders in power, in Rome from Pope Sixtus V (served 1585–1590; good) to Mussolini (served 1922–1945; less good). The United States just hasn't had that much time.

London uses names for its underground lines, one of which has meaning (the Circle Line); Paris uses numbers with a subset of termini; New York uses both numbers and letters—numbers for the former IRT lines, letters beginning with *A* for the former IND lines, and letters beginning with *N* for the former BMT lines; Boston uses colors, which its unique configuration makes possible.

Determining the success of these many transit naming strategies is not Biblical but pragmatic and contextual. For me, Boston's color coding is brilliant—and lucky; Philadelphia's SEPTA briefly had a general manager who tried to rename its lines by color, like Boston, without understanding how it worked. New York's naming is neither brilliant nor lucky. Perhaps if it had entirely cast out the past tripartite arrangement, which will seem more and more arbitrary as time passes, it would enjoy a more successful result.

London and Paris have a lot of lines, like New York, but I don't find them as confusing, perhaps because for the most part they don't share trackage as much as New York, so they image well.

Service is as important a contributor to clarity as nomenclature and coding. Extensive service variation and trackage sharing seems to be largely an American issue; in London and Paris, trains for the most part run from early morning to late at night essentially the same way, differing in headtimes at usage peaks. As a result, London's Circle Line and Paris's 1 line are each one line on one pair of tracks—no 4, 5, and 6 (New York) or A and B (Philadelphia). So, the Vignelli map, in either iteration, was not an excessive design compared to London and Paris; like those maps, it reflected the reality of the service.

Michael Bierut writes eloquently of this map's history, focusing principally on the issue of geographic distortion, using the proportions of Central Park as an example: a square on the Vignelli map, in actuality three times as long as wide. My own feeling is that anyone trying to use a diagrammatic subway map to plan a walk in the park is a fool.

Addresses are the device we use to find our way around places, usually cities. In most Western cities one of two systems are used: numbers ascending up one side of the street

The best address can be a picture. These pictographic subway stop designators, developed by Lance Wyman in 1968 for the Mexico Olympics (and a vastly simpler subway system than now exists), addressed the needs of both non-Spanish-speaking visitors and residents who might be illiterate.

Above. House numbers in Japan.

and down the other; or odd numbers ascending up one side of the street and even numbers ascending up the other side. This does not hold true in Venice (and certain other Italian towns), where street or square numbers have been assigned chronologically, preceded by the name of one of her six districts (*sestieri*), for example, Dosodoro 3127.

This, however, is fairly straightforward compared to addresses in Japanese cities, such as Kyoto (other Japanese cities do it differently). Too complicated to summarize, the address of the Kyoto Tower is Karasuma-Shichijō-sagaru, Shimogyō-ku, Kyōto-shi, Kyōto-fu, 600-8216, or, in its abbreviated form, Karasuma-Shichijō-sagaru, Shimo–, Kyō–, 600-8216.

Addresses are another example that ego—like the universe—seems to expand without limit. The result of this is an increasing use of addressing buildings by name (owner, tenant, or important nearby location) rather than by street address. In Philadelphia, there are 11 buildings named "[number] Penn Center," which happens to be between Market Street and JFK Boulevard. There is an Aramark Building (also on Market Street), and three buildings named "[number] Logan Square," which are not on, nor within a block of, Logan Square.

Renaming streets, roads, and highways in honor of local or national heroes as well as corporations is also popular. East River Drive in Philadelphia is now Kelly Drive (named for Grace's brother, Jack, an Olympic rower) and West River Drive is now Dr. Martin Luther King Jr. Drive. The drives were originally named for the way one-way traffic went during rush hours, no longer the case; the former East River Drive is both east and north of the Schuylkill River and the former West River Drive is both west and south of the river.

Never change the name of a street whose name includes:

a number;

a letter;

a compass direction;

a name that is part of a set.

Go to http://en.wikipedia.org/wiki/Japanese_addressing_system

http://en.wikipedia.org/wiki/House_numbering

See also Is a picture worth 1,000 words?; Pages 210–212.

How do you find it? A map showing buildings named One, Two, and Three Logan Square, respectively. The web gives the "main" address of Two Logan Square as 100 North 18th Street and its "virtual" addresses as 1801 Arch Street and 1800 Cherry Street, any of which would be fine with me.

True 4.3

1939 3.5

1948 3.1

1959 2.5

1972 Vignelli 2.4

1979 2.7

2010 MTA 2.4

Kick-map 2.7

Above. Manhattan's ratio of width (east-west) to height (north-south), expressed as width equal to 1.
Below. Percentage of width to height, expressed as a decimal.

.23 .29 .32 .40 .42 .37 .42 .37

The evolution of MTA maps, beginning in 1939. Manhattan got consistently fatter up to the Vignelli map in 1972, and has since slimmed down; the current map is only marginally slimmer than the Vignelli map, but the Vignelli occupies a larger area and appears beefier because of its vocabulary.

Below. The current MTA map.

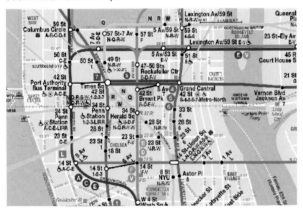

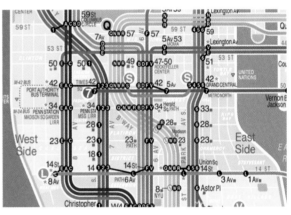

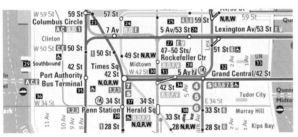

Stephan Van Dam has a long history of designing and producing lucid and handsome city maps (particularly of New York) in handy and interesting formats. This one, while mapping trackage rather than routes, nevertheless achieves a clarity and simplicity that the new MTA map lacks.

Not newer but better.
Beginning in 2007, Kickmap introduced a map that exceeds in logic and usability the MTA maps that have preceded and followed it, which has been expanded to the new vade mecum medium, apps for smartphones and tablets. Anticipating to some extent the Vignelli revision in 2008, it is nevertheless richer (one might say, too much richer) but is way out in front of competitors in terms of its intuitive information hierarchy.

(Ir)rational innovation

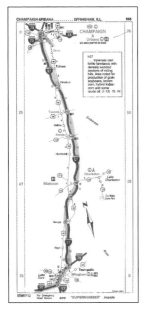

Newer but not better. *These two examples of AAA's Triptik reveal an evolution from simple, clear, two-color heads-up strip maps to more book propor-tion, full-color, north-up maps that, while significantly larger in scale than the maps in road atlases, have lost most of the clarity and distinctiveness that characterized the originals. I assume that these are much less expensive to produce and draw on current mapping technology.*

Vignelli's innovation in 1972 was to show routes rather than tracks. In many rail systems, different routes share the same tracks. If all that is shown are tracks, the problem is how to show the routes: it is usually both an issue of identification (as in alphanumeric designations) and of color (what do you do with the color, if anything, when the routes and tracks diverge?). The 1972 Vignelli map was a riot of arbitrary colors; the 2008 map is a model of both clarity and restraint.

Why is this not a problem in London? Where are the many routes that share trackage? The answer is twofold: 1) regu-larity of service; and 2) unshared trackage. The Underground has relatively no service variation: the route you get on runs the same way all day every day (allowing for certain holidays and rare specialized exceptions). The Circle Line runs the same way on the same tracks all the time; so do the District Line and the Central Line. When they share trackage, it is shown.

But they don't very often, unlike in New York. It is unlikely that this was a decision made for the convenience of the public (or Harry Beck and the Underground's subsequent map designers), but it was a gift: the more complex the service, the more challenges confront the designer.

Go to http://www.nytimes.com/interactive/2010/05/27/nyregion/new-ny-subway-map.html?scp=1&sq=an%20overhaul%20of%20an%20underground%20icon&st=cse

http://observatory.designobserver.com/entry.html?entry=2647

http://www.designboom.com/weblog/cat/8/view/2891/nyc-subway-diagram-2008-by-massimo-vignelli-for-mens-vogue.html

http://tmagazine.blogs.nytimes.com/2011/09/16/ahead-of-its-time-an-icon-goes-digital

http://kickmap.com

See also A movement network genealogy; Map or diagram?; Transitions and familiarity; Page 211.

Movement network maps highlight the conflicts between functionalism (how it works), rationalism (how it should work), experientialism (how it feels), and geography (how it "actually" is).

Three ways of alphabetizing maps

1	Albertson House
2	Anderson Hall
3	Architecture Bldg.
4	...
5	...
6	...
7	...
8	...
9	...
10	...
11	...
12	...
13	...
14	...
15	...
16	...
17	...
18	...
19	...
20	...

4	Albertson House
14	Anderson Hall
16	Architecture Bldg.
3	...
17	...
8	...
6	...
9	...
18	...
12	...
20	...
11	...
1	...
5	...
15	...
2	...
19	...
7	...
13	...
11	...

1	...
2	...
3	...
4	Albertson House
5	...
6	...
7	...
8	...
9	...
10	...
11	...
12	...
13	...
14	Anderson Hall
15	...
16	Architecture Bldg.
17	...
18	...
19	...
20	...

Legend in alphabetical and numerical order. The map is therefore numerically arbitrary.

Good for identifying a building from the map to the legend.

Less good for finding on the map a place that you want to go to if all you know is its name.

Legend is in alphabetical but not numerical order. The map is numbered in a rational sequence, say northwest to southeast.

Good for finding a location on the map from the legend.

Less good for finding the name of a place in the legend from the map.

Legend is in numerical but not alphabetical sequence. The map is numbered in a rational sequence, say northwest to southeast.

Good for finding the name of a place in the legend from the map.

Less good for finding locations you know the name of on the map vy using the legend.

Far left. Alphabetical and numerical order, as the example in the same column.

Left. Alphabetical but not numerical order, as the example in the same column.

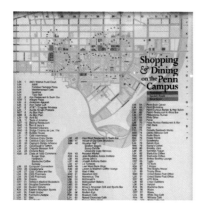

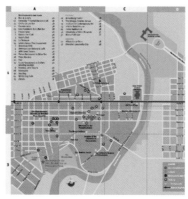

182

Perils of alphabetization

No alphabetization when you need it. *The sequence of vote totals in this at-large City Council vote is inexplicable. It's not alphabetical (either by first or last name); it's not by vote totals. A true enigma.*

The organization of information is familiar to us from middle school, when we learned to make outlines for our papers, which required establishing a structural organization and a hierarchy of our material. Once we structured and organized our content, there were no alternatives. The reader—our instructor—may not have fully agreed with our structure, and he could tell us so, but he had no alternative to reading it the way we wrote it.

Alphabetization is one of a number of possible ways of organizing a map legend (numerical and spatial being two of the others).

Richard Saul Wurman came up with the acronym LATCH for the five finite ways of organizing information: Location; Alphabet; Time; Category; and Hierarchy. This of course applies to all information, not just map legends.

Designing a map to help us find our way around a campus, a district, or a city is similar, except that we need to know who is going to use it and how. Because there is no organization of a map and its legend that will work well for all conditions and users, we need to model the user segments and prioritize them. As the examples on the facing page illustrate, every map/legend structure offers advantages and disadvantages. The client and designer need to try to understand how the majority of users (or the most important users) are most likely to use the map.

Go to http://www.informit.com/articles/article.aspx?p=130881&seqNum=6

See also Service, naming, and addressing.

Organizing a map legend that functions for its intended users is not as simple as just alphabetizing the destinations.

11	Fontane Oscure
12	Fontana dei Cavalli Marini
13	Fontana dei Pupazzi
14	Monumento a Umberto I
15	Casino dell'Orologio
16	Tempio di Antonino e Faustina
17	Monumento all'Alpino e all'Umile Eroe
18	Museo Pietro Canonica
19	Silvano Toti Globe Theatre
20	Fontana dei Mascheroni e dei Tritoni
21	Casina di Raffaello - Ludoteca
22	Tempio di Diana
23	Fontana del Sarcofago
24	Monumento a George Byron
25	Casa del Cinema [Casina delle Rose]
25	Cinecaffè Casina delle Rose
26	Propilei delle Aquile
27	Cinema dei Piccoli
28	Monumento a Wolfgang Goethe
29	Mostra dell'Acqua Felix

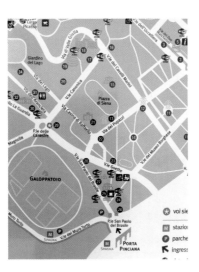

This map in the Borghese Gardens in Rome is organized numerically geographically: numbers are placed rationally on the map, so you can find out what is near you. However, if you are looking for a particular destination, say, the Casa del Cinema or the Globe Theatre, it will be extremely difficult to find without reading the entire legend.

The Anderson "Map of Midtown Manhattan," 1985, took Constantine Anderson 20 years, working alone, and reportedly shows every single window, door, awning, even telephone booth and mailbox in Midtown. It is in the same genre as the Herman Bollman map of 1962 and the Tadashi Ishahara map of 2000.

Anderson's map has a lightness that the others lack because of its sparing and restrained use of color. Bollman's and Ishahara's maps, not shown here, are weighted down by their palettes, which are unappetizingly confectionery and which emphasize the roofs.

Below. A detail of the 21-sheet Turgot map of Paris (1739), commissioned by Michel-Étienne Turgot, in isometric projection. The widening of the streets and changes in scale of objects such as boats is subtle and convincingly done.

Right. The view of the Pompidou on this north-up map is actually of the west-northwest facade.

Two views from Stephan Van Dam's "4Dm" flythrough of Manhattan. Van Dam is also the inventor of the Unfolds pop-up maps that are in the collection of the Museum of Modern Art.

The view from below—or above

Confusing tourists. Most of the buildings on the map at near left on the facing page are shown with their most important facade facing the user (because the map is north-up, the implication is that they are all south facades). By the law of averages, this is likely to be right about 25% of the time. Two obviously glaring errors are the Pantheon and the Vittoriano, both of whose principal facades face north. The Spanish steps are a little off, and it seems that the Trevi Fountain and the Vatican are correct by happenstance; the Colosseum is round. Intended particularly to help tourists, this map (which is online but unsourced), may have (and has had) the opposite effect.

Good in one orientation, less good in another. The perspective below, on well-designed and well-placed kiosks in the Jardin des Plantes in Paris, works really well when north is at the top, clearly the orientation in which the view was drawn. When rotated 180° (you can tell by the street name), below right, one gets a slight feeling of vertigo, the liability of this type of "exploding" perspective.

Do the facades of all important buildings in Rome really face south? Not the last time I looked. One night in Rome, my wife and I agreed to meet at a restaurant on a street about two blocks north of the Pantheon. She had a map, and we were talking by mobile phone. "Face away from the front of the Pantheon, " I said, "and walk two blocks." She called back. "I did; I followed the map, and I keep walking toward the river." Blessed with a fine sense of direction (unlike her husband), she was undone by using a map like the one on the facing page.

These disorienting map-views are an all-too-common example of visual misinformation, combining an accurate plan map with accurate building facades oriented in the wrong direction to completely confuse the user.

The limitation of bird's-eye maps is that, by definition, they show a lot of roof. And, depending on the bird's perspective, it is likely that a building closer to the bird will obscure some very important aspect of a building farther away. Choosing the location of the bird is also extremely important, as it can see at most only half of a building's facades.

The same is true of isometric and axonometric projections, such as the Anderson and Turgot maps on the facing page, which allow much more freedom to widen sidewalks and streets and manipulate scale to maximize real estate and the visibility of facades.

A use for tall buildings. In this bird's-eye view looking east (not current), the campus becomes congested and unreadable even in the near distance.

In this east-up map, for the MIT Campus Plan, below right, the one really tall building on the Main Campus is used as an orienter, just as it would be in life.

What good is a bird's-eye view if you're not a bird?

Read Pierre Pinon et al. *Les Plans de Paris: Histoire d'une capitale.*

Go to http://www.codex99.com/cartography/110.html

http://edb.kulib.kyoto-u.ac.jp/exhibit-e/f28/f28cont.html

http://www.theatlantic.com/entertainment/archive/2011/08/sexy-ipad-maps-a-designers-interactive-new-york-streetscapes/243110

http://www.paradoxplace.com/Perspectives/Maps/Map%20index.htm

http://www.vandam.com

See also What's up?; Guiding the traveler, then and now; (Ir)rational innovation; Page 216 top right.

185

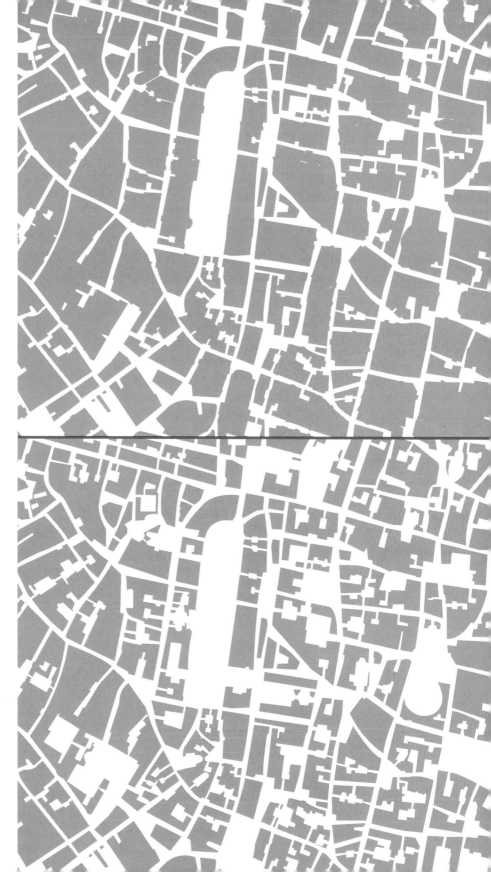

The difference between conventional mapping of enclosed public space and Nolli's is readily seen.

Right. A simplified representation of most maps even up to the present day: only streets, alleys, and unenclosed open spaces, such as squares and parks, are shown as open; all other spaces are shown as "closed."

Below right. The same section of Nolli's map showing all accessible space, including courtyards and public and church interiors, as open. It is easy to see how much more space is available to the public than is conventionally shown.

Urban open space

In 1748, Giambattista Nolli published his radical and transformative map of Rome. Much of Italian urban architecture was courtyard-based, with exteriors presenting a uniform street presence (sidewalks were, and remain, improbably narrow) and an entrance opening on to a public interior (churches) or a large interior courtyard (public buildings, *palazzi*, universities). Unlike today in many cases, those courtyards were open to the public, who entered them to conduct business.

Unlike preceding maps, Nolli represented these enclosed but accessible public and religious spaces as open space, which was as true to the pedestrian experience of Rome of his time as Beck's London Underground map is true to the experience of using the Tube today.

Marco Fabio Calvo, who died in 1527, was a Roman translator and cartographer. His *Antiquae Urbis Romae cum Regionibus Simulacrum* purports to represent street maps of each of ancient Rome's *rione*—districts—and includes the four maps of Rome above right. These maps are fascinating not for their accuracy but for their integration of the fanciful, the iconic, and the symbolic.

Go to http://nolli.uoregon.edu/

http://cluster3.lib.berkeley.edu/EART/maps/nolli.html

www.studiumurbis.org

http://rubens.anu.edu.au/htdocs/bytype/prints/piranesi/display00142.html

See also Non-wayfinding cartography; The view from below—or above.

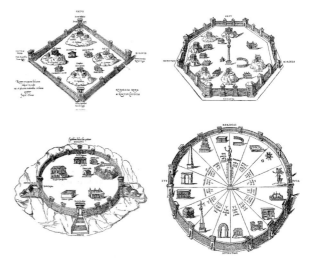

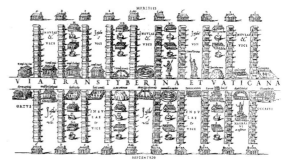

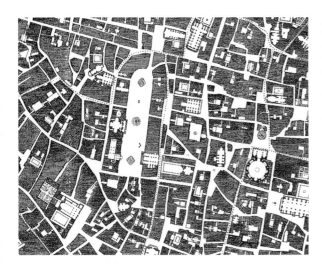

A section of Nolli's "Pianta Grande di Roma" with Piazza Navona just to the west of center and the Pantheon to its east. Commissioned by Pope Benedict XIV, the map was used in government planning for the city of Rome until the 1970s and served as a base map for all Roman mapping and planning up to that date.

Always conscious of image, Calvo's work is an early and delightful example of the cartographer's desire to impose order on urban chaos, a dream doomed to failure that he pursued by making stuff up. At top, the four "maps" of Rome are in sequence clockwise from upper left. Below them is the rione of Trastevere, equally symbolic and fanciful.

6

Documents

Stories, inventories, notes

Documents create a paper reality we call proof.

Mason Cooley

Don't put my name on it. These are simply documents I make.

Man Ray

Boxes of documents in the Archives nationales in Paris.

Credits

Section 1: Aspects of information design

All diagrams, designs, and photographs not specifically cited on the following pages are by the author and are noted below.

Section 1
14, 16, 17, 22 bottom, 23 bottom, 27 top, 28 left, 30 top and bottom, 35 left, 38 top.

Section 2
42, 43 bottom left, 44 bottom, 45, 48, 51 right, 52 top and bottom left, 54 top, 56, 57 left, 58, 61 top, 62 top left, 62 center right, 62 bottom left, 63, 64, 65, 66 center 67 right center, 71–73, 74 top, 75 right.

Section 3
78 center, 82, 84–85 left, 88–89, 94 left, 98 center, 99 right, 100, 106, 108, 110 bottom.

Section 4
112, 114, 118, 118, 119 right, 129 left, 129 right, 130 top center and right, 131 top, 134, 136 bottom, 137 left, 139, 143, 150 bottom left.

Section 5
154 top, 155 top left, 155 right, 156 top and center, 157, 161 left center, 164–165, 166, 168–169, 171, 172 top center and right, 173 top left and center, 174 left and bottom right, 176, 179 bottom, 182 top, 183 bottom, 184 right center, 185 bottom right,

Section 6
188, 192 left, 196 bottom left, 204 top, 204 bottom left and center, 205 center and bottom, 206, 208 left center, 209 bottom left, 214–217, 223.

Projects by Joel Katz Design Associates (JKDA) with contributions by other designers are credited following.

Page 12 top
Reconstruction of Irish road sign meaning "unprotected quay."

Page 12 bottom
The OPTE project. http://opte.org
This project was created to make a visual representation of a space that is very much one dimensional, a metaphysical universe. The data represented and collected here serves a multitude of purposes: modeling the Internet, analyzing wasted IP space, IP space distribution, detecting the result of natural disasters, weather, war, and esthetics/art.

Page 15 lower left
United States Army, www.psywarrior.com/DeceptionH.html

Page 15 right
From *Unser Aller Hitler*, Berlin, Nibelungen-Verlag, 1940. My uncle brought this booklet back from his service in World War II. Photographer uncredited.

Page 18
Advertisement in the *Philadelphia Inquirer*, 30 December 2011.

Page 19
Patient Protection and Affordable Care Act, P.L. 111–148; Health Care & Education Reconciliation Act, P.L. 111–152. Prepared by: Joint Economic Committee, Republican Congressman Kevin Brady, Senior House Republican Senator Sam Brownback, Ranking Member; www.freerepublic.com/focus/f-news/2650278/posts

Page 20 bottom left
Henry and Elsa Spalding. *Catholic Ladder*, 1845. Oregon Historical Society. Some of the symbols represented are:

(1) Heaven, Angels, and the 6 days of Creation;

(2) Noah's Ark;

(3) the Ten Commandment;,

(4) Elizabeth and Zachary;

(5) Star of Bethlehem, Jesus, Mary, and Joseph;

(6) The Twelve Apostles;

(7) The Reverends Blanchet and Damers.

Page 20 top right
Günther Zainer. The first page of Chapter XIV of the *Etymologiae of Isidore of Seville*. Augsburg, 1472.

Page 20 bottom right
"Overall presence of gang members in New Jersey, 2010, by county." Student assignment at Philadelphia University for the New Jersey State Police Gang Survey, 2011. Designer: Andrew Wozniak.

Page 21 bottom right
Two diagrams of Neighborhood Stabilization Program grants, for the National League of Cities, by students at The University of the Arts, 2011. Designers: Linzi Eggers, Minji Kwon, Richard Cardoza.

Pages 22–23
Charles Joseph Minard. "Figurative Map of the successive losses in men of the French Army in the Russian Campaign 1812–1813" (English translation; original in French). Paris, 1869. From *The Visual Display of Quantitative Information*, by Edward R. Tufte. Cheshire, CT, Graphics Press, 1983.

Page 22 bottom left
Data source: https://docs.google.com/spreadsheet/ccc?key=0Ai8gHZcVcFtQcDlwUXRidjAwM0hGTExyd21tbFdtTVE&hl=en#gid=0

Page 24 top
Artist: Jer Thorp. "For more information, and source code to access the NYTimes API, visit my blog: blog.blprnt.com. Built with Processing v1.0 - www.processing.org. http://www.flickr.com/photos/blprnt/3291287830/in/set-72157614008027965"

Page 24 bottom
Analysis of Banque Nationale de France by Kahn+Associates, Paris. Information architecture: Laurent Kling; design: Ralf Bähren.

"As the Internet has grown, the great libraries of the world have become accessible from the web browser. How should the great national libraries use the new communication channel connecting their vast collections not only to their own citizens, but to the entire global internet audience?"

Page 25 bottom
From *Pasta by Design,* by George L. Legendre. New York, Thames & Hudson, 2011. Pages 172–173.

Page 26 top left and center
Two parking signs on Walnut Street, Philadelphia; the more recent, in the center, is the information on which the students based their work.

Page 26 top right and page 27 bottom
A student project at the University of the Arts. Designers: Brian Alexandrowicz, Tara Taylor, and Charles Wybierala, 2010.

Page 26 bottom left and center

Two pages from the RFP (request for proposal), by the Philadelphia Parking Authority in-house staff, that led to the signs of which the top center image is an example.

Page 28 top

Lokesh Dhakar, www.lokeshdhakar.com

Page 28 bottom

David Staffell, www.inkslip.com, david@dsfit.co.uk

Page 29 left

Photograph of Massimo Vignelli by Beatriz Cifuentes.

Page 29 right

"People's Court," by Charles M. Blow. Published in *The New York Times*. Data source: Gallup; poll taken 7–20 May 2009.

Page 30 left

Anatomical illustration of the heart by Frank H. Netter.

Page 30 center

JKDA. Designers: Joel Katz and David Schpok.

Page 31 top

http://upload.wikimedia.org/wikipedia/commons/thumb/e/e5/Diagram_of_the_human_heart_%28cropped%29.svg/650px-Diagram_of_the_human_heart_%28cropped%29.svg.png

Page 31 bottom left

Diagram of the heart by Christine Zelinsky.

Page 31 bottom center

Diagram of the heart, in *Visual Heart: Anatomy, Function, and Diseases*, by George Giusti and Rudolf Hollfamn, M.D. New York, Dell, 1962.

Page 31 bottom right

From *The Way We Work: Getting to Know the Amazing Human Body*, by David Macaulay with Richard Walker. Boston, Houghton Mifflin, 2008.

Page 32 top

Diagram of kidney function by Jessica Glebe, student at Moore College of Art & Design, 2007.

Page 32 bottom

Diagrams of monoclonal antibody function for the 1986 Centocor annual report. Katz Wheeler Design. Designers/artists: Joel Katz, Dan Picard, Stacey Lewis.

Page 33 bottom right

Diagram of a liquid propellant rocket. NASA, 1953. http://history.nasa.gov/SP-4306/p152.htm

Page 34 top left

Cover of *Esquire*, November 1970. Art director: George Lois; photographer: Carl Fischer.

Page 34 top center

Poster produced by the Art Workers Coalition, 1970. Artists: Frazer Dougherty, Irving Petlin, Jon Hendricks; photographer: Richard Haeberle, for *Life* magazine.

Page 34 center left

http://www.bbc.co.uk/ahistoryoftheworld/objects/Akxq5WxwQOKAF5S1ALmKnw

Page 34 bottom left

From "The Scourged Back," by Kathleen Collins. *History of Photography* 9 (January 1985): 43–45.

Page 35 center

National Archives.

Page 35 bottom center

http://www.getreligion.org/2010/03/a-skinhead-learns-hes-a-jew

Page 36 left

Advertisement in the *Philadelphia Inquirer*, 4 February 2012; annotations by the author.

Page 36 right–page 37

Solicitations received by the author.

Page 38 top

Two mockups showing JKDA's solution for an overarching transit mark for Philadelphia (left) and the same overall design with the logo of one of Philadelphia's two transit operating companies. Neither graphic is at this location. Industrial design: Bresslergroup.

Page 38 bottom

Metrobits.org

Page 39 left

Transit logos on the websites of their respective operating authorities.

Page 39 bottom right

www.chatype.com

> Our understanding of understanding must begin with the view that what most of us deal with every day—the vast numbers of things that bombard our senses—is not information. It is merely data.
>
> **Nathan Sherdoff**

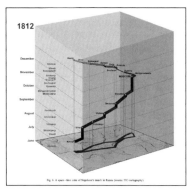

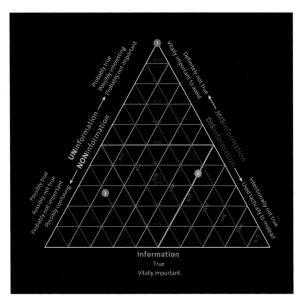

A **tri-axial graph** makes it possible to plot points, each with three different characteristics, the percentages of which always add up to 100%. While any given single piece of data can be only 100% of one characteristic, information generally is comprised of many pieces of data, which may have several characteristics.

In this example, point 1 is 100% information; point 2 is 37% information, 50% uninformation/noninformation, and 13% misinformation/disinformation; point 3 is 28% information, 12% uninformation/noninformation, and 60% misinformation/disinformation. This graph might be an appropriate way of plotting the veracity of political statements.

Learning from Minard. This dynamic cubic presentation of Napoleon's campaign (shown in grayscale—original in color) by Menno-Jan Kraak can be found—along with many others—on Michael Friendly's website, http://www.datavis.ca/gallery/re-minard.php

Learning from Minard. An interesting vision of Napoleon's route as a wall of continually decreasing height, representing the staggering loss of troops.

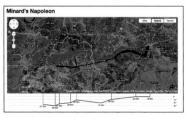

http://mbostock.github.com/protovis/ex/napoleon.html

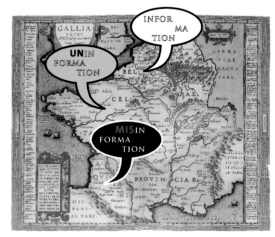

All information is divided into three parts. *Original in* Paragon, *by Abraham Ortelius. Antwerp, 1595.*

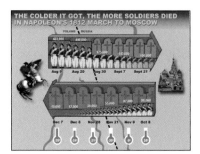

Self-attributed improvements to Minard trumpeting the "sophistication" of Powerpoint. http://extremepresentation.typepad.com/blog/2010/06/gene-zelazny-responds-to-tufte-on-the-famous-minard-graphic.html

The branding fallacy: *newer but definitely not better. The beautiful and appropriate mark above was designed for the Franklin Institute Science Museum in Philadelphia by Hans-U. Allemann of Allemann Almquist & Jones in 1990. Seduced by the notion that change is always desirable, especially after 17 years, a new mark*

was adopted in 2007, along with a name change to "The Franklin," which sounds like a club, a hotel (it is), or a condominium. The name change was rescinded after a year or two, but the ambiguous and visually banal mark remains in use.

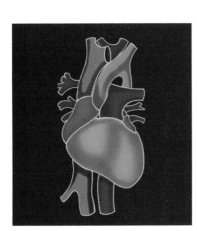

The branding fallacy. *There are only 26 letters in the alphabet, but still…. Above left. Walgreens. Above right. Washington Nationals.*

P	**1**
Problem	Green rice
PD	**2**
Problem definition	Rice with spinach for 4 people
PC	**3**
Problem components	Rice, spinach, prosciutto, onions, extra virgin olive oil, salt, pepper, broth
DG	**4**
Data gathering	Has somebody else already done it?
DA	**5**
Data analysis	How did he do it? What can I learn from him?
C	**6**
Creativity	How can I put everything together in the best way?
MT	**7**
Materials technology	Which rice? Which pot? What temperature?
T	**8**
Testing	Test by tasting
M	**9**
Modeling	Definitive sample
V	**10**
Verifying	Good, and enough for 4
CD	**11**
Construction documents	Final recipe
S	**12**
Solution	Green rice served on a warm plate

Bruno Munari (1907–1998) was a painter, sculptor, illustrator, xerographist, filmmaker, industrial designer, graphic designer, writer, and poet; he researched games, infancy, and creativity.

An example of Munari's intelligence and cleverness is his strategy of describing his design process using a recipe metaphor (for green rice), a process familiar to so many more people than that of "design."

Step 8, "Testing," is an integral and crucial part of every design process.

Anatomy and function. *Diagram of the heart by Peter Bradford.*

The same heart anthropomorphized.

Section 2: Qualitative issues

Page 40

Emma Willard. "The Temple of Time," 1846.

Page 42 top left

From a brochure for Casa di Cinema, Rome, 2011.

Page 43 right

Details of campus maps of Montana State University (above) and Yale University (below). Maps are not necessarily current.

Page 44 top

Graduate student diagram of sea level rise in Venice, 0–2000 CE.

Page 45 bottom

Joel Katz Design, for the Fifth International Pediatric Nephrology Symposium,1980.

Page 46 left

Calories diagram by Peter Bradford (reconstructed).

Page 46 left

Two food pyramids and the food plate, developed and promoted by the U.S. Department of Agriculture.

Page 46 right

A student project at The University of the Arts to redesign the food pyramid. Designers: Samantha D'Agostino, Elizabeth Friedman, and Gordon Sexton, 2009.

Page 47 bottom center

A student design competition's winning design by Renee Walker. In "Designing a Better Food Label," by Tara Parker-Pope, published in *The New York Times*, 28 July 2011. http://well.blogs .nytimes.com/2011/07/28/designing-a-better-food-label/?scp=1&sq=tara%20parker-pope% 20july%2028,%202011&st=cse

Page 47 bottom right

Current nutrition label required on food packaging. U.S. Department of Agriculture.

Page 49

Campus map from UCLA, not necessarily current.

Page 50 top left

Detail of Massimo Vignelli's 1972 map for the New York Metropolitan Transit Authority.

Page 50 top right

The same map recolored to show open space as green and water as blue.

Page 50 center right

Massimo Vignelli, Beatriz Cifuentes, Yoshiki Waterhouse, 2008.

Page 50 bottom left

The Frank H. Netter heart diagram on page 30, recolored.

Page 50 bottom center

The George Giusti heart on page 30, recolored.

Page 50 bottom right

JKDA. Designers: Joel Katz and David Schpok.

Page 51 bottom right

From the *Frankfurter Allgemeine*, 23 October 2008.

Page 52 bottom left

Fondation pour l'aménagement du Quartier des Grottes. *Étude d'Aménagement.* Geneva, Switzerland, 1971. Color system by the author.

Page 52 bottom center

"Purple America," by Robert J. Vanderbei, Princeton University. http://www.princeton.edu/~rvdb/ JAVA/election2008/

Page 53 top

"True color palette." http://onlyhdwallpaper .com/high-definition-wallpaper/truecolorpalette-there-is-any-that-picture-inside-of-high-resolu tion-desktop-4096x4096-wallpaper-294651

Page 53 bottom

Ishikawa color test. http://en.wikipedia.org/wiki/ Color_perception_test

Page 54 bottom

Map of Scandinavia by James Miho. In *Imagination 15: Scandinavia,* published by Champion Paper, 1971.

Page 55

From H. B. D. Kettlewell's 1959 article, "Darwin's Missing Evidence." In *Evolution and the Fossil Record.* San Francisco, W. H. Freeman, 1978, pp. 28–33.

Page 56 and page 57 left

Details from the author's diagram of sea level rise in Venice, 0–2000 CE. Reproduced in its entirety on page 44.

Page 57 bottom

Maps dealing with the Philadelphia archdiocese's decision to close many Catholic schools in South Philadelphia. Above, in color, as on the website, www.philly.com. Below, in grayscale, as it appeared in the printed newspaper. "Catholic school closings hit South Philadelphia especially hard," by Anthony Campisi, 9 January 2012. At right, another map on the same subject in the newspaper.

Page 59

Design for the exhibition concept by Constantin Grcic—*Black²*—at the Istituto Svizzero di Roma, 2010. Catalog designer unknown, presumed to be Grcic.

Page 60 top left

"The Revolving Door: Next Steps," by Jennifer Daniel, Peter Lattman, Thomas Kaplan, and Michael J. de la Merced, published in *The New York Times*, 29 September 2010. Photo illustrations by Graham Roberts.

Page 60 top center

"Where Wall Street Trades in Political Currency," by Andrew Ross Sorkin, Peter Edmonston, and Jennifer Daniel, published in *The New York Times,* 26 March 2009. Graphic by Jennifer Daniel.

Page 60 top right

"Bin Laden as Patriarch," by Scott Shane, published in *The New York Times,* 14 May 2011. Graphic by Bill Marsh; data source Jean Sasson, from interviews with Najwa bin Laden and Omar bin Laden.

Page 60 bottom left

From *Genograms: Assessment and Intervention,* 3rd edition, by Monica McGoldrick, Randy Gerson, Sueli Petry. New York, W. W. Norton, 2008.

Page 61 bottom left

Advertisement for the film, *Joyful Noise*, 2012.

Page 61 bottom right

Mark Lombardi. *World Finance Corporation and Associates, ca. 1970–84: Miami, Ajman, and Bogota-Caracas (Brigada 2506; Cuban Anti-Castro Bay of Pigs Veteran)* (7th version), 1999.

Page 62 top right

Original photograph by John Bartholdi.

Page 62 center left

Original photograph by Paul Kahn.

Page 64 bottom left

"Figure 2.6, Labor Force Nonparticipation, Persons Eighteen to Sixty-Four Years of Age, by Race and Gender, 1900 to 2000." From *One Nation Divisible: What America Was and What It Is Becoming,* by Michael B. Katz and Mark J. Stern. ©2006 Russell Sage Foundation, New York. Reprinted with permission.

Page 66 top center

SEPTA rail schedule for the Paoli-Thorndale line, inbound and outbound. www.septa.org

Page 66 near top center

Jules-Etienne Marey. *La Méthode Graphique.* Paris, 1885. From *The Visual Display of Quantitative Information,* by Edward R. Tufte.

Page 66 top right

Clock in railway station. iStockphoto, file #11985031.

Page 66 bottom

Joseph Priestly. "A New Chart of History," 1769.

Page 67 top

Friedrich Straß. "Der Strom der Zeiten oder bild liche Darstellung der Weltgeschichte von den ältesten bis auf die neuesten Zeiten," 1828.

Page 67 bottom

Project visualizing the spread of seafaring and agriculture by students at The University of the Arts. Designers: Joe Granato and Kay Gehshan, 2012.

Page 68 left

Jean Metzinger. *Tea Time (Woman with a Teaspoon),* 1911.

Page 68 right

Andrew Horowitz, age 5, ca. 1989.

Page 69 left

Elevation, section, and plan of the Chateau de Chambord. From *Various Dwellings Described in a Comparative Manner, being a collection of comparative descriptive drawings in perspective of 35 dwellings of significance from around the world. Drawn by 15 second-year architectural students of the School of Design, North Carolina State University,* by Richard Saul Wurman. Philadelphia, Joshua Press, 1964.

Page 69 center

Elevation, section, and plan of peppers. Photographs by James B. Abbott, www.jbabbott.com

Page 69 right

Architecture in Education, 1996–1999.

Page 70 top

From "The Mechanic Muse: From Scroll to Screen," by Lev Grossman. Published in *The New York Times,* 11 September 2011.

Page 71 bottom

www.macrumors.com, 22 January 2012.

Page 74 top

Interpretive paving showing the owners and occupations of the 500 block of the north side of Market Street in Philadelphia at the time of the Constitutional Convention in 1787. JKDA, 2000.

Pages 74–75 bottom

Four of a series of 72 (so far) interpretive panels for the reverse side of maps in bus shelters in Philadelphia, confirming my assertion that every sign has two sides (the panels are mounted on glass). JKDA. Design director: Joel Katz; designer: Mary Torrieri.

Page 75 left

Detail of the names and occupations (reconstructed) of the 500 block of Market Street north side in 1787, based on Philadelphia's tax assessment for the North Ward. Data by Coxey Toogood.

Page 75 right

Views of some of 11 interpretive stations in the form of a mast, each different, at boat landings along the Hudson River from Troy to Manhattan, 2004. JKDA. Design director: Joel Katz; designer: Mary Torrieri. Industrial design: Stuart G. Rosenberg Associates.

When I was perhaps 10 years old, I read a mystery story called "The Other Arrow" (author and source unknown) that told of a detective who read a dying woman's last scribble— "poisoninsu"—as "poison insulin" and later realized she had meant "poison in sugar."

It's a reminder of the need to examine one's assumptions whenever any change occurs in the design process.

As V. I. Lenin put it, "One step forward, two steps back."

It's about time. Edward Tufte and graphic designer Inge Druckrey produced this schedule for the Hoboken–New York line, based on Marey's timetables on page 66. It did not last long, for reasons that are obscure. It may have had something to do with the fact that all trains are pretty much equally fast, and so one of the great advantages of Marey's notation is in this case unnecessary. *From* Envisioning Information, *by Edward R. Tufte. Cheshire, CT, Graphics Press, 1990.*

It's about time. An interesting use of analog clock faces to show the opening and closing times of Paris public parks at different times of the year.

It's about time. The Office of Charles and Ray Eames excelled in exhibitions that were chronologically organized. This photograph is of the exhibit, *A Computer Perspective, and is from the book of the same name.*

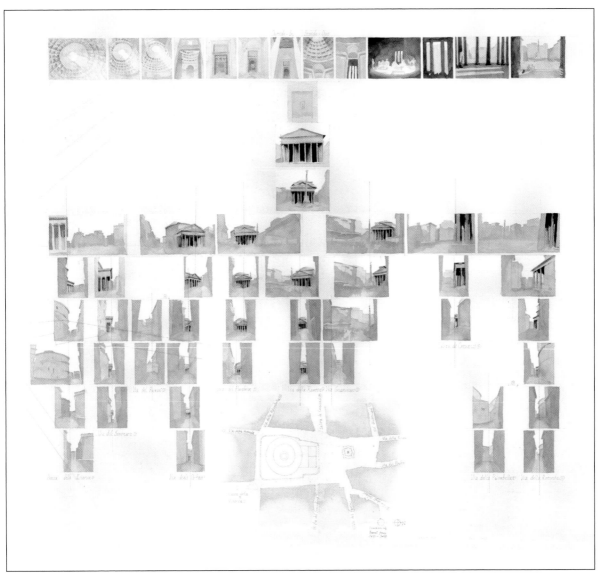

Seeing different ways. *Nancy Putnam, a participant in Yale's Rome program in 2011, produced these on-site drawings of the Pantheon and its surrounding urban context. Led by instructors Alec Purves, Stephen Harby, and Victor Agran, the program—Rome: Continuity and Change—emphasizes the importance of observation through drawing and personal experience.*

Seeing different ways. *Rudolfo Lanciani. Forma Urbis Romae. This topographical atlas was published in 1901. It is a series of 46 detailed plates measuring 25 x 36", with ancient Rome outlined in black and the modern city plotted in red. (Italians have a different definition of the word "modern" than Americans.) The original plates were drawn at 1:1,000 scale. In 1990, the atlas was reprinted by Edizioni Quasar at 1:2,000 scale, its numbered sheets folded and presented in a slip case.*

http://sights.seindal.dk/sight/290_ Lanciani_Forma_Urbis_Romae .html#photo

Section 3: Quantitative issues

Page 77

Page from student Minji Kwon's notebook for a student project dealing with reconciling statistics from four different sources on housing during the recession, for the National League of Cities, at The University of the Arts, 2011. Designers: Linzi Eggers, Minji Kwon, Richard Cardoza.

Page 78 top

Rome bus map, detail, 2008. ATAC, Azienda per la Mobilità, www.atac.roma.it

Page 78 bottom left

Philadelphia tourist map, detail, Philadelphia Convention & Visitors Bureau, ca. 1991.

Page 78 bottom right

Philadelphia tourist map, detail, Philadelphia Convention & Visitors Bureau, 2011.

Page 79

From *L'Antisèche du Métro*. CBHM Éditions, France, nd.

Page 80 top left

The *Philadelphia Inquirer*, September 2011.

Page 80 bottom left

The *Philadelphia inquirer*, 11 March 2012.

Page 80 right–page 81 left

Edward S. Barnard and Ken Chaya. "Central Park Entire: The Definitive Illustrated Folding Map," 2011.

Page 81 center

From "The Greatest Paper Map of the United States You'll Ever See," by Seth Stevenson, in *Slate*, posted 2 January 2012. http://www.slate.com/articles/arts/culturebox/2012/01/the_best_american_wall_map_david_imus_the_essential_geography_of_the_united_states_of_america_.html

Page 82

Television screen of the Baltimore-New England playoff game, 16 January 2012.

Page 83 left and center

EPA-DOT Fuel Economy and Environmental Comparison labels. http://www.fueleconomy.gov/feg/label/learn-more-gasoline-label.shtml

http://i.i.com.com/cnwk.1d/i/tim//2010/08/30/EPA_EV_label_270x589.JPG

Page 83 right

www.planetearthpeaceparty.com/wp-content/uploads/gpn-2002-000117try.jpg

Stephen S. Hall tells this terrifying story in *Mapping the New Millennium*:

"The very efficiency of satellites introduces a mapping problem….[they] generate staggering amounts of information. If you do not have the means to analyze all that data…, you may well miss the message in the data…. That is what happened….

"[They] began to notice that the amount of ultraviolet radiation reaching their instrument… had been steadily rising, meaning that ozone layers must…be dropping…. The degradation appeared to be both steep and steady. As so often occurs in science…, the immediate response…was that something was wrong with the equipment.

"What [they] didn't know [and this is a huge compression of the story] is that data analysts at NASA…had begun to 'flag' ozone measurements over the South Pole that were lower than any of NASA's computer models had predicted…. The computer in effect had been programmed to discount the data.

"Satellites get so much data that you really have to do something of the sort,' Farnam acknowledges. 'You really need to sort out the information…. What they did wrong…was that they were throwing away so much data that it should have told them that something was wrong.'"

Page 85 right

"The Wild West of Finance," by Adam Davison, published in *The New York Times*, 7 December 2011. Sources: The Federal Reserve; the National Information Center.

Page 86

JKDA. Design director: Joel Katz; artwork: Ari Winkleman.

Page 87 top left

A 19th-century photograph of the Great Pyramid. Wikipedia.

Page 87 center left

David McCandless. "The Hierarchy of Visual Distractions."

Page 87 bottom left

The New York Times Magazine, 17 April 2011.

Page 87 bottom right

"How Can a Big Gulp Look So Small?" by Tara Parker-Pope. Original image by Gabrielle Plucknette. Published in *The New York Times*, 21 June 2012.

Page 90

Photographs by James B. Abbott, www.jbabbott.com
Assemblage by Charles Wybierala.

Page 91 left

Advertisement for Southwest Airlines and the Philadelphia Phillies using an orrery metaphor.

Page 91 bottom

Spread from *The Planets on Astrolite*, a promotional brochure for Monadnock Paper Mills. Katz Design Group. Designer: Joel Katz; artist: Steven Guarnaccia, 1993.

Page 92 left

Two graphs comparing homicides in two adjacent cities but with different *y*-scales. "Two Cities, One Deadly Year," published in the *Philadelphia Inquirer*, 18 January 2012. Graphic by John Duchneskje and John Tierno, staff artists.

Page 92 bottom left

Doonesbury, by Garry Trudeau. Published in the *Philadelphia Inquirer*, 8 February 2012.

Page 92 bottom right

Graphic by Nigel Holmes. From *Understanding USA*, by Richard Saul Wurman. TED Conferences, 1990.

Page 93 top

From *The Agile Rabbit Book of Historical and Curious Maps*. Amsterdam, Pepin Press, Agile Rabbit Edition, 2005.

Page 93 bottom

"The Kids Are More Than All Right," by Tara Parker-Pope. Published in *The New York Times*, 5 February 2012. No credit for graphic.

Page 94 top right

Map of London cholera epidemic marking death and the location of public water pumps, by John Snow, 1854. Highlights by author.

Page 94 center

From *Modern Man in the Making*, by Otto Neurath. New York, Praeger, 1939.

Page 95 bottom left

Florence Nightingale. "Diagram of the Causes of Mortality in the Army in the East," 1858.

Page 95 bottom right

Stephen J. Rose. *The American Profile Poster: Who Owns What, Who Makes How Much, Who Works Where, and Who Lives with Whom*. New York, Pantheon, 1986 and ff. Poster designed by Dennis Livingston and Kathryn Shagas.

Page 96 top and center

Mark Newman (Department of Physics and Center for the Study of Complex Systems, University of Michigan).

Page 96 bottom left

Pittsburgh Post-Gazette, 22 May 2002. www.post-gazette.com

Page 97 top left

Chris Pullman.

Page 97 bottom left

Tony Auth, in the *Philadelphia Inquirer*, 16 August 2011.

Page 98 top right

Mark Newman (Department of Physics and Center for the Study of Complex Systems, University of Michigan).

Page 98 bottom

Source unknown.

Page 101

Cartoon thought to have been drawn by Elkanah Tisdale was first published in the *Boston Gazette* in March 1812.

Page 102 top

From www.worldmapper.org
Maps by Mark Newman, data by Danny Dorling, text by Anna Barford, quality control by Ben Wheeler, website by John Pritchard, poster design by Graham Allsopp, and individual country maps by Benjamin Hennig.

Page 102 center

From *2033: Atlas des Futurs du Monde,* by Virginie Raisson. Paris, Éditions Robert Laffont, 2010.

Page 102 bottom left

From *The Atlas of the Real World: Mapping the Way We Live,* by Daniel Dorling, Mark Newman, and Anna Barford. New York, Thames & Hudson, 2008.

Page 102 bottom right

From *The State of the World Atlas*, 5th edition, by Michael Kidron and Ronald Segal. London, Myriad Editions, Penguin, 1995.

Page 103 left

"Understanding the European Crisis Now," by Dyan Loeb MacClain, published in *The New York Times*, 14 June 2012. Data sources: European Central Bank; Eurostat; International Monetary Fund; Deloitte; Haver Analytics, via AllianceBernstein; Institute of Empirical Economic Research, University of Osnabrück.

Page 103 right

Nigel Holmes. "Diamonds Were a Girl's Best Friend." *Time* magazine (original in two colors; recolored for Edward R. Tufte's *Envisioning Information*, 1990.

Page 104 top and center

From *Urban Atlas: 20 American Cities,* by Joseph R. Passonneau and Richard Saul Wurman. Cambridge, MA, MIT Press, 1970.

Page 104 bottom

From *Cities: Comparisons in Form and Scale,* by Richard Saul Wurman. Philadelphia, Joshua Press, 1974.

Page 105 bottom

From *Metropolitan World Atlas,* by Arjen Van Susteren and Joost Grootens. Rotterdam, 010 Publishers, 2005.

Page 106

Portrait of George Washington, by Gilbert Stuart, 1825.

Page 108

From *Understanding USA,* by Richard Saul Wurman. Designer: Joel Katz.

Page 109 top

Graphic by Oliver Uberti. Data source: OECD Health Data 2009, Organization for Economic Co-Operation and Development.

Page 109 bottom

"Statistical Chart showing the Extent of the Population & Revenues of the Principal Nations of Europe in the Order of their Magnitude," from *The Commercial and Political Atlas and Statistical Breviary,* by William Playfair, 1787.

Page 110

Diagram of English length units and their integer relation to each other, by Christoph Päper. Deutsch: Diagramm englischer Längeneinheit und ihrer ganzzahligen Beziehungen zueinander, undated. From http://en.wikipedia.org/wiki/File:English_length_units_graph.png

Page 111 top

http://lifeskillsenrichment.wordpress.com/2010/08/08/eighteen-inches/

Page 111 bottom

Vitruvian Man, by Leonardo da Vinci, ca. 1487.

I wasn't always a performance artist. I used to teach art history.

The slides would come up on the screen and I realized I didn't know anything about them.

So I made stuff up.

The students wrote everything down.

Then, I tested them on it.

Laurie Anderson

Point of view in an attitudinal sense is about looking, and the representation of seeing, that is informed by an idea. These two illustrations are examples of seeing through thought. Saul Steinberg's iconic illustration of a New Yorker's view of the world (top); and a south-up world map possibly favored by Australians that turns our current north-up convention on its head (bottom). http://lanceschaubert.org/2012/01/23/cartography-our-picture-of-us/

Using data from NASA, Dynamic Diagrams assembled an orrery that illustrates the positions of the planets and moons in our solar system and allows a user to view their alignment at any given date in the past or present.

Orrery screen saver by Piotr Kaczmarek, Dynamic Diagrams, www.dynamic diagrams.com/work/orrery/

A reproduction of Nicolaus Copernicus's De revolutionibus orbium coelestium (On the Revolutions of the Celestial Spheres), 1643, is used in a book on the architecture of the universe. Diagram of the solar system by Gottfried Honegger. In Visual Space: The Architecture of the Universe, by Gottfried Honegger and Peter van de Kamp. New York, Dell, 1962.

Facing page, left. **A prequel to Minard's Napoleon** (pages 22–23 and 192–193). Charles-Joseph Minard did much more than his famous map of Napoleon's ill-fated Russian campaign. That map and the one adjacent—flow charts or maps—are known as Sankey diagrams, named after Irish Captain H. P. R. Sankey, who utilized this diagram type in 1898 to show the energy efficiency of a steam engine. This and the diagram to its right deal with immigration, one in the 19th century, one in the 21st. "Rough and Figurative Map representative of the year 1858: The Emigrants of the World. The countries from where they depart and the ones where they arrive, drawn by Mr. Minard, Inspector General of Bridges and Roads in retirement, principally from the public records in 'European Emigration' by Mr. A. Legoyt and the Merchant's Magazine of New York. Paris, 26 September 1862." From http://cartographia.wordpress.com/2008/05/12/minard-on-immigration

Metaphor. *This use of familiar tools and containers is a clear and dramatic way of showing how much sugar the average American consumes. Photo illustration by Kenji Aoki for* The New York Times; *Prop stylist: Nell Tivnan. Source: USDA 2009 Estimates. Published 13 April 2011.*

Integrity (not). *In the 2012 Democratic primary for Pennsylvania state representative, the incumbent sent out this mailer, backed by not a single fact. It was hard to decide whether to showcase its typography or its stupidity (there's no section in this book on stupidity) so it's an integrity issue, even though the integrity discussed in Section 3 is numerical. The incumbent lost, amid a firestorm of media criticism for this mailing.*

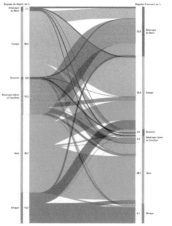

This bizarre quantitative graph, "Diagram Showing the Comparative Miles of Railroads and Telegraphs of the World," *violates many rational devices for comparing quantities visually. Nevertheless, it invites study—regardless of difficulty—with its engaging charm. From Cram's Unrivaled Family Atlas of the World 1889, by George F. Cram, page 17. Chicago, Henry S. Stebbins, 1889.*

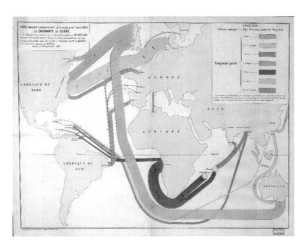

"Répartition géographique mondiale des migrants internationaux, en 2005 (Global geographical distribution of international migrants, in 2005)." From 2033 Atlas des Futurs du Monde.

> If information design
> is to be meaningful,
> it must be responsible
> to the full range of
> perceptual viewpoints.

Roger Whitehouse

Page 115 top

From *Métro insolite,* by Clive Lamming. Paris, Éditions Parigramme/Compagnie parisienne du livre, 2001.

Page 115 bottom left

Talmud, Berakhot, Venice, 1520–1523, Printed by Daniel Bomberg, BM499 1520–1523 v.1, Fols. 46v–47r. COJS, Center for Online Judaic Studoies, http://cojs.org/cojswiki/Talmud,_Berakhot,_Venice,_1520-1523,_Printed_by_Daniel_Bomberg,_BM499_1520-1523_v.1,_Fols._46v-47r

Page 116 top

From *The Form Book: Creating Forms for Printed and Online Use,* by Borries Schwesinger. London, Thames & Hudson, 2010.

Page 116 bottom

http://www.taxhistory.org./www/website.nsf/Web/1040TaxForms?OpenDocument

Pages 120–121

Student project at The University of the Arts to redesign medical leaflets. Designers: Steve Cossentino, Christen Rhoadarmer and Christine Yoon, 2009.

Page 122

Student project at The University of the Arts to redesign the Philadelphia ballot. Designers: Lucia de Sousa, Laura Segal, 2009.

Page 123 bottom left

South Florida Sun Sentinel. http://www.ruddick.com/tim/ballot/index.html

Page 123 bottom center

http://www.typographyforlawyers.com/pix/butterfly.jpg

Page 123 bottom right

Cartoon by Mike Collins, http://politicalhumor.about.com/od/funnypictures/ig/100-Funny-Pictures/Confusing-Florida-Ballot.htm

Pages 124–125

Student project at The University of the Arts to redesign the School Reform Commission's format for reporting on the evaluation of students thought by their teachers to have special needs. The report is sent to the parents or guardians of the student tested. Designers: Erin Gordon and Ryan Penn, 2011.

Pages 126–127

Student project at The University of the Arts to redesign a hospital's dashboard monitoring the institution's achieving its performance goals in several categories. Designers: John Barnett, Felicia Fagnani, Shane Romeo, 2011.

Page 129 bottom center

Plaque attached to the Pioneer F spacecraft in 1972. http://antisyzygy.wordpress.com/category/books/

Page 130 top left

From "Searching the Bones of Our Shared Past," by Edward Rothstein, in *The New York Times,* 18 March 2010. Photograph DiLoreto, Hurlbert/Smithsonian.

Page 130 center

http://www.segd.org/learning/hablamos-juntos.html#/learning/hablamos-juntos/hablamos-juntos-symbols.html

Page 130 bottom *(except 2008 and 2012)*

From *Pictograms, Icons & Signs: A Guide to Information Graphics,* by Rayan Abdullah and Roger Hübner (except 2008 and 2012). New York, Thames & Hudson, 2006.

Page 131 bottom

Print magazine, 1980s. No information available.

Page 132 top

"A visual summary of U.S. accessibility code for signs," by William Bardel, Luminant Design. http://luminantdesign.com/studies/adastudy.html

Page 132 bottom

http://www.ada.gov/ (an amazing beast of a home page; fair warning)

Page 133

http://mutcd.fhwa.dot.gov/pdfs/2009/mutcd2009edition.pdf

Page 135 bottom

From the visual genealogy section of Hesiod's *Theogony,* http://www.classics.upenn.edu/myth/php/hesiod/index.php

Page 136 right

Photographs by Beth Emmott.

Page 137 right center

From "Paul Rand: Modernist Design," by Franc Nunoo-Quarcoo, in *Issues in Cultural Theory 6,* Center for Art and Visual Culture. University of Maryland Baltimore County, 2003.

Expressive typography. *This recent poster (2006) by Niklaus Troxler, although clearly utilizing possibilities afforded by digital technology, has much of the same feeling of Dada and other pre-Modernist typography, as well as the work of Norman Ives.*

Grids in Paris.

Artwork by Matthew Cusick.
http://mattcusick.com

Dead white guys. *Above. A directional sign for Walk!Philadelphia, included to show the role of district icons in the Walk!Philadelphia pedestrian way-finding system.*

Above right. The five icons that comprise the Center City part of the system.

Below right. My original idea, to name districts after the historical figures for whom the squares in each area are named. It confirmed that all dead white guys really do look alike.

The idea didn't get any better when I added their wives.

A spread from Herbert Bayer's (1900–1985) brilliant World Geographic Atlas of 1953, privately published by the Container Corporation of America. Chairman of the Board Walter Paepcke was one of a number of Renaissance heads of corporations of the era, including Thomas Watson of IBM and J. Irwin Miller of Cummins Engine, both of whom utilized the talents of Paul Rand. A quote of Paepcke's from the introduction to the atlas is on the following spread.

Expressive typography in Paris and Rouen, 2011.

Choosing languages. When JKDA was designing Philadelphia's multilingual transit concourse map, requests went out to various agencies for language choices. One reply was "Asian." The languages finally chosen were Spanish, Japanese, French, German, and Chinese.

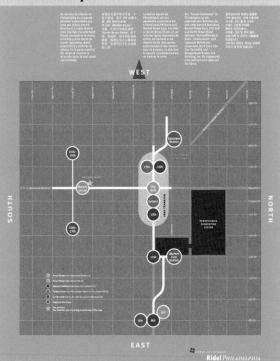

Section 5: Finding Your Way?

What's up? *A heads-up way-finding pylon. The curved edge denotes the water's edge (a safety as well as a cartographic decision) and was illuminated at night. Katz Wheeler Design, ca. 1985.*

Page 152

George Shove. *Map of London on Glove for the Great Exhibition of 1851,* ca. 1851. Printed map on leather. "The Victorian lady who owned this glove would have Hyde Park in the palm of her hand and the River Thames wrapped around her little finger." http://baltimore.about.com/od/events/ig/Walters-Art-Museum-Map-Exhibit/Map-of-London-on-Glove.htm

Page 154 center

Garmin Nuvi 3700 series, from a review, no date. http://rated4stars.com/garmin-nuvi-3750-3760lmt-3760t-3790lmt-3790t-gps-nuvi-3700-series-review

Page 154 bottom, page 155 top left

JKDA. Design director: Joel Katz; designers: Joel Katz and William Bardel.

Page 155 bottom

JKDA. Design director: Joel Katz; designer: William Bardel.

Page 156 bottom

Original photograph by J. Mullender, from *Cartes et Figures de la Terre.* Paris, Centre Pompidou, 1980.

Page 157 top left

Photograph by Carbone Smolan Agency, New York.

Page 158

Rand McNally Road Atlas. Skokie, IL, Rand McNally and Company, ca. 2010.

Pages 158–159 bottom

From *USAtlas,* by Richard Saul Wurman. Access Press and H. M. Gousha/Prentice Hall Trade, 1989.

Page 160 left

Matthew Paris. "Itinerary from London to Chambery," in *Book of Additions,* ca. 1250.

Page 160 second from left

"The Road from London to Southampton. Bagshot, Farnham, Alton, Alresford, Southampton, Romsey, Salisbury." From *Britannia,* by John Ogilby, 1698 edition. www.antiquemaps.com/uk/mzoom/29416.htm

Page 160 second from right

Harry Beck. First London Underground map, 1933.

Page 160 right

Massimo Vignelli, Beatriz Cifuentes, and Yoshiki Waterhouse, 2008.

Page 161 top left

http://www.septa.org/maps/system/index.html

Page 161 bottom left

Alex Yampolsky, Brand Que, http://brandque.com

Page 161 top right

From *Tokyo Access,* by Richard Saul Wurman. Los Angeles, Access Press, 1984.

Page 162 top

Current London Underground map. http://www.metro2.ztm.waw.pl/download/schematy/underground_map.jpg

Page 162 center

http://www.ryanboden.com/wp-content/uploads/2011/08/mark-noad-tube-map.gif

Page 162 bottom

http://ni.chol.as/media/geoff-files/sillymaps/geographical_map.jpg

Page 163

Map of London by Zero Per Zero. http://zeroperzero.com

Pages 168–169

Based on the Ride!Philadelphia transit portals project. JKDA. Design director: Joel Katz; designers: Joel Katz and William Bardel.

Page 170 top

London Underground fare zones. http://mappery.com/map-of/London-Underground-Tube-Map-2

Page 170 center

Mark Noad's fare zone map. http://focustransport2011.blogspot.com/2012/01/alternative-london-tube-map.html

Page 170 bottom

Travel time tube maps. Tom Carden. http://www.tom-carden.co.uk/p5/tube_map_travel_times/applet/

Three screen captures from the site.

Page 171

Map design for a pedestrian wayfinding system for Albany, NY. JKDA (project completed by others).

Pages 172–173 top row, far right

A reconstruction of an Egyptian concept map of the Mountains of the Moon in the Nile valley.

Pages 172–173 center row, left to right

Thomas Eakins. *Portrait of Walt Whitman*, 1887–1888.

Amedeo Modigliani. *Jeanne Hebuterne with Hat and Necklace*, 1917.

Willem de Kooning. *Woman I*, 1950–1951.

Georges Braque. *Violin and Candlestick*, 1910.

Kazimir Malevich. *Red Square*, 1915.

Pages 172–173 bottom row, left to right

Auguste Rodin. *Eternal Spring*, 1881–1907.

Alberto Giacometti. *Bust of Diego*, 1954.

Pablo Picasso. *Baboon and Young*, 1951.

Pablo Picasso. *The Lady*, 1967.

Constantin Brancusi. *Bird in Space*, 1923.

Page 174 top right

"The Road from London to Buckingham," by John Ogilby. From *Britannia*, 1675.

Page 175 bottom right

Detail of a group of Interstate strip maps on a gas station map of the Northeastern United States by H. M. Gousha, for ARCO, 1960s.

Page 176 bottom right

Map of highways and rail in the 5-county Philadelphia area. Katz Wheeler Design; designer: Joel Katz, 1980s.

Page 178

Icons for stations stops of the Mexico City Metro. Lance Wyman, 1968.

Page 179 top

http://en.wikipedia.org/wiki/Japanese_addressing_system

Page 179 center

Namazu-tro. Shimbashi Gaiku address sign. 24 December 2007. http://en.wikipedia.org/wiki/File:Ginza_%2B_Shimbashi_Gaiku_plate.png

Page 180 top and left center

Manhattan outlines and data from "An Overhaul of an Underground Icon," by Ford Fessenden, Matthew Ericson, and Shan Carter, in *The New York Times*, 27 May 2010, with a link to http://www.nytimes.com/2010/05/28/nyregion/28map.html?_r=1

Page 180 center right

http://kickmap.com

Page 180 bottom

http://www.vandam.com

Page 181 top

http://www.bizmanualz.com/blog/procedures-manuals/document-maps-show-literal-documents-produced-within-a-process.html

Page 181 bottom

Provided by the AAA (American Automobile Association).

Page 183 top

Published in the *Philadelphia Inquirer*, 18 May 2011.

Page 184 top left

Map of Midtown Manhattan, by Constantine Anderson, 1985. http://www.codex99.com/cartography/110.html

Page 184 top right

Anonymous. Map of Rome. http://www.paradoxplace.com/Perspectives/Rome%20&%20Central%20Italy/Rome/Rome_Maps/Rome_Map.htm

Page 184 center left

Michel-Étienne Turgot's map of Paris, 1739. http://edb.kulib.kyoto-u.ac.jp/exhibit-e/f28/f28cont.html

Page 184 bottom

Screenshots from Stephan Van Dam's NYC StreetSmart 4DmApp ©2012 VanDamMedia.

Page 185 center right

http://web.mit.edu/facts/campusmap.html. May no longer be current.

Page 187 bottom left

Giambattista Nolli (1701–1756). "Pianta Grande di Roma," 1748.

Page 187 right

From *Antiquae Urbis Romae cum Regionabus Simulacrum*, by Marco Fabio Calvo, 1527.

We...believe that a company may occasionally step outside of its recognized field of operations in an effort to contribute modestly to the realms of education and good taste.

Walter Paepcke (1896–1960) Chairman of the Board, Container Corporation of America, in his introduction to Herbert Bayer's *World Geographic Atlas*, 1953.

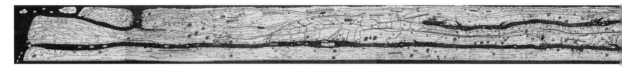

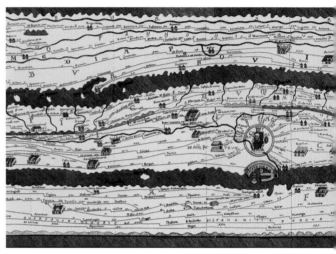

Signs and arrows. *It looks like a wall to me.*

The road is really straight. *No book that touched, however briefly, on map history and vocabulary would be complete without the "Peutinger Table," a highly diagrammatized map of the Roman road network. The original is thought to date from the 5th century CE. This map was made by a monk in the 13th century, in 11 sections. It runs from Spain on the left to India, and so is east-up. The detail of Italy centered on Rome is aligned with the same location on the complete map.*

For more information go to:

http://peutinger.atlantides.org/map-a/

http://www.omnesviae.org

http://news.bbc.co.uk/2/hi/ europe/7113810.stm

http://www.hs-augsburg.de/~harsch/ Chronologia/Lspost03/Tabula/ tab_intr.html

http://www.tabula-peutingeriana.de/ tp/tpx.html

The road is really straight. *Some 45 years after the appearance of Ogilby's* Britannia, *two English cartographers, John Owen and Emanual Bowen, published the modestly titled* Britannia depicta; or, Ogilby improved.

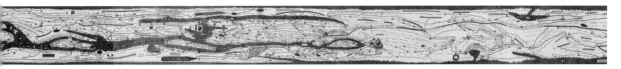

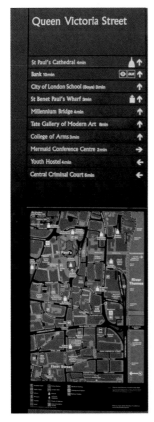

Right. "Main Route Map of Kyoto City Bus and Subway." Published by Kyoto Municipal Transportation Bureau, based on data as of October 1995.

Too much information? One of the recent pedestrian wayfinding pylons in London. Handsomely designed, well-made, and heads-up, they nevertheless have a degree of detail that might be difficult to retain after the viewer has walked away from the map.

Signs and arrows. *Below. The Magic Roundabout in Swindon, England, was constructed in 1972. Its name comes from the children's television series of that name, and in 2009 it was voted the fourth scariest junction in Britain. http://en.wikipedia.org/wiki/Magic_Roundabout_(Swindon)*

To see the 10 scariest junctions in Britian, go to http://news.bbc.co.uk/2/hi/uk_news/scotland/glasgow_and_west/8382506.stm

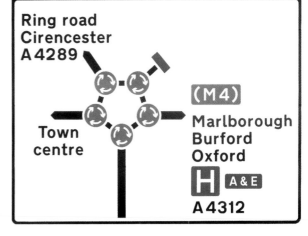

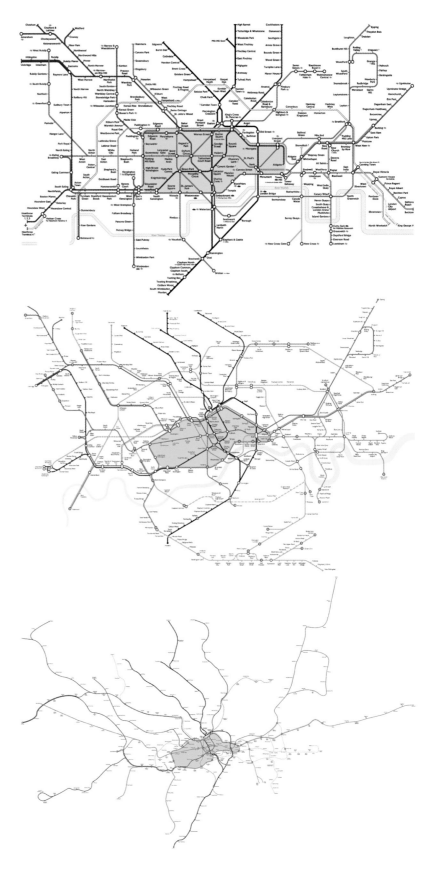

Variable scale. The maps on page 162 show the three different ways of mapping the London Underground—the Beckian, the geographic, and Mark Noad's hybrid. What they do not show is the relative efficiency of the three approaches. The comparisons at right, showing the entire Underground network at the same width, reveals that the most diagrammatic is the most efficient at showing the congested center of London at the largest scale and with the largest type size.

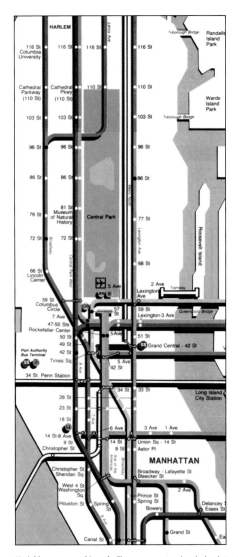

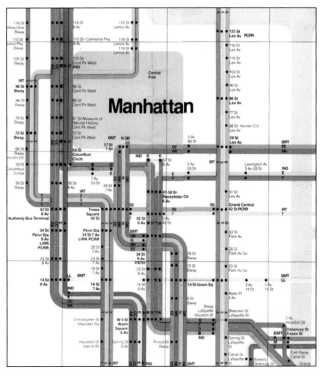

Variable vs. geographic scale. *The map above appeared in Richard Saul Wurman's NYC/ACCESS in 1983 (colors have been enhanced for clarity), combining a diagrammatic vocabulary—a 30/60/90 degree angle grid—at geographic scale overall. The success of this map, in my opinion, is mixed, although Vignelli is quoted in the book, offering a wonderful bit of design history and a cautionary tale of the bureaucratic process:*

"Originally the design of a New York subway map was part of a comprehensive project…. Three maps were designed: one abstract, for the entire system; one geographical, which showed the actual position of the stations in the context of the area; and one which explained how to get there verbally…. Of this original information

network, only the abstract system map was issued for use. That map, like the one in use in London since 1931, was organized on a 45/90 degree angle grid. That configuration has worked well in London…but obviously did not please all New Yorkers. Although praised for its elegance and design, the map's distortions proved to be difficult for users to understand.

"After several years of use, the abstract map was replaced by a new one (although it would have been better to correct the faults of one map, rather than re-educate readers to another). With water in blue and parks in green [see pages 50–51], the present map may be clearer in some instances but, in toto, is a disappointing solution.

"The NYC/ACCESS subway map represents the kind of solution we would have wanted to see as a follow-up to our map, rather than the disappointing version we are now offered by the MTA."

The difference between the two maps reveals the difficulties of assessing success and failure. One can, of course, make educated guesses based on one's own experience and an understanding of human factors, but user feedback is the ultimate determinant.

The sections of the two maps above show the same area of the subway system in rectangles of virtually identical area, centered on Central Park. Overall, the Wurman map is relatively tall and thin while the Vignelli map has squarer proportions. The value of the comparison is compromised by the Wurman map showing trackage while the Vignelli map shows routes (see pages 180–181), which constrains

space for larger type (Vignelli likes small type, anyway). The Wurman map, by being geographically accurate, shows true distances as well as the geographic relationship of stations and, therefore, of the city above, including the true proportions of Central Park. This might be appreciated by many users who would equate those relationships to travel and to pedestrian time/distance. We discussed on pages 161 and 171–173 that we apply appropriate units of measurement to different modes and different scales of the movement experience. For the subway, the unit of measure is the stop rather than feet or miles. So, while the 1983 Wurman map may not retain all the advantages of the 1972 Vignelli map, it does address some of its failings as perceived by users, and it represents a fertile field for discussion.

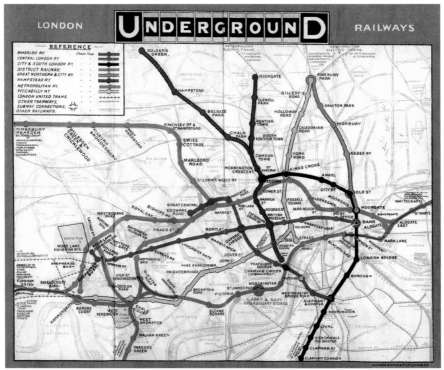

Top. A New York subway map from 1900.

Bottom. The London Underground map, 1908. http://jetsetta.com/wp-content/uploads/2010/08/metro-maps-london-2.jpg

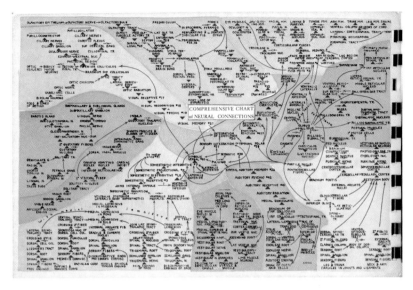

Right. Comprehensive chart of neural connections, an analogy for zone, trackage, route, and isochronic transit network maps. From A Polychrome Atlas of the Brain Stem, *by Wendell J. S. Krieg. Evanston, IL, Brain Books, nd.*

Above. A movement network map for TCL Lyon." In 2009, the public transit network of Greater Lyon faced two major challenges: the redesign of the overall bus network layout, including the introduction of new bus lines with high service levels, and the need to anticipate the full compliance with the French Public Transport Accessibility Act for 2015. The project included the design of a specific typeface and the definition of all symbols of the wayfinding guidelines, as well as timetables and maps. In particular, the new diagrammatic map reveals and emphasizes the multimodal richness of the TCL network, which includes metro, tramways, trolleys, and buses." Attoma (Paris). Design director: Giuseppe Attoma Pepe; project manager: Armand Theychené; designers: Aurélien Boyer-Moraes, Patrick Paleta, Laure Dubuc. www.attoma-design.com

Attoma specializes in making complex movement networks understandable for their users, integrating signage on site, branding, and maps at multiple scales.

Right and below right. Two screens of the user Interface for RATP's Navigo transit pass ticket vending machine.

"In a highly sensitive context, including the progressive phasing out of over the counter sales, Attoma considered a diverse user population. Accordingly, the choice of simple principles of navigation, based on intuitive text formulations and simple and expressive graphics, have permitted a positive perception of the interface that fits with the friendly brand landscape of the RATP. The service is also available on the same kiosk in alternative interaction formats designed for blind and visually impaired users." Attoma, (Paris). Design director: Giuseppe Attoma Pepe; project manager: Laurent Giacobino; user interface designer: Jennifer Sanchez. www.attoma-design.com

213

6 : DOCUMENTS

Inventory: Paris

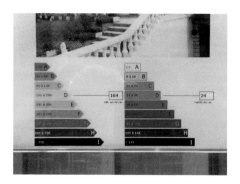

Left. A lighted bus arrival sign.

Right. All realtors now display the environmental footprint of the properties they are listing.

Above. The tropical greenhouse in Paris's Jardins des Plantes has a functional, flexible, and entertaining information display system. A kit of parts makes it possible to integrate the display of type, video, objects, interpretation on multiple levels, and other artwork.

Right. Wayfinding in the Parc de Vincennes.

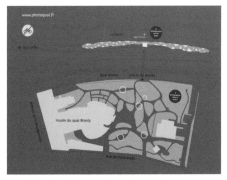

Two exterior maps at Quai Branly, the ethnographic museum of Paris. Both clearly violate the middle value principle (pages 48–49), and consequently it is difficult to discern the pathways from the open space from the building.

Lose lose. This map in Père-Lachaise Cemetery, near right, uses numbers for both Divisions (sections) and for the location of the tombs of important persons. Black circles with white type are also used for métro stations and bathrooms. (Jim Morrison's gravesite is always crowded, Fréderic Chopin's is always covered with bouquets of flowers, and Oscar Wilde's is always covered with lip prints.)

Far right, a wonderfully rational display of bus information on the stairs to the exits of a métro station.

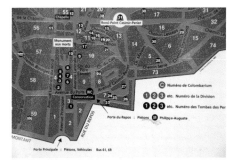

Everything you always wanted to know about your shoes.

A somewhat more successful version of the pictogram on page 130. (It's at the top of the photograph; the gentleman on the poster below is just being dramatic.)

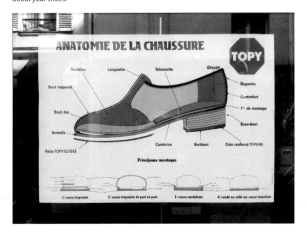

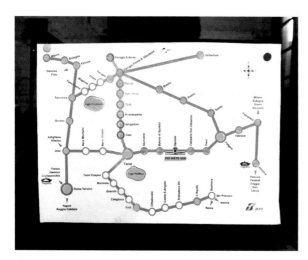

Above. A vernacular-looking poster for the Italian rail network from Rome north, at an extremely interesting, bizarre scale, clearly intended for Umbrians. Notice the distance in the upper left between Florence (Firenze) and Milan (Milano).

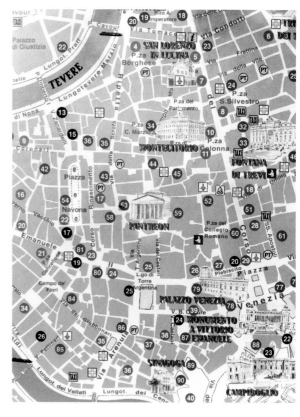

Right. Another winner in the confuse-a-tourist contest. The Pantheon and the Vittoriano are backwards, which is what happens when a building's prominent and recognizable facade faces north. See also page 185.

Facing page, top. Two braille maps, one on a street in Rome, the other in the metro station in Garbatella, a near suburb.

Which button to push? Far left. I'm looking for a green one, right?

Near left. Are parking kiosks every-where difficult to use? See also page 27.

Left and above. Two expressions of the Roman spirit. The photograph above is our dinner check at one of our favorite restaurants: unpretentious and good for evading taxes.

Bibliography

Graphic and information design/ Diagrams /Architecture

Josef Albers. *Interaction of Color: New Complete Edition*. Yale University Press, 2009.

———. *Interaction of Color: Revised and Expanded Edition*. Yale University Press, 2006.

Michael Bierut. *Seventy-Nine Short Essays on Design*. New York, Princeton Architectural Press, 2007.

Best Informational Diagrams. Tokyo, PIE Books, 1999.

Daniel Boorstin. *The Image: A Guide to Pseudo-Events in America*. New York, Vintage, 1992.

D. J. R. Bruckner. *Frederic Goudy*. New York, Harry N. Abrams, 1990.

Mimi Cazort, Monique Kornell, K. B. Roberts. *The Ingenious Machine of Nature: Four Centuries of Art and Anatomy*. Ottawa, National Gallery of Canada, 1996.

Charles Eames, Ray Eames. *A Computer Perspective*. Cambridge, MA, Harvard University Press, 1990.

Eric Ericson, Johan Pihl, Carl Reese. *Design for Impact: Fifty Years of Airline Safety Cards*. New York, Princeton Architectural Press, 2003.

Richard A. Etlin. *The Architecture of Death: The Transformation of the Cemetery in Eighteenth-Century Paris*. Cambridge, MA, MIT Press, 1984.

Jorge Frascara. *Communication Design: Principles, Methods, and Practice*. New York, Allworth, 2004.

Robert L. Harris. *Information Graphics: A Comprehensive Illustrated Reference*. New York, Oxford University Press, 1999.

Jessica Helfand. *Screen: Essays on Graphic Design, New Media, and Visual Culture*. New York, Princeton Architectural Press, 2001.

———. *Reinventing the Wheel*. New York, Princeton Architectural Press, 2006.

Steven Heller, Michael Bierut, William Drenttel. *Looking Closer 5: Critical Writings on Graphic Design*. New York, Allworth, 2010.

Steven Heller, Veronique Vienne. *100 Ideas that Changed Graphic Design*. London, Laurence King, 2012.

And other books too numerous to mention.

Robert Hobbs, Judith Richards, Mark Lombardi. *Global Networks*. New York, Independent Curators International, 2003.

Nigel Holmes. *Best in Diagrammatic Graphics*. London, Quarto, 1993.

———. *On Information Design*. New York, Pinto Books, 2006.

———. *Wordless Diagrams*. New York, Bloomsbury, 2005.

Information Design Sourcebook. Birkhäuser, 2005.

Robert Jacobson, editor. *Information Design*. Cambridge, MA, MIT Press, 1999.

R. Klanton et al. *Data Flow: Visualizing Information in Graphic Design*. Berlin, Gestalten, 2008.

———. *Data Flow 2: Visualizing Information in Graphic Design*. Berlin, Gestalten, 2011.

Marchia Lausen. *Design for Democracy: Ballot + Election Design*. Chicago, University of Chicago Press/AIGA, 2007.

Krzysztof Lenk. *To Show. To Explain. To Guide.* Cieszyn, Slaski Zamek Sztuki i Przedsiebiorczosci, 2010.

Ronnie Lipton. *The Practical Guide to Information Design*. Hoboken, NJ, John Wiley & Sons, 2007.

———. *Information Graphics and Visual Clues*. Gloucester, MA, Rockport, 2002.

Ellen Lupton. *Mixing Messages*. New York, Princeton Architectural Press, 1996.

———. *Design Writing Research*. New York, Phaidon, 1999.

David McCandless. *The Visual Miscellaneum: A Colorful Guide to the World's Most Consequential Trivia*. New York, Harper Design, 2009.

David Macaulay. *The Way Things Work*. Boston, Houghton Mifflin, 2008.

———. *The Way We Work: Getting to Know the Amazing Human Body*. Boston, Houghton Mifflin, 1988.

John Maeda. *The Laws of Simplicity*. Cambridge, MA, MIT Press, 2006.

Alex Marshall. *Beneath the Metropolis*. New York, Carroll & Graf, 2006.

Paul Mijksenaar. *Open Here—The Art of Instructional Design*. New York, Joost Elffers, 1999.

———. *Visual Function. An Introduction to Information Design*. New York, Princeton Architectural Press, 1997.

Philip Morrison, Phylis Morrison, Office of Charles and Ray Eames. *Powers of Ten: A Book About the Relative Size of Things in the Universe and the Effect of Adding Another Zero*. San Francisco, W. H. Freeman, 1994.

Fumihiko Nishioka. *Diagram Graphics*. Tokyo, PIE Books, 1992.

Donald A. Norman. *The Design of Everyday Things*. New York, Basic Books, 2002.

———. *Emotional Design: Why We Love (or Hate) Everyday Things*. New York, Basic Books, 2004.

———. *The Psychology of Everyday Things*. New York, Basic Books, 2002.

B. Martin Pedersen. *Graphis Diagrams 1*. Zurich, Graphis, 1988.

———. *Graphis Diagrams 2: The International Showcase of Diagram Design and Technical Illustration*. Zurich, Graphis, 1997.

Henry Petroski. *The Evolution of Useful Things: How Everyday Artifacts—From Forks and Pins to Paper Clips and Zippers—Came to Be as They Are*. New York, Vintage, 1994.

———. *To Forgive Design: Understanding Failure*. Cambridge, MA, Belknap Press of Harvard University Press, 2012. New York, Vintage, 2012.

William Playfair. *Playfair's Commercial and Political Atlas and Statistical Breviary*. New York, Cambridge University Press, 2005.

Karen Pomeroy, Steven Heller. *Design Literacy: Understanding Graphic Design*. New York, Allworth, 2004.

Paul Rand, Steven Heller, Jessica Helfand. *Paul Rand*. Phaidon, 2000.

Timothy Samara. *Making and Breaking the Grid: A Graphic Design Layout Workshop*. Gloucester, MA, Rockport, 2005.

Borries Schwesinger. *The Form Book: Creating Forms for Printed and Online Use*. London, Thames & Hudson, 2010.

Michele Spera. *Abecedario del grafico: Le progettazione tra cretività e scienza*. Rome, Gangemi, 2002.

Barbara Stauffacher Solomon. *Green Architecture and the Agrarian Garden*. New York, Rizzoli, 1988.

Robert Spence. *Information Visualization*. New York, Addison-Wesley, 2001.

Jan Tschichold, Hajo Hadeler, Robert Bringhurst. *The Form of the Book: Essays on the Morality of Good Design*. Point Roberts, WA, Hartley & Marks, 1997.

Edward Tufte. *The Visual Display of Quantitative Information*. Cheshire, CT, Graphics Press, 1983.

———. *Envisioning Information*. Cheshire, CT, Graphics Press, 1990.

———. *Visual Explanations: Images and Quantities, Evidence and Narrative*. Cheshire, CT, Graphics Press, 1997.

———. *Beautiful Evidence*. Cheshire, CT, Graphics Press, 2006.

These four titles are the holy quadrinity of books on information design.

William Lidwell, Kritina Holden, Jill Butler. *Universal Principles of Design*. Gloucester, MA, Rockport, 2003.

Massimo Vignelli. *The Vignelli Canon*. Lars Müller, 2010.

Jenn and Ken Visocky O'Grady. *The Information Design Handbook*. Cincinnati, OH, How Books, 2008.

Vitruvius. *Ten Books on Architecture*. Mineola, NY, Dover, 1960.

Colin Ware. *Information Visualization*. London, Academic Press, 2000.

Peter Wildbur, Michael Burke. *Information Graphics*. London, Thames & Hudson, 1998.

Alina Wheeler. *Designing Brand Identity*, 3rd edition. Hoboken, NJ, John Wiley & Sons, 2009.

Alina Wheeler, Joel Katz. *Brand Atlas: Branding Intelligence Made Visible*. Hoboken, NJ, John Wiley & Sons, 2011.

Richard Saul Wurman. *Understanding USA*. TED Conferences, 2000.

———. *Information Architects*. New York, Graphis Press, 1996.

———. *Various Dwellings Described in a Comparative Manner*. Philadelphia, Joshua Press, 1964.

———. *Cities: Comparisons in Form and Scale*. Philadelphia, Joshua Press, 1976.

———. *USAtlas*. Simon & Schuster, 1991.

Nathan Yau. *Visualize This: The Flowing Data Guide to Design, Visualization, and Statistics*. Hoboken, NJ, John Wiley & Sons, 2011.

Cartography

James R. Akerman, Robert W. Karrow Jr., John McCarter. *Maps: Finding Our Place in the World*. Chicago, University of Chicago Press, 2007.

Charles Bricker and R. V. Tooley. *Landmarks of Mapmaking*. New York, Dorset, 1976.

Daniel K. Connolly. *The Maps of Matthew Paris: Medieval Journeys through Space, Time and Liturgy*. Woodbridge, UK, Boydell Press, 2009.

James Cowan. *A Mapmaker's Dream*. Boston, Shambhala, 1996.

Daniel Dorling, Mark Newman, Anna Barford. *The Atlas of the Real World: Mapping the Way We Live*. New York, Thames & Hudson, 2008.

Ken Garland. *Mr. Beck's Underground Map*. Capital Transport Publishing, 1994.

Katharine Harmon. *You Are Here—Personal Geographies and Other Maps of the Imagination*. New York, Princeton Architectural Press, 2000.

———. *The Map as Art: Contemporary Artists Explore Cartography*. New York, Princeton Architectural Press, 2010.

Miles Harvey. *The Island of Lost Maps*. New York, Random House, 2000.

Alfred Hiatt. *Terra Incognita: Mapping the Antipodes before 1600*. Chicago, University of Chicago Press, 2008.

Frank Jacobs. *Strange Maps: An Atlas of Cartographic Curiosities*. New York, Viking Studio/Penguin, 2009.

Donald S. Johnson. *Phantom Islands of the Atlantic: The Legends of Seven Lands That Never Were*. New York, Walker, 1996.

Michael Kidron, Ronald Segal. *The State of the World Atlas*. London, New York, Penguin, 1995.

Martin W. Lewis, Karen E. Wigen. *The Myth of Continents: A Critique of Metageography*. Berkeley, University of California Press, 1997.

Mark Ovenden. *Metro Maps of the World*. Middlesex, UK, Capital Transport Publishing, 2003.

———. *Transit Maps of the World*. Mike Ashworth (editor). Penguin, 2007.

Mark Ovenden, Julian Pepinster, Peter B. Lloyd. *Paris Underground: The Maps, Stations, and Design of the Métro*. New York, Penguin, 2009.

Joseph Passonneau, Richard Saul Wurman. *Urban Atlas: 20 American Cities, A Communication Study Notating Selected Urban Data*. Cambridge, MA, MIT Press, 1967.

David Rumsey, Edith M Pun. *Cartographica Extraordinaire: The Historical Map Transformed*. Redlands, CA, ESRI, 2004.

Dan Smith. *The Penguin State of the World Atlas*. London, Penguin, 2008.

Alessandro Scafi. *Mapping Paradise: A History of Heaven on Earth*. Chicago, University of Chicago Press, 2006.

Paula Scher. *Maps*. New York, Princeton Architectural Press, 2011.

Arjen van Susteren. *Metropolitan World Atlas*. Rotterdam, 010 Publishers, 2005.

Louise Van Swaaij, Jean Klare, David Winner. *The Atlas of Experience*. London, Bloomsbury, 2000.

Type, Signs, Symbols

Rayan Abdullah, Roger Hübner. *Pictograms, Icons & Signs: A Guide to Information Graphics*. New York, Thames & Hudson, 2006.

Michael Bierut, William Drenttel, Jessica Helfand. *The Next Page: Thirty Tables of Contents*. Design Observer, Winterhouse Editions, 2007.

Robert Bringhurst. *The Elements of Typographic Style*, 3rd edition. Point Roberts, WA, Hartley & Marks, 2004.

Edward Catich. *The Origin of the Serif*. Davenport, IA, St. Ambrose University, 2nd edition, 1991.

Kate Clair, Cynthia Busic-Snyder. *A Typographic Workbook: A Primer to History, Techniques, and Artistry*, 2nd edition. Hoboken, NJ, John Wiley & Sons, 2005.

Catherine Davidson. *The Directory of Signs and Symbols*. Edison, NJ, Chartwell, 2004.

Robin Dodd. *From Gutenberg to OpenType: An Illustrated History of Type from the Earliest Letterforms to the Latest Digital Fonts*. Vancouver, BC, Hartley & Marks, 2006.

Stephan Füssel. *Bodoni: Manual of Typography*. Köln, Taschen, 2010.

Simon Garfield. *Just My Type: A Book about Fonts*. New York, Gotham, 2011.

Eric Gill. *An Essay on Typography*. London, J. M. Dent & Sons, 1941.

Georges Jean. *Signs, Symbols, and Ciphers*. New York, Harry N. Abrams, 1998.

———. *Writing: The Story of Alphabets and Scripts*. New York, Harry N. Abrams, 1992.

Robert K. Logan. *The Alphabet Effect: The Impact of the Phonetic Alphabet on the Development of Western Civilization*. New York, Morrow, 1986.

Paul Lunde, general editor. *The Book of Codes: Understanding the World of Hidden Messages*. Berkeley, CA, University of California Press, 2009.

Ellen Lupton. *Thinking with Type: A Critical Guide for Designers, Writers, Editors, & Students*. New York, Princeton Architectural Press, 2010.

Lars Müller. *Helvetica: Homage to a Typeface*. Baden, Switzerland, Lars Müller, 2004.

Pictogram and Icon Graphics. Tokyo, PIE Books, 2002.

Alston W. Purvis, Cees De Jong. *Type. A Visual History of Typefaces & Graphic Styles, 1901–1938*. Köln, Taschen, 2010.

Andrew Robinson. *The Story of Writing: Alphabets, Hieroglyphs, & Pictograms, Second Edition*. New York, Thames & Hudson, 2007.

Timothy Samara. *Typography Workbook: A Real-World Guide to Using Type in Graphic Design*. Gloucester, MA, Rockport, 2006.

Simon Singh. *The Code Book: The Evolution of Secrecy from Mary, Queen of Scots, to Quantum Cryptography*. New York, Doubleday, 1999.

Paul Shaw. *Helvetica and the New York Subway System: The True (Maybe) Story*. Cambridge, MA, MIT Press, 2011.

Erik Spiekermann. *Stop Stealing Sheep*. Berkeley, CA, Adobe, 2003.

Jan Tschichold. *Asymmetric Typography*. New York, Reinhold, 1967.

Walter Tracy. *Letters of Credit*. Boston, David R. Godine, 2003.

David L. Ulin. *The Lost Art of Reading: Why Books Matter in a Distracted Time*. Seattle, Sasquatch, 2010.

Ultimate Symbol. *Official Signs & Icons 2*. Stony Point, NY, Ultimate Symbol, 2005.

Beatrice Warde. *The Crystal Goblet: Sixteen Essays on Typography*. London, Sylvan, 1955.

Wayfinding/Notation

Donald Appleyard, John R. Meyer, Kevin Lynch. *View from the Road.* Cambridge, MIT Press, 1970s.

Craig Berger. *Wayfinding—Designing and Implementing Graphic Navigational Systems.* Mies, Switzerland, Rotovision, 2005.

Chris Calori. *Signage and Wayfinding Design: A Complete Guide to Creating Environmental Graphic Design Systems.* Hoboken, NJ, John Wiley & Sons, 2007.

Ken Garland. *Mr. Beck's Underground Map.* Middlesex, UK, Capitol Transport Publishing, 1994.

David Gibson. *The Wayfinding Handbook: Information Design for Public Places.* New York, Princeton Architectural Press, 2009.

Per Mollerup. *A Guide to Environmental Signage: Principles and Practices.* Friedricksburg, Lars Müller, 2005.

VivereVenezia3. *In the Labyrinth.* Mauro Marzo, editor. Venice, Marsilio, 2004.

Jarrett Walker. *Human Transit: How Clearer Thinking about Public Transit Can Enrich Our Communities and Our Lives.* Washington, DC, Island Press, 2012.

History/Culture/Art/Science

Edwin A. Abbott. *Flatland: A Romance of Many Dimensions.* Mineola, NY, Dover, 1992.

Christopher Alexander, Sara Ishikawa, Murray Silverstein, Max Jacobson, Ingrid Fiksdahl-King, Shlomo Angel. *A Pattern Language.* New York, Oxford University Press, 1977.

Kwame Anthony Appiah, Henry Louis Gates, Michael Colin Vazquez, Jr. *The Dictionary of Global Culture.* New York, Knopf, 1997.

Archives nationales. *Fichés? Photographie et identification 1850–1960.* Perrin, 2011.

Rudolf Arnheim. *Art and Visual Perception: A Psychology of the Creative Eye.* Berkeley, CA, University of California Press, 2004.

Isaac Asimov. *The Genetic Code.* New York, Orion, 1936, 1962.

John Berger. *About Looking.* New York, Vintage, 1992.

———. *Ways of Seeing.* Harmondsworth, UK, Penguin, 1991.

Werner Oechslin, Petra Lamers-Schutze. *The First Six Books of The Elements of Euclid.* Berlin, Taschen, 2010.

Philippe Colmar (director), *Figures du corps: Une leçon d'anatomie a l'école des Beaux-Arts.* Paris, l'École des Beaux-Arts, 2008.

Richard Dawkins. *The Selfish Gene.* New York, Oxford University Press, 2006.

Gerhard Dohrn-van Rossum. *History of the Hour: Clocks and Modern Temporal Orders.* Chicago, University of Chicago Press, 1996.

Timothy Ferris. *Coming of Age in the Milky Way.* New York, Doubleday, 1988.

> *Possibly a life-changing book.*

———. *The Science of Liberty: Democracy, Reason, and The Laws of Nature.* New York, Harper Collins, 2010.

John Andrew Gallery. *Philadelphia Architecture: A Guide to the City, Third Edition.* Philadelphia, Center for Architecture, 2009.

James Gleick. *The Information: A History, a Theory, a Flood.* New York, Pantheon, 2011.

Stephen S. Hall. *Mapping the Next Milennium: The Discovery of New Geographies.* New York, Random House, 1992.

Thomas Hine. *The Total Package: The Evolution and Secret Meanings of Boxes, Bottles, Cans, and Tubes.* Boston, Little, Brown, 1995.

E. D. Hirsch, Jr., Joseph F. Kett, James Trefill. *The Dictionary of Cultural Literacy.* Boston, Houghton Mifflin, 1988.

Craig Holdrege. *The Giraffe's Long Neck: From Evolutionary Fable to Whole Organism.* Ghent, NY, The Nature Institute, 2005.

Jamie James. *The Music of the Spheres: Music, Science, and the Natural Order of the Universe.* New York, Grove, 1993.

Paul Kahn, Krzysztof Lenk. *Mapping Websites: Digital Media Design.* Gloucester, MA, Rockport, 2001.

Michael Katz, Mark Stern. *One Nation Divisible: What America Was and What It Is Becoming.* New York, Russell Sage Foundation Publications, 2008.

Ross King. *Brunelleschi's Dome.* New York, Penguin, 2001.

Le Corbusier. *Modulor.* Cambridge, MA, MIT Press, 1968, 1954.

George L. Legendre. *Pasta by Design.* New York, Thames & Hudson, 2011.

Claude Nicolas Ledoux. *L'Architecture de C. N. Ledoux: Collection qui rassemble tous les genres de bâtiments employés dans l'ordre social.* New York, Princeton Architectural Press, 1983.

Manuel Lima. *Visual Complexity: Mapping Patterns of Information.* New York, Princeton Architectural Press, 2011.

Sophie Lovell, Klaus Kemp. *Dieter Rams: As Little Design as Possible.* New York, Phaidon, 2011.

Peter Marzio. *A Nation of Nations.* New York, Harper & Row, 1976.

Neil MacGregor. *A History of the World in 100 Objects.* New York, Viking, 2011.

Monica McGoldrick, Randy Gerson, Sueli Petry. *Genograms: Assessment and Intervention.* New York, W. W. Norton, 2008.

Leonard Mlodinow. *The Drunkard's Walk: How Randomness Rules Our Lives.* New York, Random House, 2008.

Errol Morris. *Believing Is Seeing: Observations on the Mysteries of Photography.* New York, Penguin, 2011.

Frank H. Netter. *Atlas of Human Anatomy.* Philadelphia, Saunders, 2010.

Nancy Princenthal, Philip Earenfight. *Joyce Kozloff: Coordinates.* Carlisle, PA, Dickenson College, 2008.

Diane Ravitch. *The Death and Life of the Great American School System: How Testing and Choice Are Undermining Education.* New York, Basic Books, 2011.

Roger Remington, Robert S. P. Fripp. *Design and Science: The Life and Work of Will Burtin.* Burlington, VT, Lund Humphries, 2007.

Daniel Rosenberg, Anthony Grafton. *Cartographies of Time: A History of the Timeline.* New York, Princeton Architectural Press, 2012.

John Scieszka, Lane Smith. *The True Story of the Three Little Pigs.* New York, Viking Kestrel, 1989.

Charles Seife. *Proofiness: The Dark Arts of Mathematical Deception.* New York, Viking Adult, 2010.

Fred Smith, Joel Katz, Richard Saul Wurman. *The Heart.* Newport, RI, The Ovations Press, 2001.

Dava Sobel. *Galileo's Daughter: A Historical Memoir of Science, Faith, and Love.* Penguin, 2000.

———. *Longitude: The True Story of a Lone Genius Who Solved the Greatest Scientific Problem of His Time.* New York, Walker, 2007.

———. *A More Perfect Heaven: How Copernicus Revolutionized the Cosmos.* New York, Walker, 2011.

Michele Spera. *La Progettazione Tra Creativita e Scienza.* Rome, Gangemi 2001.

Peter Tompkins. *Secrets of the Great Pyramid.* New York, Harper & Row, 1971.

Peter Turchi. *Maps of the Imagination: The Writer as Cartographer.* Hartford, CT, Trinity University Press, 2004.

James D. Watson. *The Double Helix.* New York, Atheneum, 1968.

Gratitude

Mentors

I have been privileged to have four, all of whom opened my eyes to ways of thinking and seeing.

Robert Speier, Hotchkiss

Herbert Matter and Walker Evans, Yale

Richard Saul Wurman, Philadelphia

Business partners

Alina Wheeler, Katz Wheeler Design

Peter Bressler, Paradigm:Design

David Schpok, Joel Katz Design Associates

I'm still friends with all of them. They were exemplary partners—honest, supportive, and collaborative. I was Alina's coauthor for *Brand Atlas*. http://www.amazon.com/Brand-Atlas-Branding-Intelligence-Visible/dp/0470433426/ref=sr_1_1?ie=UTF8&s=books&qid=1299341498&sr=8-1-spell

Staff colleagues

Joel Katz Design Associates—and its preceding firms, beginning in 1975—has had staff colleagues, some of whom began just after graduation and some of whom came to us as professionals. Many of them by now have gone on to practices as members of other firms or as partners in their own firms. Since information design has become the principal focus of JKDA, two of those designers deserve special mention:

Mary Torrieri, who first came to JKDA as an intern and is now a nurse as well as a designer, excelling at both; her nickname was "switchblade" because of her proofreading abilities, which she applied to this book.

Will Bardel, principal of Luminant Design.

Judy Squire, our bookkeeper, has kept everything running since 1995.

Interns

We have always had at least one intern, believing that the integration of school and life is of great benefit to a young person's professional and personal growth. Almost all of our interns have come from The University of the Arts, one of the institutions at which I am privileged to teach. Four of them worked on this project.

Marie Azcueta

Ari Winkleman

Charles Wybierala

Kay Gehshan, our intern 2011–2012, deserves special appreciation.

Clients and students

Love 'em.

Most of 'em.

Most of the time.

You learn so much by seeing how their minds work, even when you disagree with them, which usually leads to dialogue.

And no thanks to

Adobe, for killing FreeHand. See http://www.freefreehand.org

Professional colleagues and friends

One of the joys of doing this book, in addition to crystallizing thoughts, ideas, and observations that have been running through my head for 40 years, has been in making and renewing contact with designers whose work I admire and respect. Everyone I reached out to was unfailingly responsive, supportive, and generous, and I feel a greatly enlarged sense of community.

James B. Abbott	David Macaulay
Albert Ammerman	Mark Newman
William Bardel	Franc Nunoo-Quarcoo
John Bartholdi	Mark Ovenden
Michael Bierut	Giuseppe Attoma Pepe
Peter Bradford	Chris Pullman
Ken Carbone	Michael Rohde
Michael Friendly	Paula Scher
Ann de Forest	Tom Strong
Judith Harris	Mary Torrieri
Steven Heller	Edward Tufte and Inge Druckrey
Nigel Holmes	Stephan Van Dam
Paul Kahn	Alina Wheeler
Michael B. Katz	Richard Saul Wurman
Krzystof Lenk	Lance Wyman

Wiley

Margaret Cummins, an encouraging and supportive editor, has a great sense of humor and was a pleasure to work with. She prefers Manhattans (with Knob Creek bourbon) in cold weather and gin and tonics (with Hendrick's gin—great label) in warm weather.

Amanda Miller, Vice President and Publisher

Kerstin Nasdeo, Senior Production Manager

Ashima Aggarwal, Attorney

Penny Anna Makras, Marketing Manager

Mike New, Editorial Assistant

Lisa Story, copy editor/proofreader

Family

My mother, Gertrude B. Katz (1910–2002)

My beloved wife, Trish Thompson, for her incredible belief, support, and—especially—tolerance

Our son, Benjamin Katz, a joy and a delight for 27 years

My wonderful stepchildren, Ellie Rossi and Chris Jones.

Index

Book design by
Joel Katz Design Associates,
set in Myriad Pro

DATE DUE

PRINTED IN U.S.A.